Published in 2007 by The Faculty of Arts & Architecture, University of Brighton

Edited by Tom Hickey
Exhibition Curators: Tom Hickey and Pete Seddon
Film production - 'Representation: Politics, Memory, History': Ian McDonald and Tom Hickey
Video installation: Ian McDonald and Tom Hickey

Conference organiser: Tom Hickey
Project manager: Susanna Sklepek
Design & Print by Studio Tonne - studio@studiotonne.com

ISBN: 978/1/905593/26/2

Distributed nationally and internationally by

The Kentridge Project
University of Brighton
10-11, Pavilion Parade
Brighton BN2 1RA

Tel: 0044 (0)1273 643084

kentridge@brighton.ac.uk
www.brighton.ac.uk/kentridge

Acknowledgements

The curators and project manager and film producers must register their thanks to the following
without whose assistance the project would not have come to fruition in its present form:

John Warr, Mick Hartney, Colin Matthews, Sarah Atkinson, Marley Cole, Barry Barker,
Anita Rupprecht, Nicola Keith, Melissa Searle, Mark Devenney, Hugh Jones, Rebecca
Haroutunian, Alf Le Flohic, Sue Gollifer, Alex Castells and Frank Gray of the University of
Brighton; colleagues and students in the School of Historical and Critical Studies; Verity Slater
and Sally Abbott of the Arts Council (South East); Michael Maydon (video projection); Seb Pedley
(gallery construction); Jessica Dubow of the University of Sheffield; Ben Tufnel and Claire Walsh
of The Haunch of Venison Gallery; Ruth Rosengarten; Nick Tyson and Paddy Kernohan of The
Regency Town House; Tim Brown and Nicky Beaumont of the Brighton CineCity Festival; Ross
Douglas of Art Logic, Johannesburg; Bronwyn Law-Viljoen, Bazukile Biko, Soloman Mabengeza
and David Krut of David Krut Publications, and Taxi Arts Johannesburg; and last, but especially,
Anne McIlleron, Linda Liebowitz and Natalie and Naomi of the William Kentridge studio.

University of Brighton The Regency Town House Supported by The National Lottery® through Arts Council England ARTS COUNCIL ENGLAND HAUNCH OF VENISON 11/

WILLIAM KENTRIDGE
FRAGILE IDENTITIES

EDITED BY TOM HICKEY
PUBLISHED BY THE FACULTY OF ARTS & ARCHITECTURE, UNIVERSITY OF BRIGHTON

CONTENTS

PRINTS

FILMS

INTRODUCTION

TOM HICKEY

This catalogue presents images, from the animated films, from the filmic installations, and of the prints exhibited at the William Kentridge Festival mounted at the University of Brighton Gallery, and at The Regency Town House, Brunswick Square, Brighton from 7th November to 31st December 2007. It also includes five critical appreciations of the work of William Kentridge, and of the musical scores of Philip Miller for seven of the films in Kentridge's 'Soho Eckstein' series of nine films.

The Festival presented a dual-site exhibition of prints and filmic installations, and a showing of the nine Soho Eckstein films with a live performance of the Miller scores by string quartet accompanied by a Xhosa vocalist, trumpeter, and the contribution of a prepared piano. Alongside the exhibition were presented an hour-long video interview with the artist about his work, a compilation of footage from Kentridge's production of *The Magic Flute* in Johannesburg, and footage of the artist at work in his studio, and in discussion about preparations for the exhibition. A two-day symposium discussed the relationship between art and politics in the c.21st, using the experience of South African art-making during and after Apartheid as its point of departure.

Images and discussion about the exhibition, the performances, and the films, and video footage and papers from the symposium, are permanently available via the web site, which will be a portal for this archive from December 2007. The web site address is www.brighton.ac.uk/kentridge. Interviews with William Kentridge and with other South African artists, and with British artists and critics, with footage from Johannesburg and London, and with images of the artist's work, both completed and in the process of being made, are available to galleries for reconfiguration as an installation. The installation work interrogates the process of art-making and exhibiting against the political back-drop to the early c.21st. For further information about this motile installation work, or about the associated film, contact kentridge@brighton.ac.uk.

The exhibition was mounted at The Gallery of the University of Brighton, and at The Regency Town House. The latter is a heritage site in the heart of Regency Brighton, in Brunswick Square. The gradual and highly detailed renovation work, that has already covered a period measured in two decades, is engaged in the restoration of Regency splendour. Here, with the house in only partially restored form, are the residues of the past impressed onto the walls in the form of decorative scars and shadows and stains. These have a telling resonance with the prints and films of the artist, all of which are directly or indirectly about memory and the fading impressions of memory, personal and collective, and about the ways in which these memories compose for us the identities that we carry with us through our lives. Here too is an exhibition space that has a different, if related, echo of Kentridge's work. The timing of the Brunswick development suggests strongly that a substantial part of its speculative investment funding, and of the funds then used to buy or to rent these prestigious residences, was itself also stained. In this case, stained with the blood and death and suffering of slavery, and of the trade in human bodies.

On the ground floor of Regency House, in the dining room which is painted in the restored colour most conducive to digestion and culinary sensibility according to the refinements of taste in the c.18th and early c.19th, is displayed Kentridge's anamorphic film *What is to Come (Has Already Come)*. Projected onto the surface of the table are images that are to be read from their reflection on the central cylinder. On the first floor are presented his five etchings from the series *Il Sole 24 Ore,* in conjunction with the reproduction of the prints as published by an Italian newspaper, scaled up to broadsheet size. At the head of the stairs, on the mezzanine floor, is the 2m x 1.5m associated work.

In the University Gallery on Grand Parade are presented a variety of print series drawn from Kentridge's work over the past twenty years, most of which have not previously been shown in the UK. Extending his work on what we can learn about the nature of our perception in general from the images into which we invest meaning and significance, he presents six sets of dual photogravures that are to be viewed through stereoscopes. As we adjust the focus to bring the two images together, in that sudden moment when the work of left and right eyes are displaced by the emergence of that single perception, attention focuses both on the detail of the three dimensional images, and on the partially self-constructed nature of our visual and conceptual universe.

Back-projected, from dusk onwards, through the plate glass windows of The Gallery, onto the streets of the city, are his seven short films in homage to George Méliès, *7 Fragments for George Méliès*, and two further shorts, *Day for Night* and *Journey to the Moon*. In these, not only has Kentridge further experimented with the moving image, and deployed the quotidian objects of life as ciphers and symbols for the imagination, he has choreographed and filmed a trail of worker ants as actors in one of his animated dramas. These projections, in folding the gallery space partially inside out, constitute an intervention in the process of exhibiting. They open the issue and the possibility of using external surfaces of exhibition spaces for displaying work, rather than simply accepting windows as apertures to see what is inside. This is something with which he first experimented in Barcelona in 1999, where an animation was projected onto the façade of a museum, and in New York, where his animated film, *Shadow Procession*, was projected onto Times Square in 2001. From outside, one can 'look at' rather than 'peer in'. This usage does not transform the substance of the works or their referents but it does pose the question of the place of the works. In this form, these moving images become part of the cityscape; as 'public art' they insert themselves as alternatives to street signs or advertising hoardings or neon signs, and they do so not as exercises in memorialisation or other forms of instruction. Imagined on a grander scale, they pose a question concerning the possibility of projected images as forms of urban sculpture – an 'animation of the city', glass and concrete surfaces as screens and canvases, the 'gallery' reconfigured as a broadcast station rather than a cavern and a snare.

Tom Hickey
Brighton, UK
October 2007

WILLIAM KENTRIDGE
FRAGILE IDENTITIES

TOM HICKEY

William Kentridge is an artist whose dominant characteristic is a determination to work across many media, and to abjure specialisation. He makes prints using a variety of techniques, from sugar lift to drypoint to linocut to aquatint to silkscreen to photogravure to lithography. He draws with charcoal. He has worked with puppets in theatrical productions that integrate the narrative action with projected images. He is a maker of animated films based on charcoal drawing. He has investigated the nature of artistic making through experimentation with film technique. He is a playwright and a director and a set designer. He is a producer and a director of classical operas and plays that he has reconceptualised to draw out their implications for the contemporary moment, and to integrate projections and animated footage with musical and dramatic performance.

Kentridge is, moreover, a political artist. This is not a politics of slogans, however, or of programmes, or of empty reaffirmations of utopian possibilities, or equally vacuous affirmations of 'the human spirit'. Nor is it the empty claim that his art is political because all art must so be. The politics of his work emerges from its recognition of the ineluctable ground or location of all commentary or representation. That ground is history and place. It is work that, in its expressiveness, insists on the importance of context for the judgements that we make, and for the identities that are forged from the limitations of our circumstances and the actions that we take in those circumstances. It is work that is political not simply in the allusion to, or the depiction of, the conflicts and struggles that constitute our immediate circumstances or national collective histories. Rather it is so in its address to the frailties, illusions, hopes, self-deceptions, ambitions, fantasies and dreams that constitute part of what it is to be the beings that we are, with the identities that have been ascribed to us, and which we have adapted for ourselves. While grounded in the local and the particular, the work addresses a global constituency. It also investigates a global problematic: the nature and role of an appropriate form of representation for the c.21st.

In Kentridge's work, this registration of humanity, this global address, is not a mean recasting of an uncritical Enlightenment universalism that ignores differences of power and position to celebrate the lie of a 'common human condition', a celebration designed to obscure those differences in order the better to preserve them. Kentridge's work is the production of dialectical images. It declares that we are made the beings that we are by our histories, personal and collective, yet we are simultaneously the makers of our history. We cannot construct our utopias to a plan that is outside of our histories but we equally cannot fail to dream, and nor can we deny our capacity to act on our world. Thus are we forced into a choice – to change the world or to leave it as it is. This is, after all, a capacity that, in part, defines us; as humans it is our *differentia specifica*.

It is the challenge whose recognition as one that is unavoidable is an agony, and which can induce, according to Sartre, a sense of nausea or vertigo in recognition of the terrible fact of this freedom that sets us apart as a species. It is a challenge and a capacity which can only be denied in a dissembling and self-deceptive act of what Sartre called 'bad faith' – where we know that we are lying to ourselves. As the Indian historian, Ranjit Guha, once observed, what separates us from micro-organisms and mice is simply the capacity that we have to say. 'No'. This malleable world is, moreover, not only a political world of nations and movements and classes; it is a political world of the everyday. It is to be found in our personal longings, and our insecurities, and in our relationships with the mundane objects and processes of our surroundings. Like Walter Benjamin's quest, Kentridge's works seem to constitute a search for meanings in the contingent (and hence the unpredictable) events that we call experience.

What emerges sharply from the body of work – whether work on paper or on celluloid or in performance – is this interpenetration of the immediate and the conditioned, of our experience of the world as we live it, on the one hand, and the conditions that have framed and made that experience what it is, on the other. Not the least significant aspect of this challenge that the work makes to any naïve notion of 'experience' is in its refusal to represent experience as either personal or political as if these were things of different kind. Without any implication of any further agreement between them, Kentridge and Hegel seem to concur, at least on this point. In his *Aesthetics,* Hegel wrote,

> *What we see in front of us are certain ends individualised in living characters and very conflictual situations, and we see them in their self-assertion and display, in their reciprocal influence and design ... The individual does not remain shut into an independence of his own but finds himself brought into opposition and conflict with others ... Collision is the prominent point on which the whole turns.*[1]

If the substantial thematic core of Kentridge's work is political in this catholic sense, its distinctiveness lies elsewhere. It lies in the style and the approach and in the innovatory techniques deployed. His is an approach to making that is partially destructive, in the process of making objects that are exhibitable and marketable. In her study of filmic animation and its relation to critical theory, Esther Leslie recounts the fascination of Hans Richter with the transposition of drawing into other media as copies. In a reversal of the order of preference accorded to originals and copies normally associated with modernism, Richter wrote in Hans Arp's magazine, *Zelwig,* in 1919, "I made the original drawing but the essence was really the copy, the copy was the original." In the construction of his 'scroll pictures', drawings would be serially replicated with marginal variations. Scroll picturing was a technique descended from Chinese calligraphy. In the UK, it had been adopted by members of the Bloomsbury Group before the First World War.

As Leslie records, "Duncan Grant ... worked on a series of Abstract Kinetic Paintings with Collages, on a scroll, several yards long and unrolled through a light-box in time to music by Bach."[2] Kentridge's original drawings for the animated films are long lost by the time that art work is complete.[3] In this sense, he is in a tradition of making that embraces loss and transformation of the created object.

It is arguable that, in Kentridge's case, it is his experimentation, adaptation and innovation in conjoining drawing and film-making that has secured his position as a major contemporary artist both amongst his contemporaries and critics, and in the avarice of investors. Together with the confidence of his work with charcoal (his draftsmanship), it is this dogged and driven intellectual pursuit, combining philosophical insight, social sensitivity and experimental practice, that has drawn the interest of practicing artists, and the attention of galleries and the art market internationally. His fascination with time and depiction replicate a similar fascination common to those artists of the European avant-garde in the early c.20th. In the act of filming there is always the remoulding of time, and the revisioning of perception. In the framed screen it is possible to see aspects of a world of which we have knowledge but a 'knowledge' without an awareness of the aspect concerned, or even an awareness of our lack of knowledge of that aspect. This is what Benjamin referred to as the "optical unconscious" – the content of experience that, through film and photography, comes available to consciousness.[4] We can see bodily movements that are normally edited out of our consciousness (we 'know' them only as what Polyani called "tacit knowledge"), we see images of cityscapes infused with different meanings and connotations depending on their presentation, as Kracauer observed of film,[5] reusing some of Brecht's comments on, and practices in, theatre production.[6]

The time-frame and the time-lapse, as much as slow-motion or montage or superimposition or film reversal or the rebellion of inanimate objects that is animation, constitute techniques with political effects mediated through the alteration of perceptual possibilities. All constitute the banishment of a naturalistic attitude either to life or to art. They thereby also provide for the confusion and the confounding of empiricist accounts of what is, and how what exists is to be understood. Knowledge is not there to be read off 'experience', as if experience could possibly precede the framing of the world in our consciousness, or precede the theoretical work or cultural acclimatisation that invests meaning and significance in objects and processes. Whatever else may be less than adequate about Immanuel Kant's account of the nature of the knowledge that it is possible for us to have, it is not this. To have any experience at all, we must first have categories that can render the experience *as* experience. Echoing perfectly, if unwittingly, the words of the historian of science and ideas, Norman Hanson,[7] Kentridge once observed, "Seeing, as opposed to the pattern of light and shade on one's retina, is always a mediation between this image and other knowledge."[8]

If Kentridge's work is fully grounded in the specifics of place, and if it is this that ultimately renders it political, then that place is South African history. The history of South Africa is one of traumas: the trauma of the wars of colonisation and domination, the trauma of racial segregation, the trauma of Apartheid, and the war of liberation against it, and finally the traumas of confronting the implications of Apartheid after its defeat. The most immediate of these is, of course, the last. In 1994, the bloody consequences of a revolutionary culmination to the liberation struggle were avoided in a peaceful transition to democratic rule. The African National Congress (ANC) was elected with an overwhelming majority. As with all such struggles, this was less the completion of a process than it was a commencement of an even greater challenge.[9] Firstly, how were the inhumanities of the Apartheid years to be dealt with? How were the consequent resentments, and the desire for justice and retribution, and the punishment of the perpetrators of direct and indirect racial violence, to be satisfied?

During the Apartheid years, the struggle against that system had never been based on race, as far as the ANC was concerned. Both its leadership and its general membership, and indeed its armed wing, had included those of 'white' and 'coloured' hue, as well as those with black skins. Moreover, the objective of the ANC was not to replace one racial domination of society with its mirror image; it was rather for a multi-ethnic and multi-cultural society in which 'race' would play no role in determining constitutional rights, or in the framing of legislation. If the understandable appetite for vengeance against those responsible for the systematic attempt to dehumanise three generations of the non-white majority of the population (and many generations before that under Dutch and British colonialism) were to be satisfied, then South Africa might tear itself apart in an inter-racial civil war.

Secondly, if the ultimate purpose in overthrowing Apartheid was not simply to terminate that system of governance as an offence to any humanitarian sensibility (whether liberal or Marxist) but rather to provide a basis for the material improvement of a black majority in a new South Africa, then the preservation and enhancement of scientific, organisational and technical skills would be crucial. These were skills, however, that were overwhelmingly concentrated in the heads and hands of the white population. Equally, the new South Africa would depend on the retention of white-owned capital, and on the attraction of new capital investment from overseas. For an economically viable future, and one that was not to be built on a simple inversion of European colonialism, the pivotal immediate task was to avoid both 'white flight', and 'capital flight'.

The solutions to these two problems were a pragmatic mix of the novel and the tried, respectively. For the attainment of justice without vengeance, the solution was to be sought in The Truth and Reconciliation Commission (TRC). Under the leadership of Archbishop Desmond Tutu, the Commission oversaw a process of personal admission of guilt by the perpetrators of crimes in return for the promise of amnesty, and the detailed personal testaments of the victims of those crimes, or of their relatives, whose silenced and marginalised histories would be released and revealed. There proceeded months of declarations and admissions and explanations and exculpations, all exhaustively publicised by the media.

No longer could any privileged South African say that they did not know what had been done to preserve their privilege. Now, the weight of the past which had crushed limbs and spilt blood, and denied education and opportunity, was lifted. Whether suspected or known by the white population, and certainly known by the black population, and by all of those engaged in resistance, the terror and torture and murder on which the preservation of Apartheid had been maintained was now broadcast daily. Overseas assassinations of ANC leaders, the illegal occupation of Namibia, war against the liberation forces and the new post-colonial Government in Angola, extra-judicial domestic killings, and the 'disappearance' of those engaged in opposition, and the burning and burying of their remains across the country on isolated farms, were all revealed. Social trauma and moral shock were the consequences. For those who would express surprise and outrage, the question was 'what did you think was preserving the unsustainable for so long?'[10]

The problem was that amnesty meant that the guilty would walk free, and though the victims had their day of testimony, they could feel little other than cheated of justice, however much they might recognise the historical necessity of the bargain. The solution for the strategic economic problem was singularly unimaginative by contrast. Committed to the reduction of unemployment and the raising of living standards for the black population, the first ANC Government in its early years, believing that these ambitions were only achievable through the preservation of a vibrant capitalist sector, signed up to international undertakings with the World Bank and the IMF in return for loans considered to be prerequisites for economic development. These agreements, however, hemmed in the Government's freedom of policy manoeuvre. Free markets and private capital-holding were inviolable; structural changes in the economy through government intervention or outright nationalisation were precluded. The ambition for black improvement, and a redressing of the imbalances of the past, could now be pursued only through social policy, infrastructural investment, and highly circumscribed redistributive policies.

The consequences of these strategies are palpable in contemporary South Africa. On the one hand, and amongst some of those who have personal memories of Apartheid, there is a sense of grief that seems to pervade discussions about the past. This can be sensed in talking to those who are black or who are white, to those who are Zulu speaking, or Xhosa speaking, or English speaking, or Afrikaans speaking. It is not a sense of grief experienced as a regret at something lost, and is certainly not universally felt amongst the privileged, many of whom still live in denial. It is, for those who appear to feel it, a grief that history should have been as it was. It is a kind of sorrow without tears, and appears to be felt by victims and beneficiaries alike amongst those who experience it. Dangerously, however, there is scant evidence that, amongst those who do not have direct memory of the system or the struggle against it, there is much appreciation of the historical sources of current inequalities, and hence little analytical appreciation of the complexity of those origins, or the nature of the struggle. Such ignorance provides fertile ground for populist rhetoric.

The paradox of the TRC's achievement was that bloody vengeance was avoided at the cost of an insistent and permanent tension. After the TRC, it was simultaneously necessary and yet impossible to forget the past, as Hilary Mantell recently observed.[11] South Africans could barely live with that knowledge which was before them (whether they were or are victims or perpetrators or beneficiaries) yet any remotely satisfactory explanation for the manifest divisions of wealth and influence and power along racial lines that currently obtain in the country would require repeated reference to that impossible past.

If this was the political difficulty bequeathed by the TRC, as a consequence of its attempted settlement with the past, then the ANC's accommodation with neo-liberal economic policy, as an attempted settlement with the present, matched and compounded the difficulty. Economically, ANC governments since 1994 have found themselves partially paralysed by the international agreements entered into early in the post-Apartheid period, and which they have inherited as binding constraints. The consequence is that, despite governmental intent and rhetorical commitment, the gulf between rich and poor in South Africa today is in many respects greater that it was under Apartheid.[12] Multi-racialism, and the increasing multi-racial character of the elite and the middle class, has not been matched by economic egalitarianism, and has certainly not delivered a process of progressive economic equalisation. Upward mobility for some has been overbalanced by downward mobility, and by a growing polarisation of incomes. Overlaying this deep structural fissure are the more obvious patterns of African post-colonial crisis. These include corruption amongst both senior and junior officials, progressive deterioration in educational standards, the bizarre misdirection of Government funds towards arms procurement, a health sector unequal to the challenge of the HIV/AIDS pandemic (and with parts of the Government unsure whether or how to try to deal with it), rapid escalation of the rate of violent crime, and a police force distrusted and disdained by the population.

These constituted the core political and economic conditions under which art-making was practiced both during the years of Apartheid and during the first decade of a democratic South Africa. Kentridge's early Soho films, and his play *Woyzeck on the Highveld* (1992), addressed the former, while the later Soho films and his *Ubu and the Truth Commission,* mounted jointly with the Handspring Puppet Company, addressed the latter. These confluences of media and styles (of drawing and animation and light projection and the use of silhouettes) culminated in the work for his production of *The Magic Flute* (2005), and his miniature cinema / theatre installation *Black Box / Chambre Noire* (2005).

In Kentridge's hands, Mozart's opera is transformed. His intervention is not simply into the perennial debate over the significance of the Masonic core of the opera.[13] In his production, that element is central. The struggle between darkness and light, between the Queen of the Night and Sarastro, and thus the struggle of the young heroine and hero to maturity and realisation, is the struggle for the victory of reason over passion, for science over mystical superstition and sentimental identity. Yet, in this production, it is a deeply problematised victory. This is a victory whose misappropriation and misapplication can compound rather than confound the terrors of the pre-modern. One actual outcome of reason's victory in history was, as a matter of fact, colonialism - the self-imposed and deeply self-interested attempt to bring the light of reason to the 'dark continent'. Under the guise of a 'civilising mission', military subjugation and colonial exploitation were imposed by European powers on a continent of peoples. Thus, the assessment of reason's role and its achievements, as with the evaluation of the progress that history has attained for humanity more generally, depend on the optic through which they are perceived. It is the indispensable lens or eye, pre-informed as they are by our conceptual resources and theoretical frameworks, that construct our histories, and thus provide us with our judgements. Kentridge embraces Mozart's serious intellectual and political project but he subverts its easy, undialectical confidence. Work for the 'performing rhino' projected scene in the opera can be seen further developed in the photolithograph *Rhinos* (2007), while the aquatint and drypoint prints *Birdcatching* (2006) show prints of drawings that constituted preparatory work for the opera.

Its European tour took the production of *The Magic Flute* from Brussels to Lille, to Caen, and to Naples. It then went to Tel Aviv and to New York before being staged in Cape Town and Johannesburg. In Africa, and with a mainly black African cast, the production is overlaid with yet another layer of meaning. Achille Mbembe has written of Africa, and of South Africa in particular, as a geographical and political region that faces a possible descent into populism, nationalism and millenarianism – i.e. it possesses an inclination to 'political suicide'. Violence, and particularly in the case of South Africa unnecessary violence inflicted in the course of domestic robbery, he sees as part of this pathological condition, an expressive excess of the post-colony.

The accommodation with neo-liberalism has, according to Mbembe, produced popular demoralisation and a widespread discontent. This has generated a sense of intense but diffuse grievance - though a grievance with no ideological or organisational form that could provide the aggrieved with agency. Amongst those with power it has produced a degradation of public life, and the mobilisation of populist rhetoric in appealing to a 'democratic mob' with the symbols of traditionalism. Crowding the political container that is the South African constitution, from which this maelstrom threatens to burst, is the question of identity – the question, 'what is it to be African?' Elsewhere he has written of Africa as a chimera – ineffable, irreal, absurd – and, plagued by the shadows of the past, the powerful and the powerless embraced in a dance of obscenity in which there is a normalisation of death and the celebration of the grotesque.[14] This is a destiny that he hopes South Africa can refuse. To do so, however, it needs both to confront and to transcend its history.

It is into this political context that Kentridge has stepped with both *The Magic Flute* and the installation piece (or miniature theatre/cinema) *Black Box / Chambre Noire.* They are not themes that he addresses directly. Having an appropriate rectitude in recognising that a white voice is not necessarily the first that should be raised in the new South Africa, he approaches them obliquely via a consideration of history and memory. These historical conditions and collective memories are what frame African identities, and that render them insecure: white voices that cannot yet sing to African rhythms, and black voices that must stretch beyond tradition and the traditionalist idiom in a globalised world but which cannot relinquish the ground of that tradition. What is the character of an embrace of modernity, and of its indispensable universalist principles, that can simultaneously contain the fiercest criticism of that very modernity; how can one occupy the place of modernity so as to offer a critique of it from within? What is it that these young heroes of the opera must learn about modernity that will allow them to surpass the limitations of Sarastro as they enter the white light of reason? It is doubtless for these, as for other reasons, that Mbembe has described Kentridge as possessed of one of the best minds that Africa has produced.

In *Black Box,* Kentridge presents, in minature, the narrative of the war of extermination fought by the German colonial army of occupation of South West Africa (Namibia) against the Herero and Nama peoples. Commenced while he was already working on the Mozart opera, it also confronts the issue of the Enlightenment and its relation to colonialism. The installation combines music, drawing, and projections and has constituted a major triumph of multi-media work in the first decade of the century.

The twelve drypoint prints with engraving, *Copper Notes* (2005), were completed in the same year as *Black Box*, and reflect some of the themes: technological change and the displacement of the human, and states of transformation of one's sense of self as one reflects on traumatic moments from history, and on one's collective memory.

Kentridge's next opera production will be of the Dimitri Shostakovich opera, *The Nose,* commissioned by the New York Metropolitan Opera for 2010. Conceived in 1927, and first performed at the Maly Theatre in Leningrad in 1930, the opera has a plot drawn, as a free interpretation, from a short phantasmagorical story by Nicolai Gogol in his *Petersburg Stories,* it tells of the separate adventures of the anti-hero Platon Kovalev and his nose - once the two have been separated from each other. Having lost his promontory, Kovalev finds himself also deprived of his influence and his virility, while the nose finds itself first a celebrated and then a rejected member of the community. The surreal plot is a rich satire on bureaucracy and the 'civilities' of power. Its targets variously emerge as the police, the representatives of religions and their certainties, petty greed and other forms of self-regard. The general target is petty officialdom, and its vanities. The indicated gulf is between ideals and heroic sacrifices, on the one hand, and their transmutation into slogans and ritual performance, on the other.

If this subject matter was not of sufficient challenge in the Soviet Union of the 1930s, under the developing tutelage of a Stalinist bureaucracy that had been entrenched in the task of eradicating revolutionary sentiment and experiment in both politics and art since 1926, Shostakovich supplied a score that constituted a *musical* affront to the authorities as a supplementary challenge. A collage of musical genres drawn from Berg, Schoenberg and Stravinsky, with unfamiliar rhythms, strange orchestral compositions, and unsingable lyrics, and played before a mobile stage set, the combination looked and sounded and felt more kaleidoscopic than associative. Inaccessible and irreverent, both the idea for the opera and its musical result earned the composer the ire of the state's art officials. This was, according to the Russian Association of Proletarian Musicians, an example of 'formalism', and as such expressed the decadence of a deracinated bourgeois culture. The first production ran only for 16 performances. The young composer had to be rescued, even if against his will, from this insipient 'formalist' degeneration.

The opera was revived in 1974 in Moscow, and then in various productions internationally, most recently by the Kirov Opera, whose production toured Europe in 2006. The attraction of the work for Kentridge seems clear. It is a defiance of the rule of narcissism and self-delusion and self-deception, of the easy appeal to certainties and to dogma; and it is a technical challenge that lends itself to the solutions and potentials offered by Kentridge's innovatory use of drawing and collage for projection on the operatic and theatrical stages. Preparatory work for the production can be seen in the large print *Arithmetique*, and in the studio footage for part of the video sequence in the exhibition.

It is not simply the direct appeal of the surreal plot and the target of the satire, or of the opportunity further to experiment with the use of the stage, that may be operative here as the source of Kentridge's interest in this Shostakovich piece, however. Between *The Magic Flute* and *The Nose* there are more commonalities of intent than the sharp differences in musical style and narrative substance would immediately suggest. If the Mozart is a paean to reason and to the principles of the Enlightenment as the requisite resources of hope in the face of tyranny and narrow-minded self-aggrandisement, and their demeaning of human potential, the Shostakovich is an echo of it, though in a negative register. The latter's satire is of the petty and the pompous and is *not* a satire of the politics of engagement or of social and political change and revolution, however malformed or distorted or abused the latter may be. This is, after all, the composer who, speaking of the penultimate movement of his Leningrad Symphony (his no.7), registered its dedication to light over darkness, wisdom over frenzy, and lofty humanism over monstrous tyranny. He could as easily have been speaking about Sarastro and the Queen of the Night as he was of the defeat of the Nazis, the actual object of his dedication.

Amongst the key questions for a production of the work in New York in the c.21st, however, is how the historical specificity of the work is to be preserved without the dissolution of its satirical edge. Ridicule of pompous officialdom has, like all else, one meaning in one context and the opposite in another. If *The Nose* provided a critical but positive political intervention (however dangerous) in Stalinist Russia in 1930, it could by contrast furnish a comforting reassurance and self-affirmation for a Manhattan glitterati today. Most members of the Met's audience are today as opposed to state redistribution or corporate regulation as were their forebears opposed both to the New Deal and to socialism (between which entirely different projects neither generation has proved capable of distinguishing). That is the not inconsiderable challenge that Kentridge has now accepted.

There can be little doubt that Kentridge has had a major impact on art practice over the last decade. The chief feature of this impact is not in the form of imitation by others but rather in the form of an alteration of the visible. If, following the work of Rancière, we treat artistic practices as 'ways of doing and making' that intervene in the general activity of doing and making, and in ways of being, one of their crucial effects is to contribute to an existing regime of making visible, or to subvert it. Kentridge has changed not just the landscape of making in his major contribution to the reestablishment of figuration and narrative as respectable pursuits, and to the rediscovery of history and politics by practitioners. He has also altered the aesthetic division between the visible and the invisible, the sayable and the unsayable. This is the most important sense in which his is properly described as political art – it is an "interruption of the distribution of the sensible".[15] Indeed, this constitutes, for Rancière, a definition of politics – the transformation of the aesthetic coordinates of a community by implementing in one's activity the universal presupposition of politics: equality. Democracy, for Rancière, is not a form of government or a style of society but a process by which these coordinates are redistributed to make silent voices heard, and to make hidden pain visible. It is not necessary to embrace such exhorbidant re-stipulative definitions to recognise the power of this invitation to re-conceptualise and to re-periodise the ages of transition in society, and in the realm of aesthetic judgements. From a 'representative' to an 'aesthetic' regime is the alternative that Rancière offers to conceptualising the transition as one from the traditional to the modern.[16] If the subversion of today's dominant 'aesthetic regime' is about giving voice to the mute events of history then Kentridge is without doubt a mole.

In this one can see a further way in which the work of William Kentridge relates to an early-mid c.20th European style. It is in respect of his adaptation of the early filmic techniques of the avant-garde, and the association and integration of different media. In his drawings for the Soho Eckstein series of films, the 'drawings for projection' as they have come to be known, it is in the bitterness and resentment towards those who spoil a world, confound hope and aspiration, and maintain a determined disingenuous ignorance about their destructiveness, that his work is an echo of German Expressionism. The particular lineage would seem to reach back to the works of George Grosz, Käthe Kollwitz and Max Beckmann. In the films are depicted power in struggle with poverty, authority against the oppressed, the fight for emancipation – all chronicled through the narrative cartoon depiction of the interrelations of the fictive mine-owner and property developer, Soho Eckstein, his wife and her lover Felix Titlebaum. The charms and dramas of their existences are played out against the back-drop of the grinding poverty and ferocious oppression on which white lives and white privilege depended in Apartheid South Africa. Here too a choice – one of identity and one of voice. No presumption in the works to speak *for* the oppressed, in the sense of presuming to 'stand in', yet equally no reticence in speaking eloquently against the oppression.

The technique was as significant as the theme. The serial erasure and reinscription of charcoal and pastel marks on large-scale drawings, which are filmed, in one or two-frame sequences, with each alteration of the drawing. Thus an animated film whose excess or residue is not a collection of drawings numbered in thousands but rather a small number of drawings (one for each scene) plus the only partially erased marks of their previous incarnations. These marks, of course, are not casual elements in the production. They stamp the history of the work on the face of the work, as if challenging the present to present its credentials similarly. These physical marks that can be discerned on the paper, and on the projected images, are the preservations from the past; they are the material counterpart, in this process of making, of personal memory, of the collective memories that we call 'culture', and of the political recollection and conscious construction that we call 'history writing'.

This is not, however, a style and a practice that are tied to the past. They are not relevant only to a degenerating and degenerate Weimar society as the world edged towards war in the 1920s and 1930s, on the one hand, or to a society that was founded on incoherent and dehumanising racial categories, and which no longer exists since the first democratic elections in South Africa in 1994. The issue of memory, and the seeking of the true depiction of our worldly condition, the naming of injustice and barbarity, are issues of today as much as they were issues of yesterday. Memory and history, and their conjoint responsibility for our sense of who we are, must be and must remain a central concern for any social practice, whether art or politics or other, which wants to remain more than a parody of itself. Our contested histories, and our personal and collective memories, may only yield fragile identities but that is part of their achievement – a de-centering of the self, a subtraction from an overly confident sense of who we are, a recognition that identity is as much a creative act of elective affinity as it is an inherited imposition. Ricoeur is correct that each of us has a name received from another, a patronym (in Western culture) giving the line of filiation, and a further name to distinguish us from our siblings. These are words as names, and words that carry identifications, and that attempt to impose themselves imperiously on entire lives.[17] Yet the suffering subjects of history that we thereby become are simultaneously and immediately, and from our beginnings, members of a collectivity. Though these collectivities pre-exists us, and though this sense of belonging is ascribed to us from our first moments, it is a sense that remains malleable. The ascription is a graft; it is not a natural feature. It is not simply in his work of the Apartheid years that this truth is proclaimed. Nor is it limited to Kentridge's work in the first decade of the new South Africa. In the *Atlas Procession,* as in the animated film, *Shadow Procession* (not exhibited here), we see the theme re-emerge, here with a sensitivity to new global forces that are destabilising whole societies, and creating some of the greatest population movements that history has known. With whom do we identify in such circumstances?

Who is to be included, and who excluded, from 'we' and 'us' and 'ours'? Will we rest on our ascribed identities, and build protective fences and walls, scatter mines and dig moats, install surveillance equipment and invent new technologies of exclusion, or will we render our identities subject to our judgement and our wills? Will we choose honourable or dishonourable lives, and how will we identify an appropriate moral sentiment to guide our decisions?

It is, after all, the contemporary emphasis on 'the New', and the presumption of its identity with 'the good', irrespective of its content, that has delivered growing inequalities nationally and internationally – 'new' beginnings, 'new' parties and 'new' programmes. These programmes regularly inaugurate the review of practices and processes under the rubric of 'modernisation'. In contemporary politics, this does not so much constitute the reinvention of the past, in the form of a rewriting of history, as it does an *abolition* of the past in the interests of eluding the constraints of memory so as to build a future by whim. Wars and imperial adventures, once preceded as they were by jingoism and now by the rhetoric of 'humanitarian intervention' and the rhetoric of global security, are invariably succeeded by the discovery of the lies and deceptions on which those adventures had been justified. The demons of the past are discovered, after the event, to have been the victims of a process of demonisation. So will it be with 'the war on terror', and the treatment of Muslims as 'the enemy within'. So too in any attempt at a partial forgetting or erasure of the past in order to accommodate to the present, whether in today's South Africa or elsewhere, and whether in accommodations to neo-liberalism or in the turning away from persisting oppressions, global and local. The attempt to abuse the past to occlude the failures in the present constitutes a testimony to the strong belief that political authorities have in the power of memory and forgetting. They fear history and favour amnesia. It is history that reveals processes of demonisation. It is history that provides for the later revelation that the identification of demons, of internal and external enemies, and the later disingenuous penance of the demon-finders, are cyclical processes. These cycles are ones that we are doomed to repeat endlessly unless we are rescued by history. For authority, the danger is of a popular appreciation of this history, one that threatens to interrupt the cycle. In this sense, and depending on one's position and interest, memory can be as inconvenient as truth.

William Kentridge's marks on paper and his works for projection constitute a partial antidote to this sickness. The nature of the works themselves render a challenge to any facile claim to authority or certainty or Truth. *Their* truth lies precisely in their representation of a fractured and smudged reality, in which engagement with the world, however hard-fought its basis in analysis and reason, cannot be excused as inevitable, or presented as guaranteed, or be described as other than an act of judgement. There are no certainties. There is only the permanent challenge of justice, and the question of how to secure it.

Models and analysis are of worth only insofar as they serve the struggle for this judgement. Irrespective of whether this was Kentridge's intent, these claims and affirmations scream forth from the works themselves. They do so not just through theme and content but in the very techniques that he has developed and deployed. This was the central element of Krauss' comment on the technique in reviewing his film *Monument*.[18] While the practice produced an animated film, it is as if the logic of filming is being interrupted she observes; it is as if even film's inherently encapsuled and serrated process is being impeded, as if time is being suspended to allow the raw materials of memory to set.

This was figurative art in Expressionist style, and clearly constituted a choice for the artist. It can only be read as a rejection of abstraction's ferocious search for a pure art in Europe and America, or Conceptualism's pursuit of political engagement through critical thought and its expression in installation work. In Kentridge's own words, it was not a dismissal of these moves by his contemporaries that led him in a different direction but rather a recognition of his own discomfort with their insistent minimalism. In contrast, in his works of the 1980s and early 1990s, the brutal realities of Apartheid, in the form of both state violence and the casual oppressions suffered by the black population, on the one hand, and the exculpatory self-pity and hand-wringing engaged in by white liberal opinion, on the other, play centre stage as theme and content. His own ferocity and intensity are exhibited in the intellectual striving for techniques that measure up to the content of what is being depicted.

In her sensitive and incisive essay on Kentridge's print work, Susan Stewart in noting Kentridge's attraction to this form, registers the resonance between technique and his political context in Apartheid South Africa:

> *Where a system of justice is an inscribed system of injustice and cannot be resorted to for moral authority, an art framed by metaphors of 'resistance' and 'ground' and offering this kind of fluidity, individuality and freedom guided by universal principles has a particular power and appeal ... there is a phenomenological resonance between mining and ploughing/agricultural labour on the one hand and the tapering, scratching and pushing of a hard mineral surface on the other. Kentridge's two main materials for marking – the charcoal of his drawings and the lampblack that is the key ingredient of printer's ink – both have a direct relation to his native landscape with its charcoal fires burning in the townships around the city and the resulting soot that comes from home fires and industry.*[19]

Part of the fascination generated by Kentridge's work resides in the way in which both the thematic and the technical features of the work address the question of memory in relation to history and politics. This is the case whether we are referring to the marks of the past retained in the present (as in the Soho films and their technique), or to the re-creation and refraction of the experiments of Méliès in the *7 Fragments*, to the interrogation of 'truth' and 'reconciliation' in the Ubu plays, or to the mournful work of light and remembering in the later installations. Ricoeur, quoting Spinoza's definition of time or duration as the "continuation of existence", observes that the absence in such a definition of a respectable role for memory, its impoverishing treatment, needs to be countered by sharply distinguishing between memory and imagination.[20] While both share the presence of something absent, the former is about the past while the latter is about the fictional, the possible and the utopian. In their different ways, Kentridge and Sartre undo this claim. If imagination is concerned with the unreal, and memory as recall is concerned with the real, then there is a curious reversal. As imaginings that cannot pass away become the pathological obsessions of the individual consciousness that suffers hallucinations (the impossibility of unthinking, or stopping thinking, about that which is forbidden), so does the haunted character of cultures emerge in which the past inhabits the present not as an origin but as a barnacle or encrustation.[21]

From the plight of Eckstein in the later Soho films, through the Ubu plays, to the unsettling challenges of the anamorphic projections and the latest series of prints, Kentridge is scraping at this surface. In the face of the challenges confronting our civilisation globally, and the specific challenges confronting present and future governments of South Africa, his response is to point again to the dialectic of modernity and to the double edge of reason. He does this most evidently in his production of *The Magic Flute* and in his installation *Black Box / Chambre Noire:* while modernity's celebration of reason, and its espousal of universality, are indispensable in the struggle against both want and tyranny, they can equally become the tools of a different domination and deprivation – colonialism, as the dark underbelly of instrumental reason run rampant. With Ricoeur, he is not advocating or promoting a position but rather evoking and invoking a feature of, and a fact about, the potential of memory. He is also pointing to the attendant responsibility attaching to those who are in possession of recall, and who are armed with a discursively defensible account of the past. Kentridge expresses it in images. Ricoeur puts it in words.

> *... there is a privilege that cannot be refused to history; it consists not only in expanding collective memory beyond any actual memory but in correcting, criticising, even refuting the memory of a determined community, when it folds back upon itself and encloses itself within its own sufferings to the point of rendering itself blind and deaf to the suffering of other communities. It is along (this) path of critical history that memory encounters the sense of justice.*[22]

1. G.W.F. Hegel *Introductory Lectures on Aesthetics* (trns. Bernard Bosanquet), Penguin 1993

2. Esther Leslie *Hollywood Flatlands: animation, critical theory and the avant-garde*, Verso, London, 2002, pp.36-7

3. See the essay by Pete Seddon in this catalogue

4. Walter Benjamin 'A Small History of Photography' in idem. *One Way Street and Other Writings* (trns. E. Jephcott and K. Shorter), New Left Books, London 1979, p.243

5. Siegfried Kracauer *Kino*, quoted in Leslie, *op.cit.*, p.75, in presenting comments on the contrast between the films of Ruttmann & Vertov.

6. These are, of course, the filmic techniques now widely used for the production of mass market cinema and television drama, which use partially desensitises the viewer but also contributes to a subversion of the smooth surface of a culture or an ideology, as an awareness of perspectival imaging becomes more widespread.

7. N. R. Hanson *Patterns of Discovery: An Inquiry into the Conceptual Foundations of Science*, Princeton 1952, "... what we see is more than meets the eyeball", p35

8. William Kentridge 'In Praise of Shadows', in Museo d'Arte Contemporanea, *William Kentridge,* Skira Editore, Milan 2003

9. See Tom Lodge *Politics in South Africa: from Mandela to Mbeki,* David Philip, Cape Town, 2002

10. See Antjie Krog *Country of my Skull,* Vintage 1999

11. Hilary Mantell 'Saartjie Baartman's Ghost', *London Review of Books,* v.29, n.18, 20th September 2007

12. See Jeremy Seekings and Nicoli Nattrass *Class, Race and Inequality in South Africa,* University of KwaZulu-Natal, Scottsville, 2005

13. Were Mozart and his librettist, Shikaneder, motivated by their shared membership of a secret society that then (i.e in the c.18th in contrast to its current instantiations in Europe and elsewhere) represented a private commitment to the defence of Enlightenment reason, or were they merely seeking a marketable plot for this musical enterprise that would attract large audiences in an era and a city of intrigue?

14. Achille Mbembe *On the Post-Colony, (Studies on the History of Society and Culture), University of California Press, 2001*

15. Jacques Rancière *The Politics of Aesthetics: The Distribution of the Sensible* (trns. Gabriel Rockhill), Continuum 2004. The argument if further developed in *idem. The Future of the Image* (trns. Gregory Elliott), Verso 2007

16. The alternative forms of periodisation since the work of Greenberg have been usefully identified in a recent essay, see Peter Osborne 'Time and the Artwork' in *idem. Philosophy in Cultural Theory,* Routledge 2000, pp.78-85

17. Ricoeur, op.cit., p.129

18. Rosalind Krauss 'The Rock: William Kentridge's Drawings for Projection', *October,* Spring 2000, p.10

19. Susan Stewart 'Resistance and Ground: The Prints of William Kentridge' in David Krut Publishing and Faulkener Gallery, Grinnell College *William Kentridge Prints,* David Krut Publishing, Johannesburg, 2006

20. Paul Ricoeur *Memory, History, Forgetting* (trns. Kathleen Blamey and David Pellauer), University of Chicago, 2004, p.6

21. John-Paul Sartre *The Psychology of the Imagination,* Macmillan 1973

22. Ricoeur, op.cit., p.500

UP-TO-DATE CONJURER SEEKS VANISHING LADY: GSOH ESSENTIAL WILLIAM KENTRIDGE'S SEVEN FRAGMENTS FOR GEORGE MÉLIÈS

MICK HARTNEY

Two of the earliest films made by George Méliès – in 1896 and 1899 respectively –were entitled *Escamotage d'une dame chez Robert-Houdin* and *Illusioniste fin-de-siècle,* which translate approximately into the Lady and the Conjuror of my title. Only approximately, because Anglophone audiences probably didn't know who Robert-Houdin was, nor what kind of dissolution the lady might undergo at his hands, while by the time Edison and the other big cinema operators in the English-speaking world had distributed the hundreds of pirated copies they had made of Méliès' films, a turn-of-the-century illusionist would be out of date.

As for the good sense of humour, Méliès was an illusionist and impresario well before he made films – in 1888 he had bought the Theatre Robert-Houdin, named for Jean Eugène Robert-Houdin, the 'father of modern conjuring' (not to be confused with the later magician and escapologist Harry Houdini),[1] and he presented and managed the series of magical shows which took place there, while maintaining the extraordinary collection of automata built by Robert-Houdin, which came with the theatre. Laughter and applause were his fuel, and by the time he discovered the brand-new art of cinematography in 1895, he knew just how to evoke them.

In fact, Méliès looked after the mechanical figures with more care than he would reserve for his finished films: the majority of the more than five hundred short films he made are lost. Many, he himself destroyed, in despair at being cheated by the fast-growing and unscrupulous cinema industry, which could distribute and profit from illicit copies of his works faster than he could make them.[2] But the received wisdom, that Méliès ended his days in anonymous poverty, is just not true. He did become bankrupt in 1913, under pressure from the big studios, and his long-time rival Pathé-Frères bought out his Star Films company. For many years after this Georges and his wife Jeanne d'Alcy –the first-ever female film actor, thanks to Georges – managed a small shop in Montparnasse station, selling toys and conjuring kits.

Then in 1929 Georges was recognised by a shopper who happened to be a film historian. Méliès was rediscovered. The French government gave him a fine new home and the *Légion D'honneur.* He also found a new and enthusiastic audience to entertain with his films, which, while they had been up-to-date, even futuristic, when he made them, were by the 1930s quaint, old-fashioned, but no less enchanting. And so they remain. Within a few years of the invention of the film camera, and slightly later the projector, there were plenty of filmmakers using the rapidly growing repertoire of tricks and effects that Méliès deployed: jump cuts, in-camera dissolves, reverse filming, superimposition, and so on. These techniques developed the language of cinema, eventually helping to create a simulacrum of reality, the *mis-en-scene,* a putting of the viewer in the picture, which enabled a product to be made which could be totally consumed in one sitting by a massive audience.

Méliès, the showman, the conjurer, wanted none of that – well, perhaps the profits. But he rejected reality in favour of fantasy. The Lumière brothers, who could claim the first public cinema screening, adhered earnestly to the recording of the real world: a train entering a station, workers leaving the Lumière factory: that strand of cinema which, despite all the deceit, subterfuge and selectivity that would haunt the genre, became known as 'documentary'. Méliès, meanwhile, wanted to create worlds, not just stare at the one we already have. With his gifts for theatre, illusion, and painted scenery, conjoined with his newly -developed skills with the film camera, the audience could go to the moon, or under the sea. They saw a rapid succession of magicians, ghosts, demons, fantastic beasts, mutating humans, bottomless pits and bottomless cabin trunks, smoke, flames, talking planets and living playing-cards, appearing and dissolving, all made somehow unthreatening by a regular accompaniment of giggling, flirty soubrettes, one of whom the filmmaker married.

It was Méliès' constant, enthusiastic presence in his purpose built studio – drawing the storyboards, painting the sets, instructing the actors, placing and operating the camera, and regularly appearing in front of it (he preferred to stay behind the scenes at his theatre) – which give his films a unique, enduring quality, a quality his rivals could only aspire to replicate. Each film that survives – an example was rediscovered as recently as 2005[3] – contains more life and personality than a season of Hollywood. Méliès was the original cinema *auteur*.

If William Kentridge seems, by contrast, less extrovert, more thoughtful, more haunted than haunting, a brief roll-call of his talents will explain why he decided to create an homage to George Méliès, in the eponymous *Seven Fragments...*, and the often accompanying two film loops, *Journey to the Moon* and *Day for Night*. Kentridge has said that he was 'reduced to being an artist'. In the apartheid years of South Africa he waited until there was a liveable society before deciding what he wanted to do with his life. Meanwhile he drew, and drew. By the time South Africa seemed to have a future, however uncertain that future might be, he felt that drawing was all he could do. Quite a contrast, it would seem, to the positive act in which Méliès sold his share of his father's shoe factory in order to buy a theatre of magic.

There's more to it than that, of course. Kentridge had gained a degree in Politics and African Studies at the University of the Witwatersrand. He then took a diploma in Fine Arts from the Johannesburg Art Foundation. From 1975 to 1991 he acted and directed in the Johannesburg-based Junction Avenue Theatre Company. In the 1980s he studied mime and theatre at the Ecole Jacques Lecoq in Paris and then worked back in South Africa on television films and series as a production designer.

Kentridge earned an international reputation in the 1990s for his animated films, produced by drawing in charcoal, erasing, smudging, and reworking each of a few drawings for each film, exposing the film to the drawing frame by frame as he worked. The films depicted the country and society he lived in, and dealt with the contradictions, contrasts, doubts and tensions that confronted a white citizen of South Africa, with a kind of intimate political sense, imbued with a subtlety of insight and humour that was found in few other contemporary artists. The lives and tribulations of characters like Soho Eckstein and Felix Teitlebaum – each a fragment of a caricature of himself – were observed against the harsh scrubland and industrial detritus that surrounds Johannesburg, a setting that Kentridge felt was best depicted in monochrome. They are not narratives in the conventional sense, but internal visual monologues, driven forward partly by the stimulus of external events, and partly by pictorial cues, puns and diversions.

While only a few drawings – battered palimpsests – physically survive each film, leaving their hundreds of successive ghosts in negative on the celluloid, Kentridge is a prolific artist alongside his filmmaking.

"I cast a wide net and haul it in," he has said. "Some of my works start as videos, turn into drawings, then film and back to video to projection, to photographs, to photogravures (an etching technique)."[4]

One should point out that Kentridge is skilled in making puppets, some of which are cut out of drawings or prints, and which may find themselves operating in films, shadow-plays or installations. These in turn may become part of works of opera and theatre.

"I had a theatre, film and drawing background and animation was a natural combination of all three. It is impossible to find money for a feature film [in South Africa]. This way I do filmmaking with a crew of one. On the first day I set out to make a film, I can have the first few seconds made. That is a privilege in the world of film."[5]

When Kentridge was awarded an Honorary PhD by his alma mater, the University of Witwatersrand, Johannesburg, on the 20th May 2004, he gave a remarkable address to the graduating students. At one point, he reviews some advice he had received:

> *"I was told by many intelligent people who only had my best interests at heart: 'Do one thing only. If you do everything you will always be a dilettante, unable to master any field. Either be a filmmaker, or an actor or an artist, and you will do it better.' For many years I tried to keep to this good advice. I sold my etching press when I went to acting school. I stopped doing theatre when I started working in film. It was through hard work and good fortune that I escaped that advice...I am wary of advice. But more than that I am wary of the certainty that lies behind most advice. I am mistrustful of certainty. Show me a certainty and I will show you a policeman with a sjambok standing behind it."[6]*

In the *Seven Fragments...*, Kentridge foregrounds doubt, celebrates the positive aspects of uncertainty, of perseverance with particular kinds of incompetence, until the effort, the continued insistence on being not quite right, emerges as, not a certainty, but a kind of resolution. In many of the looped films, the artist is seen moving around his studio, taking up whatever comes to hand: books, paper, a coffee pot, an ink-soaked rag, a stick of charcoal, using them to carry out what seem to be purposeless tasks. Kentridge knows, and admires, the work of Bruce Nauman, one of the most respected living American artists, whose films, video pieces, photographs and sculptures of the 1970s resulted from just such desultory pacing and sitting in the studio. Both have been influenced by Samuel Beckett's doubt-driven, compulsive-obsessive characters.

> *"Last year I spent some time looking at the early films of Bruce Nauman, films of him walking backwards and forwards in his studio, of him bouncing a ball, walking in slow motion, walking with contra-posto, doing a 'Beckett' walk. Perhaps it was the athletic body in jeans and T-shirt that reminded me of the films of Jackson Pollock painting in his studio. It was as if Pollock's canvas had been taken away and Nauman's left, with the studio as canvas and himself as brush and mark in one. When I saw the films of George Méliès I was struck by the continuity. Méliès' films are studio films par excellence. The artist Méliès is in the studio performing in front of his paintings. Although Méliès' films had many subjects - with a predilection for devils, romantic classics, conjuring tricks performed in front of the camera - the central subject is always Méliès and his painted sets, the artist using the images he has made to try and see himself. When I came to work on the fragments for Méliès, the given, the parameter, was the artist in the studio. I kept hoping the fragments would expand beyond this tight world, but somehow all of them, even Journey to the Moon, kept within this frame."[7]*

Kentridge's actions or non-actions are, however, transformed by his knowledge of film and animation technique, and by his desire to emulate the cinematic magic of Méliès. One technique he uses frequently in these films is reversal in time, running the film backwards for its show print, so that books are languidly, perfectly, caught in the air, that in reality were hurled aside, or ink originally spilled or smeared on paper is miraculously cleaned away.

Fragments of a life-size drawing of the artist are pulled together into a convincing whole, mirroring in dress and stance the figure of the artist himself. And knowing what the reversal in time can achieve, Kentridge plays tricks with this device, deliberately reversing his own actions in front of the camera to complicate the game.

This stratagem, acting 'backwards' and then reversing the record of the act, has an interesting history in cinema. Méliès deployed it, of course, as did his rival at Pathé-Freres, Gaston Velle. Chaplin used it in his comedies, so that, for instance, a battleaxe held by a haunted suit of armour would appear to fall, embedding itself in the floor millimetres from an advancing actor's foot. In reality, of course, the axe was lifted as the actor walked away backwards: reversing the film created a dangerous-looking stunt.

Much later in 1974, the Canadian artist and filmmaker Michael Snow used the technique in his film *Rameau's Nephew...*, an epic series of meditations on the relationship between sound and image. He gave himself the added complication that the actors' lines had to be learned and performed backwards, in order to make anything like sense when the film was reversed. The American video artist Gary Hill refined the device. His 1984 piece *Why do Things Get in a Muddle?(Come On Petunia)* is a study of entropy based on a passage by the anthropologist and linguist Gregory Bateson, in the form of a dialogue between a scientist and his daughter, mostly spoken backwards. When the video is reversed, we hear the words, strange-sounding but comprehensible, while the scientist's pipe sucks in smoke, and the girl's bedroom miraculously tidies itself.

For Kentridge, the reversal of time had a particular attraction.

"At first I had thought to do a whole series of films running backwards; Reversals of Fortune or Anti-entropy it was to be called. The technique or possibility is used a lot in the Méliès fragments, but not in the exclusive way as I had first imagined. I suppose the possibility of reversing film or tape is so seductive because of its immediately revealing what the world is like if time is reversed, what it would be like if we could remember the future. Film reversed shows a utopian perfection of one's skills. Throw a pot of paint and when you catch it in reverse, not a single drop is spilt. Tear a sheet of paper in half and it restores itself without the smallest crease. There is an extreme politeness of objects; pull a book out of a shelf and when you replace it, the books at each side at the last instance shift just the right amount to make space. From chaos there is return to order. The page of text returns letter by letter, word by word into the pen, leaving the load of ink pregnant with infinite possibilities."[8]

Anti-entropy is a key concept here, I believe. 'Entropy' is used to describe the process by which things, and planets and people, decay, fall apart and die: the heat death of the Universe. Entropy is to blame when I put down a vital piece of paper and then spend the next half-hour looking for it. It is why a set of cables or cords can be placed in a perfectly tidy way, and not be touched, but the next day be found inexplicably, inextricably knotted together. As my faculties begin to falter and fail, and I suppose that William Kentridge's, to some extent, are doing the same, we inevitably dwell occasionally on the possibility of reversing time.

Only two French newspapers reported the first public cinema screening by the Lumière brothers, at the Salon Indien in Paris, on the 28th December 1895. Both reports dwelt on the new medium as a kind of resistance to the fact of death. In *La Poste* this passage appeared:

> *"When these cameras become available to the public, when all are able to photograph their dear ones, no longer merely in immobile form but in movement, in action, with their familiar gestures, with speech on their lips, death will no longer be final."*[9]

Roland Barthes asserted that death was always present somewhere in the portrait photograph. André Bazin, author of *What is Cinema?* saw the plastic arts, including film, as alluding to a 'mummy complex', affecting all societies, from ancient Egypt to our own, and embodying our desire to stave off the inevitable. I don't want to end this essay leaving the impression that William Kentridge's *Seven Fragments for Georges Méliès* are about death or the abolition of death. What they do seem to be about, over and above the humour with which Kentridge approaches his own musings, frustration, achievements, desires and amusements in his studio, with their constantly looping, repeated and reversed movements, the suspension and reiteration of entropy, is something like the death of finality.

1. Harry Houdini was born Erich Weisz in Budapest in 1874, and emigrated with his family to America when he was four. When he became a professional magician in 1893, he adopted the name Houdini in homage to Robert-Houdin. This was traditional practice for magicians. The 'Harry' was a more alliterative version of Erich.

2. In addition, almost unbelievably, the French Army melted down hundreds of copies of films, including those of Méliès, to make boot heels for soldiers in World War I. (For this piece of trivia, and much else, I am indebted to Wikipedia: *caveat emptor.*)

3. Cleopatra, aka *Robbing Cleopatra's Tomb,* a two-minute film from 1899, long thought lost, was rediscovered in a store room in Paris in 2005.

4. Interview with Kristin Sterling: Columbia News, University of Columbia, New York, December 5th 2002

5. Ibid.

6. Address to Graduands: *I realize why I draw,* by William Kentridge, Hon. PhD, on occasion of his award, University of Witwatersrand, Johannesburg, Gauteng, South Africa, Thursday 20 May 2004. Reproduced in *William Kentridge's Noiraille: Politeness of Objects,* by Jennifer Arlene Stone, 2005, javaribook.com

7. William Kentridge, Baltic Art Centre, 2003: www.balticartcenter.com

8. Ibid.

9. *La Poste,* Paris, 30 December 1895.

ERASURES & PALIMPSESTS
THE HAND OF POLITICS

PETER SEDDON

Trawl through the Google website references on Kentridge, and one remark about Kentridge's technical procedures keeps occurring. All point out that instead of using standard animation techniques of simple cell drawings, one on top of the next, each filmed in sequence, resulting in possibly hundreds of drawings, Kentridge works on one sheet of paper, usually a very large one, continually rubbing out and adding marks, filming these changes as he goes along. This produces odd effects of growth, change, visible erasures and additions on one image that then become animated into a sequence, resulting in peculiar narrative effects that many commentators have noted. This technical method positions his work differently to that of most 'animation' art. It claims the gallery space rather than the TV or cinema screen, and is part of that current hybrid of gallery practices that show a blend of video, digital forms and digital animation and projected imagery. To some extent, it might be claimed that he is essentially a theatre-based 'animateur' who has been adopted by the art/gallery world. He has, after all, had training in, and extensive contacts with, the world of the theatre. Nevertheless, whatever his interdisciplinary playfulness, this essay argues that his practice should be located firmly within the terrain of the visual arts. To pursue this claim one must return to what I see as the very core of his practice, drawing.

When I was being taught to draw in my first basic year of professional training, back in 1967, there was a tension in the pedagogy over the use of erasers. The use of erasers from the outset was firmly discouraged and frowned upon since the fear of getting it 'wrong' needed to be overcome. (Drawing, as one might guess from this, was something to be done from observing motifs and models.) "Be positive," the tutor would say, "and don't tickle the paper with your pencil, make a proper mark." The making of a drawing was a learning experience which needed to be made evident, and not be disguised by incessantly rubbing out to a clean slate to begin again in the vain hope that, on that returned 'whiteness', things would come out okay, and that one might get it 'right' - however this 'right' might be conceived. The aim was to get the student to look carefully, to draw what they saw in the context of a vocabulary of marks made by a variety of graphic tools on paper - usually an HB pencil, sometimes a B or 2B; never softer. This is a point echoed by Kentridge himself, "My drawings don't start with a beautiful mark, it has to be a mark of something out there."[1]

Then one day, after two months of drawing like this day in and day out, the tutor came in with a large eraser in his hand, and proceeded to demonstrate how to use it on our drawings. His hand flew rapidly and firmly at just the right pressure over my drawing, across the entire sheet from top left to lower right (he was left handed), in vigorous repeating strokes. Seeing my horrified face (I thought my drawing was rather good) he said,

> ... notice that the echoes left on this palimpsest on which you will redraw, are the marks you were most confident about; confident that the mark is both the result of careful looking, and has been felt with your hand. Those less certain, less confident marks have either disappeared or have left faint echoes, smudgy traces on which you can build. Now do it again, and then rub out and do it again, and then rub out just as I have shown you. Now you can understand what erased marks can do, what they can really contribute. To rub something out is not simply to make it disappear.

Some things in art practice are simple to conceive in the head but difficult for the hand to do. Most people refer to this by using mysterious words such as 'talent' but talent has little to do with this. What we were being taught was an old 'academic' trick about drawing that had been repeated in various forms down the years in academies and art schools. In one sense, what Kentridge has done is to realise that this process could be filmed, producing possibilities for a peculiarly fluid, effective and dramatic form of sequential imagery. All good and effective ideas are somehow simple, and in Kentridge's case one wonders why no one had done or thought of using this technique before with quite the full and powerful scale that he has deployed. It is also the case, however, that things are never that simple.

Technical recipes and methods are never neutral. They carry meanings, implications and their own raison d'être. Behind the hand that rubs and marks the paper lies a politics appropriate to the circumstances and historical understanding of the body and mind to which that hand is attached. This drawing method is a physical act through which thought emerges. Kentridge acknowledges that the narrative flow is determined by this procedure not the other way round. It is analogous, he claims, to the syntagmatic chain of words in a sentence but once that basic structure of a sentence is understood "one does not have to think through or test every sentence before actually speaking it", and once a 'grammar' has been acquired one can play with images in a similar manner. The classic repertoire of graphic media used in Kentridge's drawings is charcoal, both scene painters and compressed, and occasionally pastel chalks. Scene painters charcoal, brittle sticks requiring a good tooth on the paper or fabric to hold the mark, is called such because of its use in theatre back-drop painted scenery. Kentridge also worked in his early career in making drawings for use in the film industry. His construction of lighting, composition and space in his drawings reflect that experience.

The other form known as 'compressed' gives a much denser black mark, and is itself a highly suggestive word in the context of Kentridge's imagery and iconography.

There is a clear socio-political intent behind Kentridge's hand and drawing but this remark says no more than do the many commentators who make it, and then coyly retreat back to discussing his work *as art,* leaving unremarked what is most awkward, even vulgarly nostalgic, about it. Something of this hesitancy is conveyed by the critic of the New York Times, April 10th 2007, who writes of Kentridge's work as being "easy to grasp." One reason may be the fact that it moves, has a narrative of sorts, and is intensely theatrical and moody. These qualities are difficult for a certain strand of modernist criticism. It was Michael Fried in his writings who contrasted the presentness and grace of properly modernist art against the theatricality of certain visual arts, and saw this as a watering down of standards.[2] To be fair, in his essay *Art and Objecthood,* he uses the term 'theatrical' to refer to the inert blankness of certain minimalist sculpture that like theatre props needed presences other than themselves to activate them into significance. Although Kentridge's work is very different, it could certainly be described as theatrical in the way it constructs possible gallery audiences. Nevertheless his work is also opposed, in a Friedian sense, to the packaged manipulation, skill and slickness of contemporary film culture and performance. Michael Fried may well agree with the following remark by Kentridge on political art.

> *I am interested in political art, that is to say an art of ambiguity, contradiction, uncompleted gestures and certain endings – an art (and a politics) in which optimism is kept in check and nihilism at bay.*[3]

Some might say in response to the above remark by Kentridge that 'oh well he's an artist, and artists do rather tend to say things like that, don't they? They have a fear of being fixed or overly literal, or obvious. They never say what they really mean. Their attitude is a 'take it or leave it' one, in which the audience is free to interpret their works and their words in their own way, and a hundred other such prevarications of the confused muse of contemporary practice!' If they did say this they would be wrong, not about the work having such qualities as these but about the political meanings that can be read from it. In his drawings for projection there is certainly a messiness, a never-ending incompleteness, that does induce an odd melancholy, lassitude, enervation and nostalgia.

There is also an uncanny sense of participation on the part of a viewer who watches this work of the unseen hand. This unseen hand becomes a metaphor for South African History, specifically that of the white South African experience. In this sense, the hand of politics suggests not only the artist's own hand but a hand in another sense altogether; the one you are inevitably dealt as in a pack of cards. The hand of the state falls very differently across black and white experience both in Apartheid and in post-Apartheid South Africa. As my old drawing tutor would put it "to rub something out is not to make it disappear."

For Kentridge then the politics behind the hand of his work is necessarily tangential, expressed in highly metaphorical rather than direct terms. It often takes the form of specific fictional characters. His *History of the Main Complaint* (1996) shown in MACBA Barcelona in 1999, and here in this exhibition with the live performance of Philip Miller's score, uses a character, Soho Eckstein, a mine magnate whose empire has now collapsed, who lies in a hospital bed in a coma, and whose wife has a lover, Felix Teitlebaum. The strange disjointed narrative produced in this projected drawing has literary parallels with other famous characters lodged helplessly within oppressive systems seeking somehow to survive, examples being Jarry's *Ubu* or Hasek's *Svejk* or Herbert's *Mr Cogito*. This strategy is perhaps an attempt to turn personal into collective memory, and, as has been remarked elsewhere, "the gate that leads to healing is opened by remembering." This aspect of Kentridge's work, at its best, clearly links to current South African experience, and to other post-conflict reconciliation effort elsewhere.

On the other hand, the work of Kentridge's hand is fêted in biennales, major museums, galleries and collections worldwide. He is South Africa's pre-eminent contemporary artist figure. His work is positioned within the manners and modes of production current in the international postmodern art world. The work is imbued with an intense expressive nostalgia. There are frequent references and homages to other artists such as Vertov, Méliès, Grosz, Heartfield and others. One might compare Kentridge's work, with its simultaneously international and yet located vernacular, with the work of current African artists shown in exhibitions such as the Hayward's Africa Remix (2006) - a show which incidentally included Kentridge - or the African Pavilion at the recent Venice Biennale (2007). Good ideas don't stay useable for ever, and it is an evident strength that Kentridge's work is moving on from the hand that deals the stack of cards to construct new marks and manoeuvres on top of the old palimpsests and erasures.

1. www.en.wikipedia.org/wiki/william_kentridge

2. Michael Fried 'Art and Objecthood' (1967) *in idem. Art and Objecthood: Essays and Reviews,* University of Chicago 1997. See also Charles Harrison and Paul Wood (eds.) *Art in Theory 1900-1990: An anthology of Changing Ideas,* Blackwell 2002, pp.822-834

3. www.gregkucera.com/kentridge.htm

TIMBRES & TEXTURES FOR ANIMATION
MILLER'S MUSIC FOR THE KENTRIDGE SOHO FILMS

MARK ABEL

What is the function of music in the films – or animated drawings – of William Kentridge? While music is a crucial component of most cinematic experience, Kentridge recognizes that, for his films, because of what he describes as their 'stone-age animation' techniques, the music must shoulder an extra responsibility.

> *What putting music to it can do, it can change how you actually see the images. Without any music, the drawings can sometimes be so jagged and so jerky they're incomprehensible. And if you put the wrong kind of music it's just exacerbated and becomes completely unwatchable. But if you find the right music, suddenly the images flow in a way that seems incomprehensible, and there is a sense made into the visual images. So it's not just finding music to augment what is done, but often the music is needed to make sense of what is done as well. It was partly to rescue the deficiencies in the animation that the first music was brought in.* [1]

This, then, was the nature of the task facing the composer, Philip Miller, when he was first asked to write the score for the short films of the Soho Eckstein series that are to be shown in Brighton, collected as 9 *Films for Performance*. In addition, Miller had to cope with a threat. For *Felix in Exile*, he was under pressure to write something that worked better than the piece of Dvorak that Kentridge had originally used to accompany the film. The penalty for failure would be to have his music rejected.

He was successful. The music for *Felix in Exile* is one of seven scores which link together the films they accompany through their use of string quartet, accompanied variously by piano, trumpet and vocalist, depending on the performance. The choice of this instrumentation, quintessentially associated as the string quartet is with the chamber music of the c.18th and c.19th, is interesting and distinctive for three reasons. First, it immediately imparts the kind of intimacy associated with chamber music – intimacy between the performers, and intimacy between performers and audience – to the experience of viewing the films. Secondly, it provides a relatively narrow palette of timbres and textures from which to work in a cinematic context, at least compared with most mainstream film-making's appetite for a broad range of sounds – orchestral and/or synthetically produced – which can be deployed on a grand scale for maximum contrast and variety. Of course, Miller is aided in this choice by the brevity of the films, but nonetheless, it represents a self-disciplining constraint on the compositional process which complements the self-limiting nature of Kentridge's choice of working methods.

Thirdly, the use of strings in this way cannot fail to evoke a certain sense of 'pastness', of the atmosphere and aura of former times. It is this quality which Miller exploits to the full in *Felix in Exile*, using the nostalgia, which this instrumental combination seems to bear within it, at least to the Western ear, to generate the feelings of desolation, longing and loneliness which are the subject of Kentridge's images. The musical language, too, appears to have been chosen for its nostalgic allusions, its themes and textures bearing some similarity to turn-of-the-century (c.19th to c.20th) Expressionism. But this is no pastiche of a bygone style; the elements borrowed from the nineteenth century are not presented to us neutrally or at face value, but are rather held at a distance through an ambiguous use of tonality and an indefiniteness of form. The purpose is not to take us back to former times but to create the sense of lack and loss which engulf Felix as he contemplates his own past.

The second of the string ensemble pieces, the music for *Weighing and Wanting,* is more dynamic, more synchronized with the rhythm of the images. According to Kentridge, the role of the music here is to make believable the images of shattered objects reconstituting themselves which form the core of this film. Miller stretches the palette available to him to its extremes, using rapid arpeggios to accompany the disintegrating images, and whistling harmonics which reinforce the squeaking weighing scales of the film.

The score for the last of the films with live music, *Stereoscope,* is an exercise in thematic unity and motivic development lasting some 8 minutes. Kentridge's subject is a fissured world whose internal contradictions and discontinuities are rendered visible by the film's stereoscopic imagery, leading to crisis, revolt and conflict. This is an idea which is potentially rich in musical possibilities for a composer. For example, one could complement the divergent stereoscopic split-screen images with stereo sound in which one side is deliberately out-of-phase, desynchronised or out-of-tune with the other. Granted, this would be much easier to achieve with a recorded soundtrack than a live one. Alternatively, the ensemble itself could be divided into two, each half diverging from the other in some way. Miller has rejected this kind of approach as too literal. Instead, he has opted for a more thematic solution, building his piece around a five-note motif (E-F-D-D-E). It is not clear whether the choice of notes is intended to have any significance in relation to the stereoscopic theme – perhaps the second pair of pitches (D-E) is a divergent stereo image of the first pair (E-F). In fact, the motif is a nearly exact inversion of the B-A-C-H theme, often referenced by composers of the late nineteenth/ early twentieth centuries, exactly the period from which Miller draws his musical inspiration. Whatever the intention behind the choice, Miller proceeds systematically to exploit this thematic resource in the unfolding of the piece. The motif is employed in a quasi-serialist manner, undergoing various metamorphoses and recombinations as Miller weaves the texture, and becoming, at the climax of the film, a driving asymmetrical 7/8 figure (D-E-F-D-E-D-E).

In the score to this film, Miller expands his timbral options with the addition of (prepared) piano, used sparingly, and trumpet. Having grown used to the sound-world of the string quartet, the intrusion of trumpet at this point seems somewhat gratuitous, especially as Miller appears to be much more comfortable writing for strings than for winds. The only other addition to the strings in these scores is the vocal element to the soundtrack for *Felix in Exile*. Whether this should be considered part of the score or part of the soundtrack is a moot point, since it consists of a song sung by female vocalist superimposed over, rather than integrated with, Miller's string trio music. There is an incongruity to its presence in the soundtrack that adds to the sense of disjointedness which the film projects.

This vocal, however, raises another issue in relation to Miller's music for these films in that the song is clearly of South African origin and sung in Xhosa. Apart from this snippet, however, and despite the clear geographical rootedness of Kentridge's work, no other obvious South African influence finds its way into the music. In contrast to some of his other output – particularly the cantata *REwind* comprising testimony from South Africa's Truth and Reconciliation Commission – Miller has chosen to adhere to the musical aesthetics and compositional procedures of the European tradition. There are more than hints of eastern Europe at times – of Bartók, Shostakovich, and Martinu. Some may consider this to have been an opportunity missed. This choice works well, however, in the context of these films, focussed as they are on the alienating effect of Apartheid and its aftermath on the oppressors rather than the oppressed, the better to evidence the corrosive effect of racism and exclusion on the whole of a society and not just on their immediate victims.

[1]. Mary Rörich radio interview with Kentridge and Miller, Classic FM, 28 September 1998

HISTORY AS THE MAIN COMPLAINT
WILLIAM KENTRIDGE & THE MAKING OF POST-APARTHEID SOUTH AFRICA

JESSICA DUBOW & RUTH ROSENGARTEN

Behind a *cordon sanitaire,* dressed in his signature pin-striped suit, South African mining magnate Soho Eckstein – one of the stock characters in William Kentridge's body of animated films – lies in his hospital bed: prone, insensible. Talking of his *History of the Main Complaint* (1996), Kentridge says, 'Here's a person who's in a coma because of the weight of what he sees. The question is, is it going to kill him?'[1] For Nietzsche, the chances are that it will. Indeed, in his famous essay *On the Uses and Disadvantages of History for Life,* Nietzsche suggests one of the motives of a willed amnesia. By means of the parable of the grazing animal wholly 'contained in the present, like a number without any awkward fraction left over' (61), he discusses the ways in which human happiness and a creative future politics might depend on a practice of active forgetfulness, on the capacity to forget purposefully so as to avoid that descent into regressive rumination which a surfeit of historical awareness threatens to entail. 'With an excess of history man again ceases to exist,' Nietzsche argues, 'and without that envelope of the unhistorical he would never have begun or dared to begin (61).' To be committed to memory or forced to recall what has happened an infinite number of times, is thus to assume an encumberance that might crush us: a load which, though enjoining us to the affective ground of the past, might also preclude the vital, invigorating foundation 'upon which alone . . . anything truly human, can grow' (63). It is, as he writes, 'possible to live almost without memory, and to live happily moreover, as the [unhistorical] animal demonstrates, but it is altogether impossible to live at all without forgetting (61).'[2]

While Nietszche sees the constancy of historical awareness as an enervating and unendurable constraint, Milan Kundera suggests the opposite. Citing Nietzsche in the opening chapter of *The Unbearable Lightness of Being,* he asserts that if 'eternal return is the heaviest of all our burdens, then our lives can stand out against them in their splendid lightness.'[3] But for Kundera, lightness, or the historically liberated, is as much of a problem as Nietzschean gravitas. For while lightness may '[cause] a man to soar into the heights, take leave of the earth and his earthly body', it also produces a subject that is 'only half real, his movements as free as they are insignificant'[4] Here the choice is whether to survive Nietszche's 'consuming fever of history' (102)[5] by releasing or repressing it: does one live with the virtuous, but untenable, weight of the past or in the vaporous air of a free, but unhistorical, present? And the decision, as Kundera shows, is irreducibly ambivalent. For while the former risks producing a Nietzschean stasis (Soho's coma?), the latter offers no succour as it threatens the category of history with transcendance and so produces a speciously bouyant, and thus equally disabled, subject. In *History of the Main Complaint,* Kentridge shows how either case offers only a feigned resolution, a failure issuing from a non-recognition of the dialectic. Understood thus, at issue in the image of the sick Soho is not a man made insensible because of the weight of what he has seen, but rather because of the burden of what he has not yet seen.

What this means, then, is that the moment of regained consciousness, for Kentridge's character, can be understood as an enlivening to history, or, more strongly, as an enlivening by history. And indeed, Soho awakens from his coma precisely at the instant that the past hurtles unexpectedly into the present. It is a head-on collision.

Or to start again. Soho Eckstein, Kentridge's allegorical figure of rapacious mining capital, lies dressed in suit and tie in a hospital bed. He wears a respiratory mask, his eyes are closed, his body rasps for breath. X-ray images, MRI scan and heart monitor report on his interior: the patient's broken pelvis, vertebrae, bruised organs, intestines.[6] Against the doleful strains of a Monteverdi madrigal erupts another soundtrack: the insistent beep of medical technology; the dull syncopations of a typewriter, telephone, ticker-tape machine – the accoutrements of Soho's life as an industrial empire builder – and the sizzle of electrical contact. A physician and his retinue of consultants prognosticate around the body. On the sonar screen, doubling as a car windscreen, Soho's insides metamorphose into a landscape. The scene cuts to Soho driving, his eyes reflected in the car's rear-view mirror, the road in front flanked by an avenue of pylons and thickening trees sketching the deep V perspective of spatial progression. But at the same time that we are propelled forward, the unfolding scene rushes towards us as memory. The transaction of past and present, of retrospection and return, is abruptly interrupted. Forks of high-voltage current crack across the screen; they course through a Sunday roast, become electrodes that wrap around a toe that itself mutates into penis and testicles. Then a body abandoned on the roadside. This is the first of a series of anonymous figures injured, beaten to the ground by rifle butts, kicked about the torso. The assaults are registered internally as red crosses on Soho's body scan.[7] Windscreen wipers/medical scanner dial move repeatedly back and forth to eradicate the marks. Suddenly, a figure charges out of the darkness, hurtles into view, is momentarily held in the beam of the car headlights. The impact is brutal: the face is crushed, the windscreen shatters. Soho wakens to the crash. The collision is as much a matter of temporalities as it is of objects, bodies, images.

For Kentridge, in other words, it is the moment of crisis itself that signals the awareness of history, an awakening to the past at the point it is wrenched into shocking correspondence with present sight. As such, *History of the Main Complaint* stands, epistemologically, on entirely different ground from the logic of traditional historicism. Indeed, in this scene of a body revivified both by and to danger, might be discerned nothing less than the critical potential of Walter Benjamin's dialectic at a standstill: that instant in which the sequential relation of past to present is exploded in a freeze-frame filled to the bursting point with 'the differentia of time',[8] that flash irruption of a radical temporal discontinuity which otherwise lies bonded within the smoothed neutrality of classical historical narrative.

The possibility gestured at here, however, is not that Benjamin's dialectic – like Kentridge's accidental insurgence of memory into the real – is simply the recollection of the past or of a consciousness assailed by an indirect referent in the manner of a Romantic reprise. Indeed, if that were the case, Soho would simply have continued driving forwards, his eyes reflected in the rear-view mirror contemplating the past as reverie, as recall, as retrospection. Rather, what is realized here is the notion of time at the present and as the present, that unforeseen instant in which explodes the past immersed in immediacy. It may be said, then, that what the crash scene involves is less an image of time than a plunge into the time-image itself,[9] into that Benjaminian dimension in which the compaction of the 'what-has-been' and the 'now' is apprehended – and, indeed, the density of their consonance and dissonance.

If this refers to a certain historical sensibility, it is also history effectively derealized, resistant to sense and assimilation. For Benjamin, this is the critical power of the image blasted loose from the 'vulgar naturalism of historicism',[10] in which transition is eclipsed by crisis and conciliation made to yield to destruction. It is in this sense that Soho's crash may be linked to that dialectical structure of temporal shock that Benjamin takes to be the ground of history and historical consciouness itself. The same accidental danger sounds in each. As such, the conjunctural terms in Kentridge's title might be reversed, for at stake, here, is not a 'history of the main complaint', but rather history as the main complaint: the experience of that incomplete temporality in which things are realized at the moment of their awakening, in and through a confrontation with crisis.

Kentridge's film was made in 1996, in direct reponse to the establishment in April of the Truth and Reconciliation Commission, set up in the National Unity and Reconciliation Act of 1995.[11] To understand the historical index of the work as a contextual one, however, is only to go so far. For beyond the merely referential or mimetic, it is an index of the very problematic inherent in the relation of history to time in the process of political change. And, indeed, in 1996 the problem of historical time was a vital one. What transpired in South Africa during the early 1990s was not the political apocalypse that had been widely anticipated. The spectacle of a 'classic' decolonization, a violent insurrection, or even a last-minute military coup by Afrikaner military generals, would all have been consistent with the modernist lexicon conventionally used for discussing the processes of radical social change. However, that a struggle of stark, but stabilizing, antagonisms ultimately resolved itself through the rationalization of political reconciliation foreclosed the clarity of any definitive catharsis. As the South African academic and writer Njabulo Ndebele has put it, what the liberation struggle was denied was 'the ultimate experience, the witnessing of the enemy's resounding defeat'. 'The Bastille', as he says, 'was not stormed.'[12]

Against any such expectations, the choice of a negotiated settlement neccessitated the logic of political compromise. The Truth and Reconciliation Commission, in fact, was the key transitional statutory body created to promote a postauthoritarian constitutionalist political order enabled, in part, by the language of human rights reformulated as restorative justice. Its aim was to provide 'as complete a picture as possible of the nature, causes and extent of gross human rights violations committed between March 1 1960 and December 5 1993'.[13] Over a five-year period, the Commission was to provide a public forum for the victims of state racism to confront their perpetrators and to have the brutality of apartheid – its horrific catalogue of death squads, assassinations, mutilation, torture, rape – publicly exposed and admitted to. With its origins in the pragmatics of Realpolitik and guided by a moral-theological injunction to 'forgiveness', its mandate was to grant indemnity to the perpetrators – aligned to both the State and the African Nationalist Congress – from judicial prosecution in exchange merely for a full admission of crimes authorized and committed.[14] It was on this basis that a post-apartheid South Africa was to stake its claim to an inclusive notion of participatory citizenship exercised most crucially through a discourse of a new-found ethical sociability. Here, indeed, public confession divorced from retributive justice not only aimed at a corrective 'national history lesson'[15] but at the very re-historicization of civic life grafted on acts of redemptive reflection. With its motto of 'Reconciliation Through Truth' lay the appeal to a new basis for moral reintegration and a redefined conception of the nation. In short, in confronting the past as a means of affirming the uniqueness of the present, the Truth and Reconciliation Commission was simulateneously the only responsible political position to adopt and a liberal ideal fraught with contradiction.

For at the limits of truth-telling's purported 'normalizing' capacities lies the more awkward question of historical memory and the extent to which the past might yet disturb the conscious periodization of a national present. Indeed, what kind of present is it when the horrifying becomes the ghostly and the ghostly is itself surmounted by the structural visibilities of a new historical moment? Alternatively, what kind of present is it, as Michel de Certeau asks, when in the chronology of historical change is 'traced the decision to become different or no longer to be such as one had been'?[16] The problem that de Certeau points to might be called one of psychic historicism; that is to say, the creation of temporal delineation as part of the remedial relation of sickness to cure, of retrieval to reflection to repair. That this therapeutic discourse was to be played out under the glare of the broadcast media – and, moreover, that post-apartheid South Africa came to represent a re-enchantment of liberal rationalism for a world desperate for a successful conclusion to horrors of a very long twentieth century – imposed a peculiar kind of spectacularizing imperative onto the new nation's curative project.[17]

The retrieval of memory under the mandate of the Truth and Reconciliation Commission came up against a central problem. The problem is one of temporality – or, rather, a certain codification of time linked to the synthesizing or harmonizing ideal of a restored body-politic. For at issue, in effect, was less the retrieval of trauma than an attempt to be free of its fixations; not a remembrance of the past but the relegation of history to the past. For those who perpetrated politically motivated abuses, in other words, the rhetoric of the confessional purge announced the potential of a new ethical subjectivity. At the same time the victims were confronted with the possibility of their reincorporation into the social as a belated healing of their initial excision.

Such language has a clear psychoanalytic tenor. Indeed, it corresponds to a double Freudian legacy: firstly, to that process of exteriorization and of 'working through' that, in *Mourning and Melancholia,* Freud termed Trauerarbeit, or the labour of mourning. Secondly, to the prophylactic procedures of the 'talking cure'; that is to say, the belief that it is only when forgotten (or repressed) psychic material has been brought into symbolic circulation that the subject may come to break the circular reiteration of the pathological symptom. Freud is explicit that the lost object of mourning may be not only a loved person, but also 'an abstraction', such as 'one's country, liberty, an ideal, and so on.'[18] As such, it is precisely a Freudian-inflected idea of mourning that social historians have commonly designated as essential to the forging of a collective identity in contexts profoundly shaken by catastrophe and trauma.[19] Simply put, what is aimed for, here, is the configuration of mourning as decathexis: the gradual disinvestment of energies from a lost object which, in incrementally confirming that loss, enables the subject to reconstitute itself and so figure a future untrammelled by infinite repetition. Indeed, if the aim of such a procedure is, as Freud says, to '[declare] the object to be dead', and '[offer] the ego the inducement of continuing to live',[20] it is, in effect, the labour of mourning itself that, in killing off the object once and for all, stands as the precondition for the sustained future life of the subject. Implicitly, then, it is not the process of mourning that, for Freud, enables the agency of memory but, rather, its moment of closure that inaugurates the work of remembering. Put another way, with the process of decathexis successfully completed, it is precisely in the newly sundered space between the subject and its relinquished object that memory begins to find its place.

With the relationship of mourning to memory thus regarded, Trauerarbeit may be taken as the political and psychic premise guiding the tasks of South Africa's Truth and Reconciliation Commission. For here, arguably, the work of memory came to be driven less by any practice of historical re-engagement than by a retraction of that very energy binding subject to object, present to past: a form of release intimately linked to the instrumentalism of a pragmatic and progressive politics. Indeed, like a realization of Nietzsche's question about the value of history to life, the memory act, under the aegis of the Truth and Reconciliation Commission, functioned less as a dedicated retrieval of the past than as a means for moving beyond and living on. In order to think a future, the recollection of trauma was at once allied to the formation of a revivified state and citizenry. Indeed, in its view of history as the significant site of illness and alterity, the recovery of both the subject and the social functioned as the means of their very constitution. It is here, in its discourse of critical self-examination, that South Africa was to embark on the work of nation-building and state-formation, that is to say, to a process of institutionalizing the past in the cause of a stable and effective future polity. It is also here, however, that the limits of South Africa's 'labour of mourning' have to be confronted, that is to say, the limits of a politics of psychic reconciliation in which memory is 'commisioned' to take the place of history.

In looking at these limits, we return to Soho Eckstein. At its furthest reaches, his coma may be read as a matter of time, that is to say, as a chronic illness, a sickness of time, or rather, of chronology as sickness itself.[21] Accordingly, if the imperatives of a new nationalism, as suggested, threaten to absorb the specificity – indeed, the historicity – of a traumatic event, how may its meanings be restored to material presence? How may we escape the deadening weight of an already determined (and de-cathected) past the political violences of which, now concluded, have been relegated to the space of stabilized memory? Differently put, if the comatose state is taken to be a matter of chronos, what sort of temporalization would Soho's awakening inaugurate? The crash scene, as earlier suggested, is one such refusal of historicist reverie, for it is a rejection, too, of that process of psychic detachment that seeks to lay the lost object forever to rest. When Soho drives into the landscape, he does not merely cover space; he is immersed in the densities of time. Likewise, when the anonymous figure hurtles into the car windscreen, it emerges not from surrounding space but from the thickets of an occluded time. The point, in other words, is that it is by means of an accident of discordant temporalities that Soho is resuscitated to the present: a re-animation that depends less on the mnemic apprehension of a previous event than on the instant of living an unmediated relation with it. Indeed, in a graphic exemplification of this point, the image of Soho crashing into consciousness hinges on another image that immediately precedes it: on his arm the crash victim wears a wrist watch which explodes on impact.

Such oneiric (or dream) appearances of the traumatic moment, Freud explains, 'have the characteristic of repeatedly bringing the patient back into the situation of his accident, a situation from which he wakes up in another fright.'[22] Freud connects this belated appearance of the truth – its deferred address in a dream or flashback – to the subject's incapacity to assimilate trauma as it occurs. Thus, if, in Benjaminian terms, the moment of temporal rupture bespeaks an awakening to history to that perilous moment in which time is seen to 'put on its true – surrealist – face',[23] then in the Freudian model, Soho's crash may be equated with the compelling discussion of memory presented in *Beyond the Pleasure Principle*. For it is here that both the talking cure and the labour of mourning are associated less with the exteriorization of the contents of a concluded event, than they are with the performance of their sustained repetition.[24] In fact, much like Benjamin's constellatory instant, in which past and present objects collide to release their dialectic significance, Freud promotes the process of transference as the means of a dynamic temporal realignment and thus as the mechanism by which an unconfigured past might be re-enacted 'as contemporary experience'.[25] Here, in short, the redeeming of a historical referent – as object, image or thought – is not a fulfilment or a movement towards closure, but the sharpening of the question. It is the insurgence of a rupture in the mind's experience of time,[26] the irruption of a past made newly and shockingly recognizable in the present. Indeed, as Shoshana Felman observes, the psychoanalytic experience itself might be described as the testimony to an accident, as the site of a catastrophe known only retrospectively.[27] And Kentridge materializes this moment.

Indeed, in line with what he has referred to as the dangerous etymological coincidence between amnesty and amnesia,[28] Kentridge has developed a unique graphic technique in which charcoal drawings of objects and bodies are sketched, partially rubbed out and re-emerge – transfigured – in a ceaseless flow of erasure and re-inscription. Forms body forth from sooty amorphous ground only to be swallowed up, subsumed and re-formed in a style of animation that renders the process of its own production materially evident, visible, factual. The procedure, one that Kentridge has dubbed 'stone-age film-making',[29] is at once lengthy and physical. It involves what the artist calls 'stalking the drawing',[30] the spatial action of walking backwards and forwards between the incremental metamorphoses of the charcoal image and the movie camera that tracks these changes. Indeed, here, as Rosalind Krauss has pointed out, the proliferation of drawings of traditional cell animation techniques gives way to a idiom of 'extreme parsimony and of endless round trips',[31] in which, at the end of filming, there remain only a handful of drawings that, like a palimpsest or mystic writing pad,[32] bears within it the time – the history – of its making. Thus, in History of the Main Complaint, the physician's stethoscope boring down into Soho's spinal column becomes the metal plunger of a cafetière.[33] The contents of his abdomen metamorphose from paper-punch to telephone.

Bruised intestines become a joint of meat which itself is transformed into a sign of bodily torture as it sketches an outline of toes and testicles tied with electrical cord. In this highly dynamic procedure Kentridge attributes the fortuitous collision with found objects to the agency of 'Fortuna' – 'something other than cold statistical chance, and something too outside the range of rational control'.[34] Such found objects within the artist's local range – a cafetiére, a telephone, a newspaper, more recently (in *Voyage to the Moon,* [2003]) a cup and saucer – become the arbitrary agents that metaphorically or metonymically bind the visual fragments into a narrative chain. Such a process is governed by a praxis – a performance in a bodily and visual field – unmediated by stabilized ideational schemes.[35] Rather, the imperatives of the drawing act is itself foundational, unleashing in its actual instant mnemic streams which fix upon objects and bodies as triggers or hooks. In such a procedure, the relation between sight and knowing is at once contingent and meaningful: as in surrealist practice, discovery mines the always-already fluent contents of the unconscious, as, in a materialist practice, the instability of the visual field, its refusal of allotted form, prolongs a perceptual dimension which cannot be readily converted into prediction or progress.

Once again, the issue of time – retarded, dilated, made dense – is crucial. For it is precisely in moving from one image to another while simultaneously incorporating them as trace, as shadow, as graphic trail, that Kentridge's work materializes the relation of the historically disparate and non-identical. Indeed, it is in this peculiar temporal structure, as in the application of the charcoal mark itself – the medium, like ash, being the residue of an annihilating event, a conflagration, a fire – that Kentridge's aesthetic attempts to forestall what we have termed psychic historicism.[36] That is to say, it resists that ineluctable process of events becoming unrecognizably remote and available only through the backward reach of recollective thought. It resists, too, that phantasm of progressivism which, aimed at understanding the past, 'honours and buries it.'[37] Rather, in the production of visibilities and invisibilities, as in the activity of the charcoal mark formed in terms of its residues and its anticipations, Kentridge sustains the past as both immanence and desire. More than this, he suggests that any concept of personal and collective reckoning must be thought outside the historicist logic of epochal closure and coherent re-beginnings, indeed outside the narrative abstraction of the 'once upon a time'[38] that the event of new nationhood threatens to entail.

If *History of the Main Complaint* deals specifically with the dangers of conceiving the past as placid memorium, much of Kentridge's earlier work is concerned with the analogous category of space – or, more precisely, with the temporalization of space. Thus in *Felix in Exile* made between September 1993 and February 1994 (the period just before South Africa's first democratic elections), the landscape of Johannesburg's East Rand becomes the central trope for thinking the relation of history to memory.[39]

In one particular sequence, a figure walks into a landscape and, as the camera tracks its procession, its charcoal contours dematerialize into the structures of civil engineering: a derelict drainage dam, a pipe-line, an abandoned roadwork. A body is shot down by a bullet, covered over with sheaves of newspaper, which then flutter, dissolve, and become interred within an invisible subsoil. The red cordon lines of a forensic crime-scene evaporate and fade into illegibility; later the outlines of the corpse reform to diagram a constellation in the night sky. In another sequence, the camera action is reversed so that what at first appears to be an industrial gash in the earth recovers and recomposes itself to assume the specious unity of nature.

Kentridge's assimilation of walking bodies and massacre victims as landscape features renders space as the product of both history and nature and, as such, hints at the falsity of their categorical separation. At the same time, however, a landscape able to absorb the blood of so many fallen bodies and entomb the markings of so many crime-scenes speaks of the earth's capacity for representing repression as renewal. In a manner akin to the absorptive properties of its soil, its (ideological) power lies in its tenacious capacity to outlive the past, to surpass rather than to recall those events and violences played out on its surface. Landscapes, as Jonathan Smith similarly argues, allow 'historical context [to] decompose . . . Over time, their permanence which is a function of their tangibility [allows] them to be cleansed of the taint of their creators, and to displace themselves from this context into the realm of private memories.'[40]

Raymond Williams, as Smith notes, refers to this process of historical transcendence as the 'enamelled pastoral';[41] that is, the ability of landscape to exist beyond the time of its original enactments and thus neutralize the marks of practice and intention. It is precisely such 'marks' that Kentridge seeks to rematerialize: restoring visibility to the trace, reactivating those meanings in landscape experience repressed by its surface sufficiency. For it is dangerous, as Kentridge's dissolving landscapes seem to say, when the referents of history metamorphose into the passivity of the memorial,[42] when the stabilizing persistence of space, as a container of experience, functions to reduce the specificity of an event by interring it. Thus, a landscape might well retain the imprint of an earlier temporal occurrence – as the trails of partly effaced charcoal markings in Kentridge's animations suggest – yet it will never restore the full presence of its encrypted meaning. The result for Kentridge is an uncomfortable quiescence, the hidden haunt of a history undisclosed. Speaking of the notorious events of Sharpeville where, in March 1960, a peaceable anti-pass law protest resulted in the police massacre of sixty-nine people, he says,

> . . . [P]erhaps images from photographs and documentary films that may have been seen [recall the events]. But at the site itself, there is almost no trace of what happened there. It is an area that is still used, an area in which people live and go to work. There are no bloodstains. The ghosts of the people do not stalk the streets. Scenes of battles, great and small, disappear, are absorbed by the terrain . . .[43]

For Kentridge, then, the curious ability of landscape to conjure away thick time and so render it as a space of specular ephemera produces a form of historical vertigo. Like the mutation of bodies into corpses and corpses into earth, it means that potentially any phenomenon is able to signify anything else or, as Derrida contends, it means 'to suffer the memory but lose the narrative'.[44] Indeed, like the empty continuum of traditional historicism, the loss of material specificity, for Kentridge, leads irrevocably to that pathologization of the past that, in *History of the Main Compliant,* renders Soho comatose, and which in *Felix in Exile,* threatens to create a national space whose historical traumas lie atrophied under the sign of natural plenitude.

Eric Santner has voiced analogous concerns. In discussing the psychic and mnemic adjustments necessary to the narration of a unified Germany following the collapse of Eastern European Communism, Santner points to the dangers inherent in the extraordinary coincidence of Kristallnacht, 9 November 1938, and the first breach of the BerlinWall, which occurred on the same date fifty-one years later. 'Would the weight of shattered glass', he asks, 'be buried and, as it were, metamorphosed under the sheer weight of all that crumbling concrete?'[45] The question, however, is not just one of chronological continuity. More problematically, it concerns the structure of what Santner calls 'narrative fetishism': that is to say, the disavowal of historical loss by imagining its 'site and origin to be elsewhere', an undoing of past trauma by 'simulating a condition of [present] intactness'.[46] In this sense, while the fall of the Berlin Wall may well stand as the punctual point of a long-sought political goal, in the past from which it is distinguished is promoted the amnesia necessary to present legibility. Nietzsche's words seem apt: 'Written over with the signs of the past, and even these signs overdaubed with new signs: thus have you hidden yourself well from all interpreters of signs.'[47]

The caution has clear relevance to contemporary South Africa. It is at issue at every moment that an apartheid place-name or geographic designation is surmounted by the procedures of re-nomination and re-territorialization. It is at issue at every occasion that the Truth and Reconciliation Commission expressed its concern to have the narrative – 'often called by the commissioners "this chapter of our history"' – closed.[48] Above all, it is the problem built into the incantation of a 'New South Africa' instantiated as much in the ritualistically demanded 'working-through' of a past as it is in the portentous language of birth and death, beginning and ending that attends the 'progressive' rhetoric of a new bureaucratic rationality.

Kentridge's films seek no such settlement. In the radical upheaval to which he submits visuality as much as chronology and teleology, the principle of his construction – the progressive-regressive mutations, the eruption of historical debris through surface intactness, the infinitesimal arrests and disjunctions between filmic frames – disables all sense of resolution. More than this, it is the perpetual mobility of the signifier – its changeability of forms, its endless metamorphic potential – that offers an alternative to the very theoretic of reconciliation.[49] For it is not that, in dissolving and mutating, Kentridge's graphic marks cancel each other out or fashion linear movements of causal addition. What is revealed, instead, is the fortuity of their co-presence, the sense in which the imperfect erasure of a past inscription, its after-image, folds into an equally imperfect precipitate, its fore-image, to reveal the otherwise obscured materiality of their necessary interconnection.

To address what is at stake here demands a return one final time to Soho Eckstein's crash. The accident, previously secured within his body's insentience, is now an insistent nearness that Soho can no longer ignore, an event that will no longer be left behind. In his revival to the past – as both flashback and present fright – Kentridge's character confronts not only his own near-death in the crash, but also his own survival as crisis. The meaning of this is two-fold. First, following Freud, it suggests that traumatic experience is precisely that which cannot be assimilated as it occurs; which cannot, in other words, be contained in a single temporal frame but which surfaces, rather, in the relationship between temporalities. Second, that the work of assigning meaning to trauma always occurs retroactively as the belated address of a truth that otherwise cannot be known. And, indeed, as Soho jolts up in his hospital bed, he is immersed in the currency of that aftermath which, for Benjamin, constitutes the terms of a properly materialist consciousness, and which Freud ascribes to the repetition compulsion inherent to the survival of trauma. Understood thus, what is given along with Soho's accident is a project that can only be called epistemological. For not only is it with the unexpected shock of a past made present that memory is activated. It is also at just such a temporal instant that a genuinely engaged historical awareness might, for the first time, begin.

In short, what is demanded in such an account is a conception of time linked to the impossibility of ever mastering fully what has taken place. If this troubles the stabilization of the past and spurns the possibility of aesthetic and historical completion, it also gives form to a particular moral imperative: that is to say, the need to respect the contemporary claims of history's victims, to understand the terms of their survivorship and, indeed, to reposition the past as a present vigilance. *History of the Main Complaint* or, rather, the idea of history as the main complaint, thus relates not only to the constant shock experiences of a radical temporal structure. It also bears on the ability of critical thought to sustain the moment of crisis, to keep alive the 'weight [. . .] of surprise, of fright'[50] and so to transform the 'past forgotten [. . .] into the possibility of a future'.[51] Indeed, for Freud, for Benjamin – and implicitly for Kentridge – it is precisely this dynamic temporality that not only defines an always active past, but which is also the accidental locus of 'present hope'.[52]

First published in *Art History*, the Journal of the Association of Art Historians, vol.27, no.4, September 2004, pp. 672-691, reproduced with the permission of the authors and the publisher.

1. William Kentridge, cited in Carolyn Christov-Bakargiev, *William Kentridge,* Brussels, 1998, 110.

2. Friedrich Nietzsche, *Untimely Meditations,* trans. R.J. Hollingdale, Cambridge, 1963. For an excellent analysis of Nietzsche and the danger of ressentiment as it formulates suffering as moral virtue, see Wendy Brown, *States of Injury: Freedom and Power in Late Modernity,* Princeton 1995.

3. Milan Kundera, *The Unbearable Lightness of Being,* trans. Michael Henry Heim, London, 1984, 5.

4. Kundera, *The Unbearable Lightness of Being,* 5.

5. Nietzsche, *Untimely Meditations,* 102.

6. For a detailed, frame-by-frame discussion of this work, see Michael Godby, 'Memory and History in William Kentridge's *History of the Main Complaint',* in Sarah Nuttall and Carli Coetzee, eds, *Negotiating the Past: The Making of Memory in South Africa,* Cape Town, 1998, and J.M. Coetzee, *'History of the Main Complaint',* in Dan Cameron, Carolyn Christov-Bakargiev and J.M. Coetzee, William Kentridge, London, 1999, 84–93.

7. In Kentridge's *Felix in Exile* (1994), and the *Colonial Landscape* drawings (1995) similar red crosses denote the markings of landscape surveyors and forensic scientists.

8. Walter Benjamin, *The Arcades Project* [N1,2], trans. Howard Eiland and Kevin McLaughlin, Cambridge, Mass., and London, 1999, 456.

9. On the notion of time-image in cinema, see Gilles Deleuze, *The Time-Image,* trans. Hugh Tomlinson and Robert Gelta, Minnesota, 1985, 38–43.

10. Benjamin, *Arcades Project,* [N2,6].

11. In 1997 Kentridge produced two works in direct response to the Truth and Reconciliation Commission. The first was a theatre performance, *Ubu and the Truth Commission,* with a script by Jane Taylor and with the collaboration of the Handspring Puppet Company; the second was *Ubu Tells the Truth,* an animated film incorporating documentary footage.

12. Njabulo Ndebele, *Rediscovery of the Ordinary,* Johannesburg, 1991, 9.

13. *Truth and Reconciliation Commission of South Africa Report,* vol. 1, Cape Town, October 1998, 55.

14. While the issue of amnesty was not directly dealt with in CODESA I and II (the multi-party consultative process which negotiated South Africa's new interim constitution in 1991–3), it was entered as a last-minute postscript to the Constitution in December 1993 following a closed political deal between the National Party and the ANC.

15. Richard Wilson, *The Politics of Truth and Reconciliation in South Africa: Legitimizing the Post-Apartheid State,* Cambridge, 2001, 14.

16. Michel de Certeau, *The Writing of History,* trans. Tom Conley, New York, 1988, 3.

17. While the Truth and Reconciliation Commission has clear correspondences with similar forums in Chile and Argentina, it is significant, as Richard Wilson notes, that in other contexts the discourse of human rights was developing along very different lines, with the creation of an International Criminal Court and the prosecutions brought about by the United Nations war crimes tribunal for the former Yugoslavia and Rwanda.

18. Sigmund Freud, *Mourning and Melancholia* (1917), in *The Standard Edition of the Complete Psychological Works of Sigmund Freud,* trans. under the general editorship of James Strachey in collaboration with Anna Freud, London, 2001, (henceforth SE), 243.

19. The reconstitution of a German national identity after 1945 and the more recent questions surrounding the reunification of the Federal Republic and GDR are amongst the most vivid examples here. For a Freudian analysis of nationbuilding in postwar Germany, see Eric Santner, *Stranded Objects: Mourning, Memory and Film in Post- War Germany,* Ithaca and London, 1990, and 'History Beyond the Pleasure Principle: Some Thoughts on the Representation of Trauma', in Saul Friedlander, ed., *Probing the Limits of Representation,* Cambridge, Mass., 1992.

20. Freud, *Mourning and Melancholia,* 257.

21. Deleuze, *Time-Image*, 25.

22. Freud, *Beyond the Pleasure Principle* (1920), SE, vol. 18, 13.

23. Benjamin, *Arcades Project*, [N3a, 3].

24. In *Beyond the Pleasure Principle*, Freud sets up an analogy between the irruption of the catastrophic event in the symptoms or flashbacks of trauma victims and the famous ritual performance of loss and mastery in a child's game. Both are interpreted as the forging of a 'new' identity sponsored by a repeated enactment of its founding loss.

25. Freud, *Beyond the Pleasure Principle*, 18.

26. Cathy Caruth points out that Freud's discussion of the repetition of the traumatic event highlights such temporal rupture. See her *Unclaimed Experience: Trauma, Narrative and History*, Baltimore and London, 1996, 61.

27. Shoshana Felman, 'Education in Crisis', in Shoshana Felman and Dori Laub, *Testimony: Crises in Witnessing in Literature, Psychoanalysis and History*, London and New York, 1992. Both Felman and Cathy Caruth (*Unclaimed Experience*) discuss the tropos of the accident in Freud's *Beyond the Pleasure Principle* as an event that is only known, paradoxically, through its psychic aftermath.

28. See William Kentridge. '*Felix in Exile*: Geography of Memory' (extract), 1994, originally presented in longer form as a lecture at North Western University, Illinois, November 1994. Numerous edited versions have appeared. Here cited from Cameron, Christov-Bakargiev and Coetzee, *William Kentridge*.

29. William Kentridge, '"Fortuna": Neither Programme nor Chance in the Making of Images', 1993, extract in Cameron, Christov-Bakargiev and Coetzee, *William Kentridge*, 113.

30. Kentridge, '*Felix in Exile*: Geography of Memory', 122.

31. Rosalind Krauss, '"The Rock" William Kentridge's Drawings for Projection', *October*, no. 92, Spring 2000, 6.

32. Freud evolved the analogy between the memory traces left by perception on the mind and the 'mystic writing pad': a slab of resin or wax covered by a sheet of translucent waxed paper and a sheet of transparent celluloid. While the upper layer becomes blank when no longer adhering to the lower, the wax or resin contains the whole history of inscription upon the slab. See Sigmund Freud, 'A Note upon the "Mystic Writing Pad"', SE, vol. 19, 227–32.

33. Here, Kentridge is citing the celebrated transformational sequence in his earlier film *Mine* (1991), where the cafetière plunger is seen to bore through the breakfast tray on Soho's bed and down into the subterranean depths of a gold mine, thus establishing a relationship between the stability of white South African domesticity and the occluded underground activities which render that surface space both possible and always only provisional.

34. Kentridge, '"Fortuna": Neither Programme nor Chance in the Making of Images', 118.

35. Rosalind Krauss makes a similar point when she notes that Kentridge's automatism – and here she is, unusually, equating 'automatism' with medium – places procedure before meaning. Krauss, '"The Rock" William Kentridge's Drawings for Projection', 13.

36. For a fascinating discussion of ash as memorytrace, see David Farrell Krell's reading of Derrida's journal article 'Feu la cendre' ['Fire, the ash'], 1985, in David Krell, *On Memory, Reminiscence, and Writing,?* where, 1990, 309–314.

37. De Certeau, *The Writing of History,* 2.

38. Walter Benjamin, 'Theses on the Philosophy of History' in *Illuminations,* trans. Harry Zohn, London, 1970, 264.

39. For a further discussion on the relationship between landscape and memory in Kentridge's work, see Staci Borris, 'The Process of Change: Landscape, Memory, Animation', in *William Kentridge,* Chicago and New York, 2001.

40. Jonathan Smith. 'The Lie that Binds: Destabilizing the Text of Landscape' in James Duncan and David Ley, eds, *Place/Culture/Representation,* London and New York, 1994, 80.

41. Raymond Williams, *The Country and the City,* London, 1973, 18.

42. In a related way, Robert Musil refers to monuments as 'invisible'. For a discussion of this, see Andreas Huyssen, 'Monumental Seduction', in Mieke Bal, Jonathan Crewe and Leo Spitzer, eds, *Acts of Memory: Cultural Recall in the Present,* Hanover and London, 1999.

43. Kentridge, '*Felix in Exile:* Geography of Memory',127.

44. From the first of Derrida's 'Memoires: For Paul de Man', in Krell, *On Memory, Reminiscence, and Writing,* 283.

45. Santner, 'Beyond the Pleasure Principle', 143.

46. Santner, 'Beyond the Pleasure Principle', 144.

47. Friedrich Nietzsche. 'Of the Land of Culture' in *Thus Spoke Zarathustra,* trans. R.J. Hollingdale, London, 1969, 142.

48. Ingrid de Kok, 'Cracked Heirlooms: Memory on Exhibition', in Nuttall and Coetzee (eds.) *Negotiating the Past: The Making of Memory in South Africa,* 59.

49. In her discussion of Kentridge, Rosalind Krauss invokes Eisenstein's analysis of Disney cartoons. Eisenstein coins the term 'plasmatic' for morphological elasticity and mutability, for the 'rejection of a once-and-forever allotted form'. *Eisenstein on Disney,* ed. Jay Leyda, Calcutta, 1986, 39, in Krauss, '"The Rock" William Kentridge's Drawings for Projection,' 15.

50. Freud, *Beyond the Pleasure Principle,* 13.

51. Miriam Hansen, 'Benjamin and Cinema: Not a One-Way Street', *Critical Inquiry,* 25, Winter 1999, 339.

52. Andrew Benjamin proposes a project of 'stripping hope of its utopian garb' thus refiguring it as 'one way of naming the inherently incomplete nature' of the present. Andrew Benjamin, *Present Hope: Philosophy, Arcitecture, Judaism,* London, 1997, 10.

LITTLE MORALS (1991)

Drawn from a remark by Theodore Adorno in *Minima Moralia,* the title of this series of six etchings with sugar lift, names a series of anxieties and conceits, and desperate gestures, during a period of seismic change that bore both threat and promise in South Africa at the time of their making. They were made in the period when the Apartheid laws were gradually being unravelled, and after the release of Mandela, but before the first democratic elections in 1994.

LITTLE MORALS (TAKING IN THE LANDSCAPE)

1991

Etching with
sugarlift, each
from 1 zinc plate,
on Vélin d'Arches
Blanc paper

Image 23.7 x 31.8 cm
 9.3 x 12.5 inches

Paper 32.5 x 44.5 cm
 12.8 x 17.5 inches

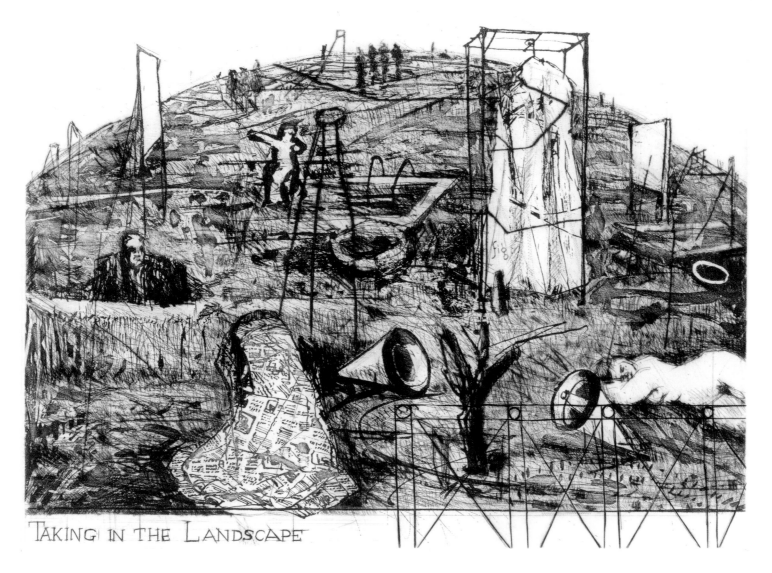

Taking in the Landscape

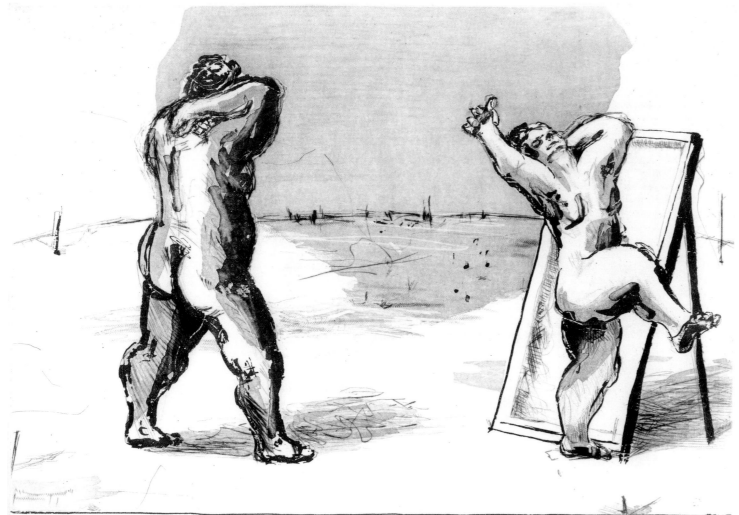

PREPARING FOR THE DAY

LITTLE MORALS (PREPARING FOR THE DAY)

1991

Etching with sugarlift, each from 1 zinc plate, on Vélin d'Arches Blanc paper

Image 23.7 x 31.8 cm
 9.3 x 12.5 inches

Paper 32.5 x 44.5 cm
 12.8 x 17.5 inches

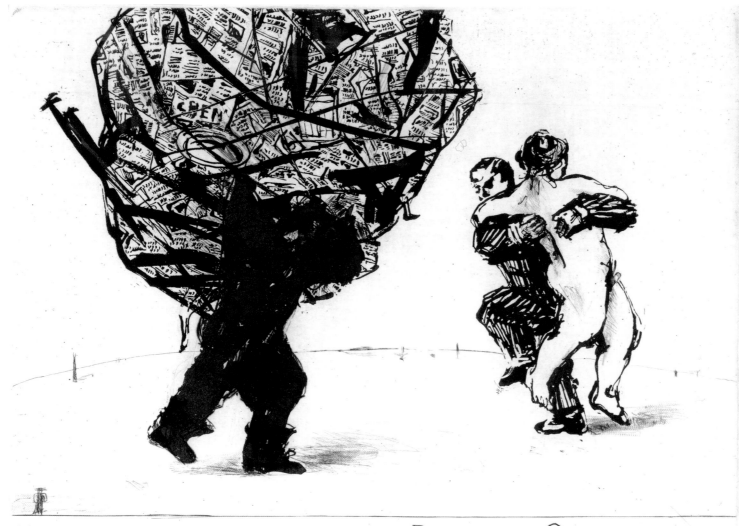

PRACTICAL CONSIDERATIONS

LITTLE MORALS (PRACTICAL CONSIDERATIONS)

1991

Etching with
sugarlift, each
from 1 zinc plate,
on Vélin d'Arches
Blanc paper

Image 23.7 x 31.8 cm
 9.3 x 12.5 inches

Paper 32.5 x 44.5 cm
 12.8 x 17.5 inches

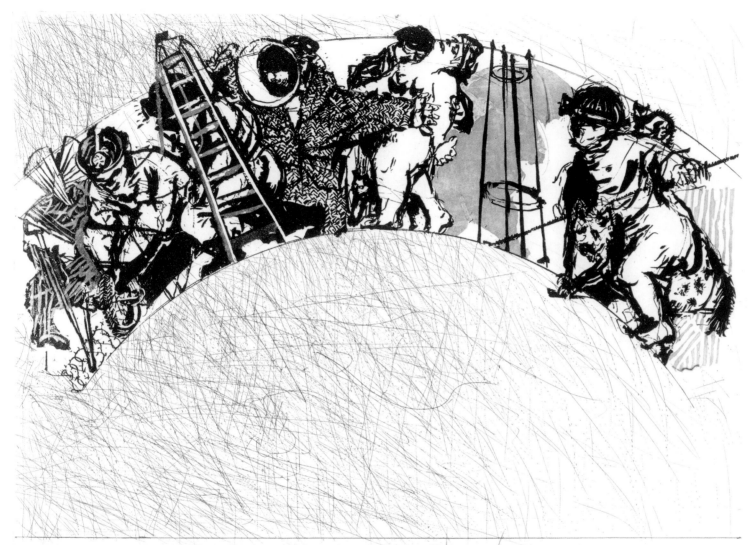

PROCESSION OF THE DELEGATES

LITTLE MORALS (PROCESSION OF THE DELEGATES)

1991

Etching with sugarlift, each from 1 zinc plate, on Vélin d'Arches Blanc paper

Image 23.7 x 31.8 cm
 9.3 x 12.5 inches

Paper 32.5 x 44.5 cm
 12.8 x 17.5 inches

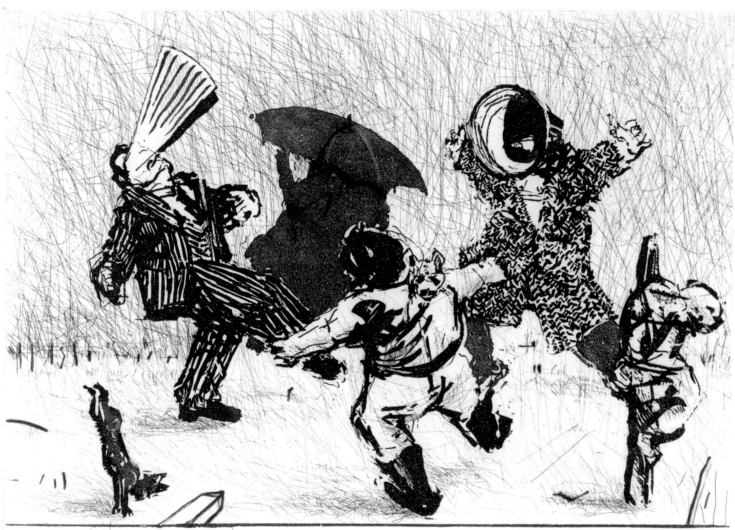

NEGOTIATIONS BEGIN

**LITTLE MORALS
(NEGOTIATIONS BEGIN)**

1991

Etching with
sugarlift, each
from 1 zinc plate,
on Vélin d'Arches
Blanc paper

Image 23.7 x 31.8 cm
 9.3 x 12.5 inches

Paper 32.5 x 44.5 cm
 12.8 x 17.5 inches

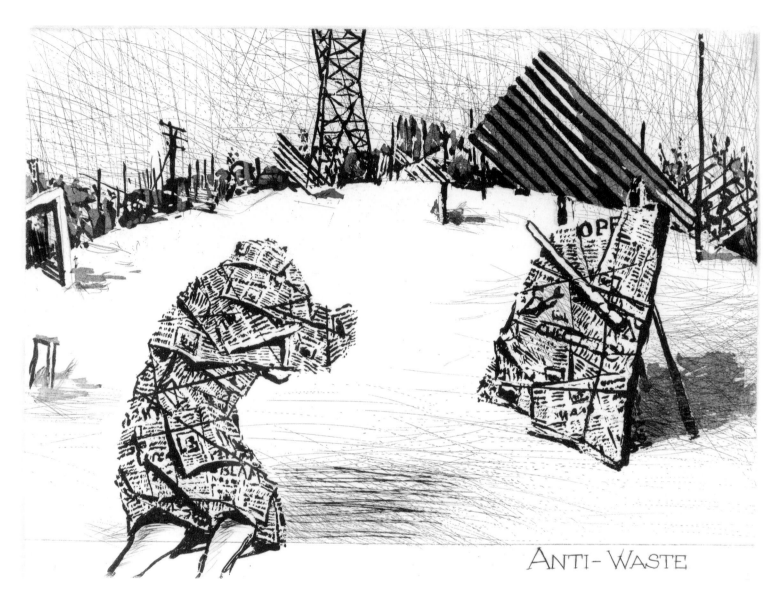

LITTLE MORALS (ANTI–WASTE)

1991

Etching with sugarlift, each from 1 zinc plate, on Vélin d'Arches Blanc paper

Image 23.7 x 31.8 cm
 9.3 x 12.5 inches

Paper 32.5 x 44.5 cm
 12.8 x 17.5 inches

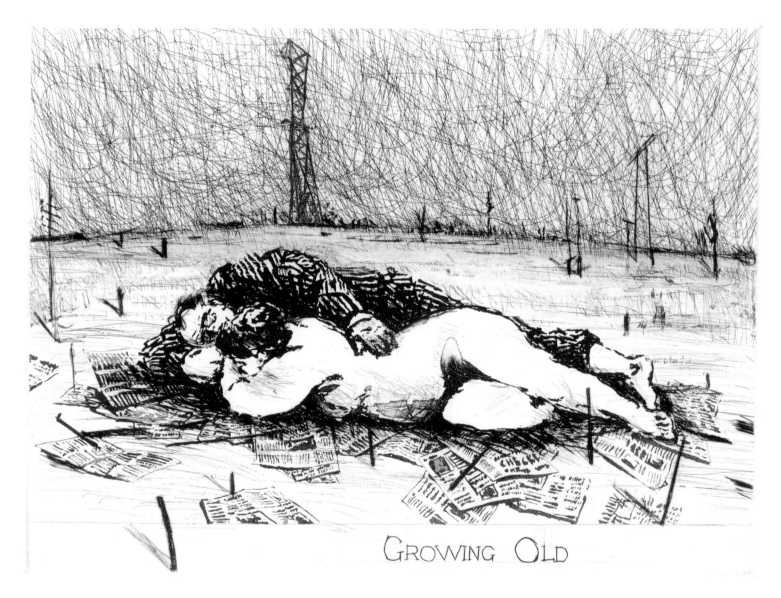

GROWING OLD

**LITTLE MORALS
(GROWING OLD)**

1991

Etching with
sugarlift, each
from 1 zinc plate,
on Vélin d'Arches
Blanc paper

Image 23.7 x 31.8 cm
 9.3 x 12.5 inches

Paper 32.5 x 44.5 cm
 12.8 x 17.5 inches

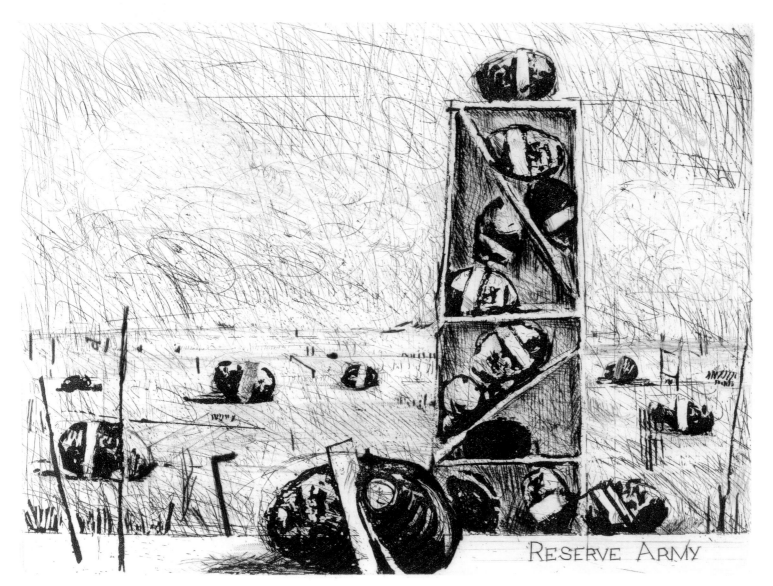

LITTLE MORALS (RESERVE ARMY)

1991

Etching with
sugarlift, each
from 1 zinc plate,
on Vélin d'Arches
Blanc paper

Image 23.7 x 31.8 cm
 9.3 x 12.5 inches

Paper 32.5 x 44.5 cm
 12.8 x 17.5 inches

UBU TELLS THE TRUTH (1996-7)

This set of eight etchings were produced as part of a collaborative celebration, with the artists Deborah Bell and Robert Hodgins, on the centenary of Alfred Jarry's *Ubu Roi*. Jarry's play, a Surrealist invective that deployed comic lasciviousness against the arbitrary power of tyrants, inspired this graphic parody of representation. Presented as a series of fictive storyboards with invented numbers for acts and scenes, Kentridge adapted Jarry's own drawings of Ubu as chalk sketches on a blackboard but, rather than simply presenting his adaptations of the drawings, he depicted the act of drawing itself by a figure derived from photographs of himself in his studio. In their turn, the etchings then suggested to the artist a possible animation of the blackboard figure.

The result was to be the theatre production *Ubu and the Truth Commission* (1997), followed by the film *Ubu Tells the Truth* (1997). Both are direct engagements with the violence and brutality and dehumanisatin of the Apartheid years as progressively revealed in testimonies made to the Truth and Reconciliation Commission.

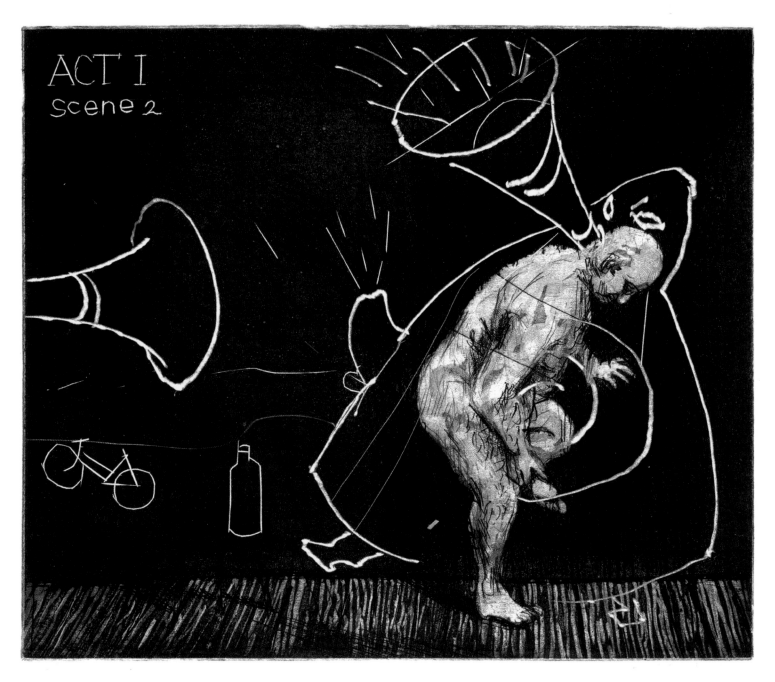

UBU TELLS THE TRUTH (ACT I SCENE 2)

1996-7

Soft ground, aquatint, drypoint

Image 25 x 30 cm
 9.8 x 11.8 inches

Paper 36 x 50 cm
 14.2 x 19.7 inches

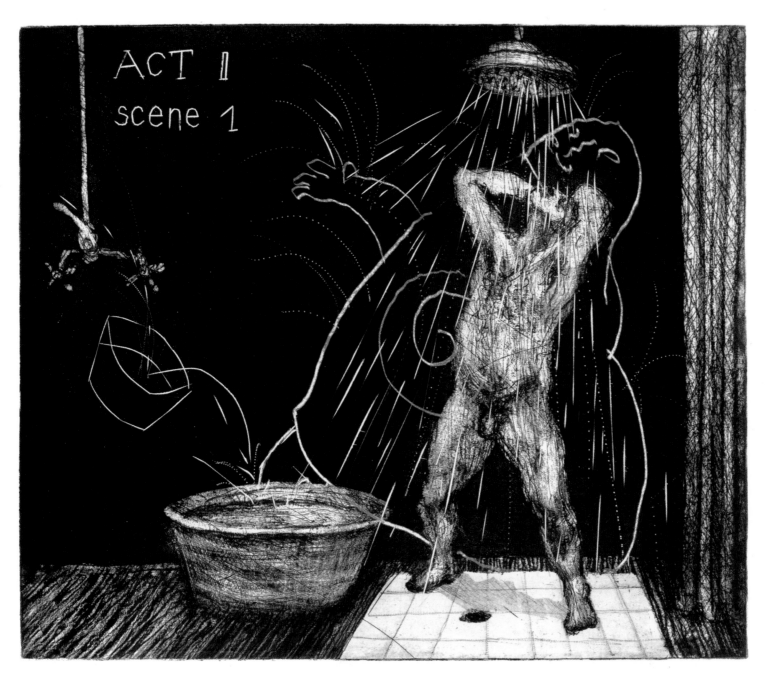

**UBU TELLS THE TRUTH
(ACT II SCENE 1)**

1996-7

Soft ground,
aquatint, drypoint

Image 25 x 30 cm
 9.8 x 11.8 inches

Paper 36 x 50 cm
 14.2 x 19.7 inches

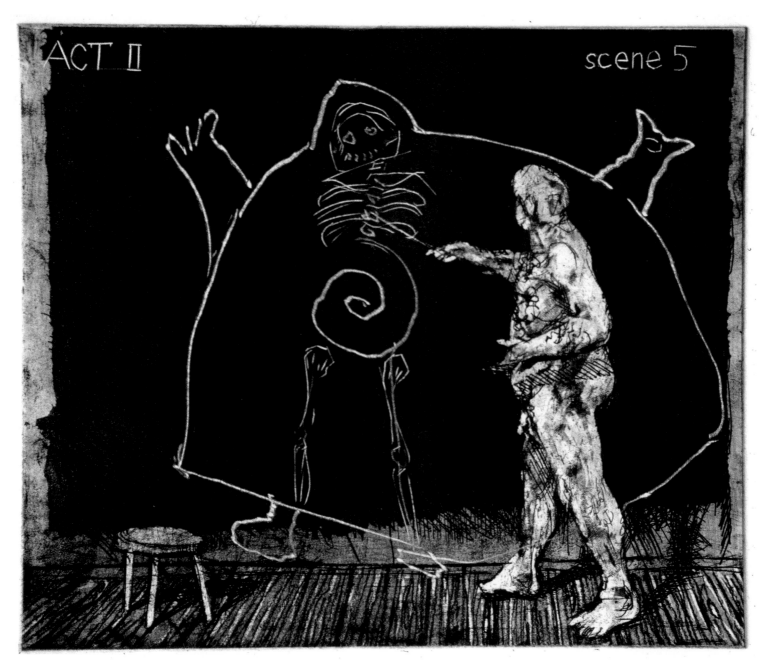

ACT II scene 5

UBU TELLS THE TRUTH
(ACT II SCENE 5)

1996-7

Soft ground,
aquatint, drypoint

Image 25 x 30 cm
 9.8 x 11.8 inches

Paper 36 x 50 cm
 14.2 x 19.7 inches

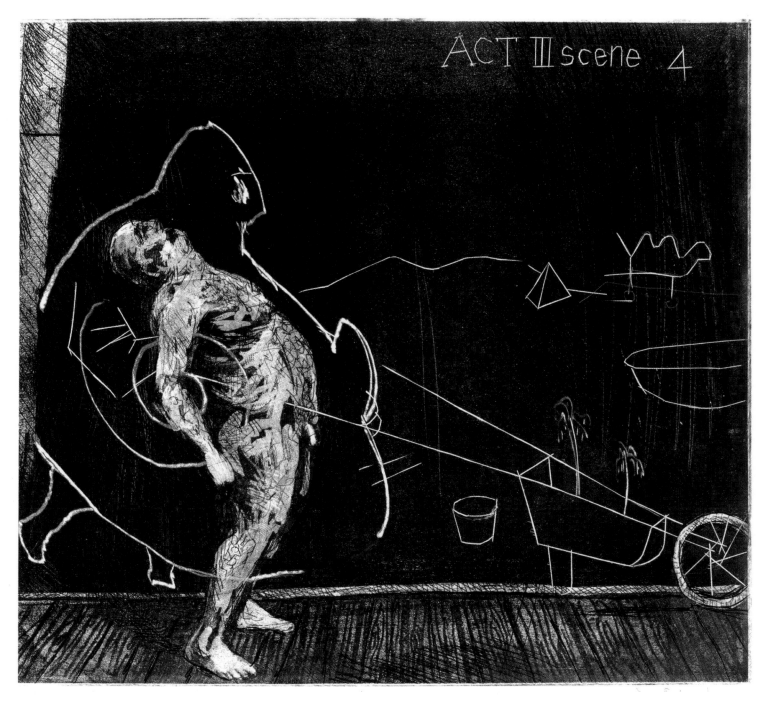

**UBU TELLS THE TRUTH
(ACT III SCENE 4)**

1996-7

Soft ground,
aquatint, drypoint

Image 25 x 30 cm
 9.8 x 11.8 inches

Paper 36 x 50 cm
 14.2 x 19.7 inches

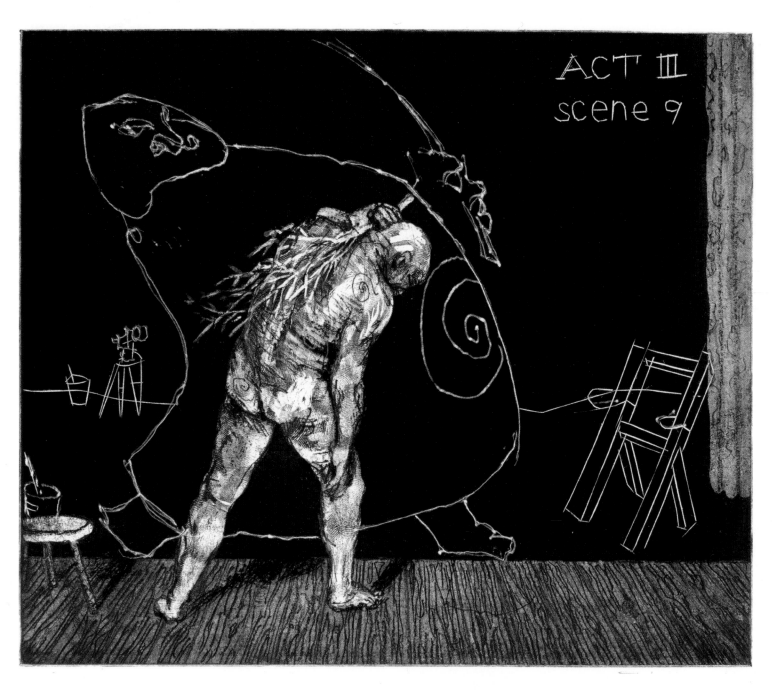

**UBU TELLS THE TRUTH
(ACT III SCENE 9)**

1996-7

Soft ground,
aquatint, drypoint

Image 25 x 30 cm
 9.8 x 11.8 inches

Paper 36 x 50 cm
 14.2 x 19.7 inches

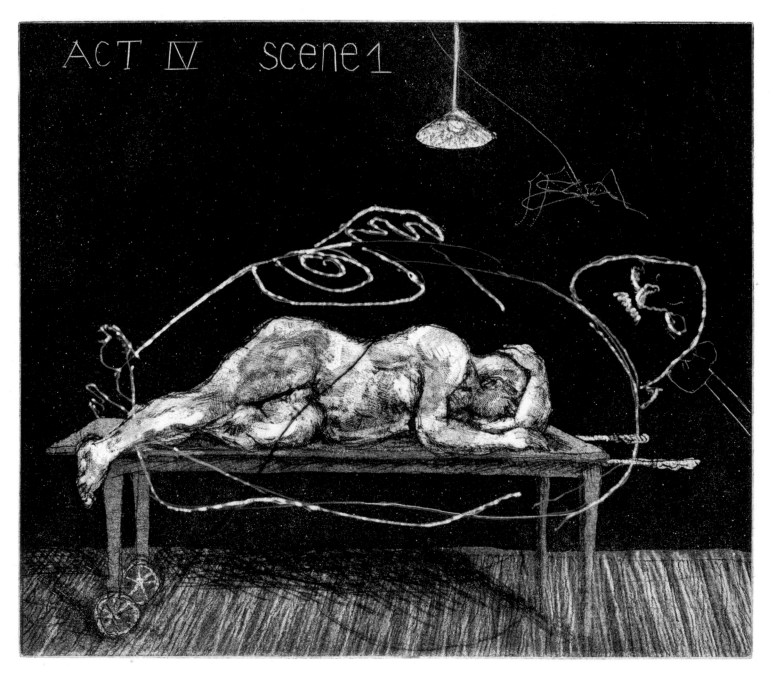

**UBU TELLS THE TRUTH
(ACT IV SCENE 1)**

1996-7

Soft ground,
aquatint, drypoint

Image 25 x 30 cm
 9.8 x 11.8 inches

Paper 36 x 50 cm
 14.2 x 19.7 inches

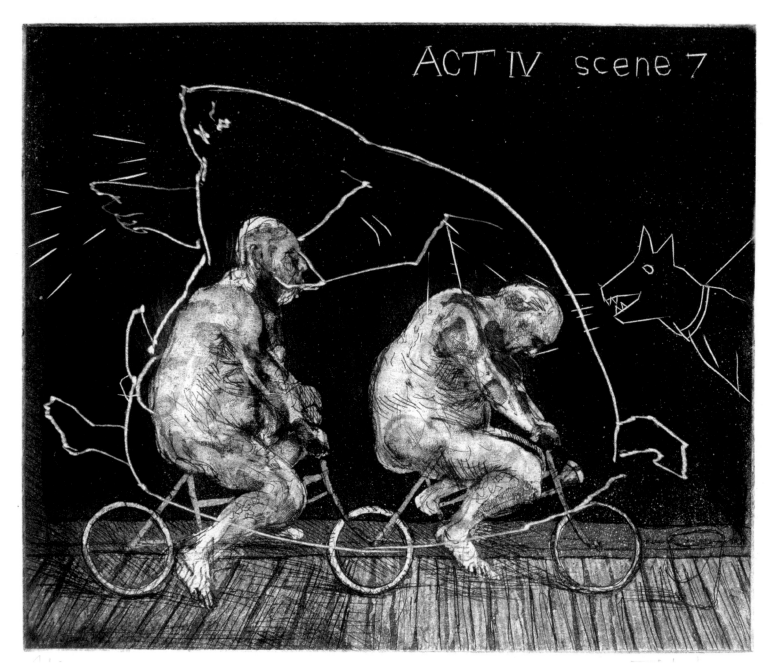

**UBU TELLS THE TRUTH
(ACT IV SCENE 7)**

1996-7

Soft ground,
aquatint, drypoint

Image 25 x 30 cm
 9.8 x 11.8 inches

Paper 36 x 50 cm
 14.2 x 19.7 inches

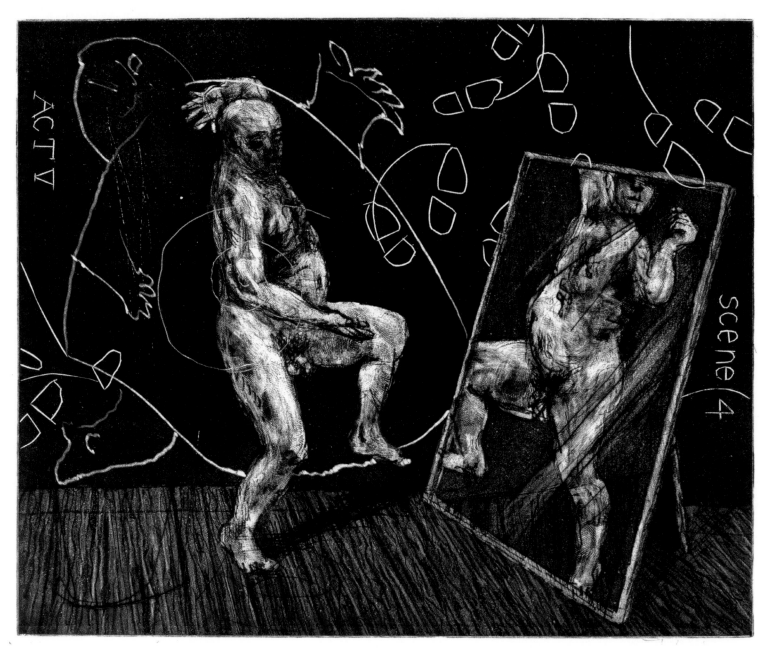

UBU TELLS THE TRUTH (ACT V SCENE 4)

1996-7

Soft ground,
aquatint, drypoint

Image 25 x 30 cm
9.8 x 11.8 inches

Paper 36 x 50 cm
14.2 x 19.7 inches

LIVING LANGUAGE
VINYL PRINTS (1999)

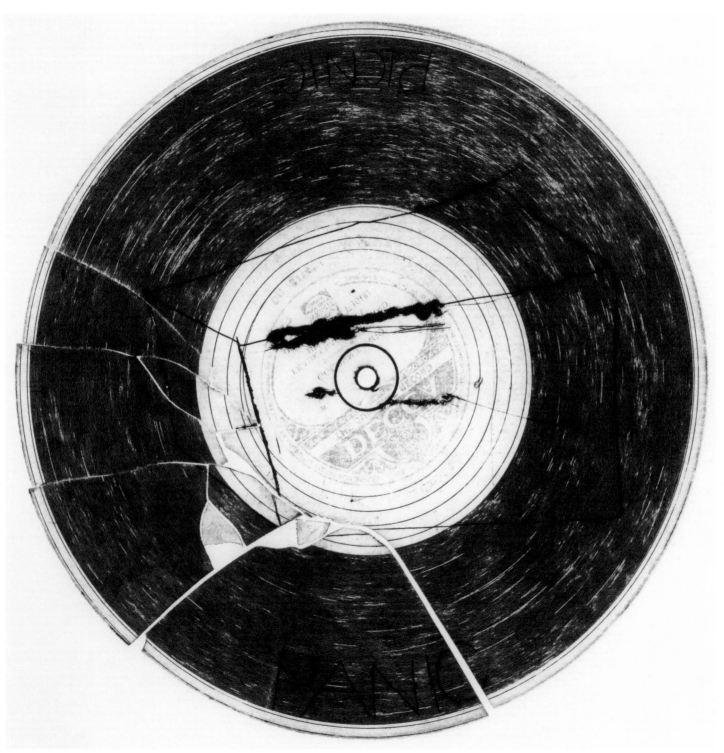

PANIC/PICNIC

1999

Drypoint, from 1 vinyl gramophone record

Image
Diameter 24.7 cm
9.7 inches

Paper 34.5 x 32 cm
13.6 x 12.6 inches

Having discovered that old 78rpms would shatter under the pressure of printing, he turned to 33rpms.

The idea of printed or projected images in circular form would thenceforth return repeatedly to the body of work.

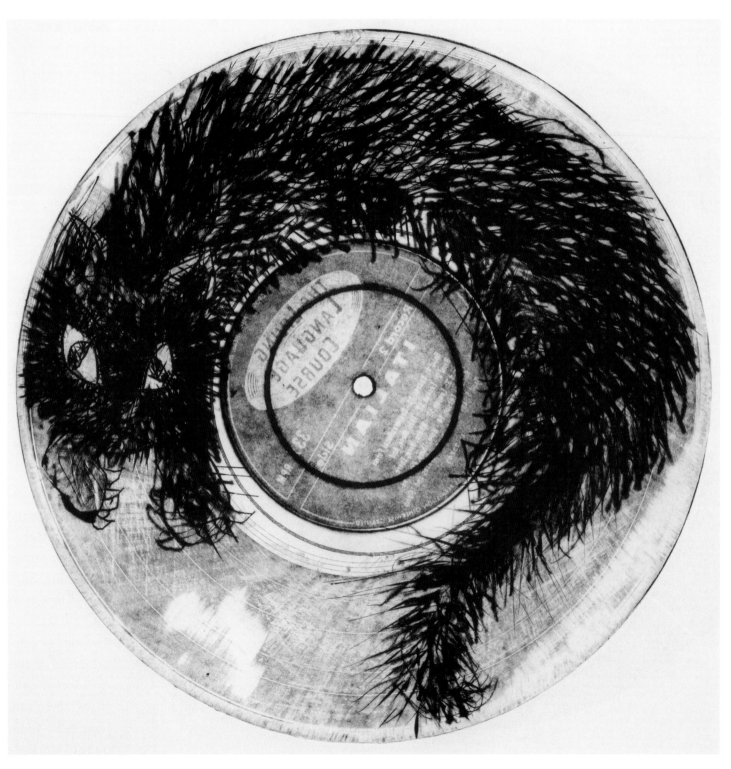

**LIVING LANGUAGE
(CAT)**

1999

Drypoint, from 1 vinyl
gramophone record

Image
Diameter 24.7 cm
9.7 inches

Paper 34.5 x 32 cm
13.6 x 12.6 inches

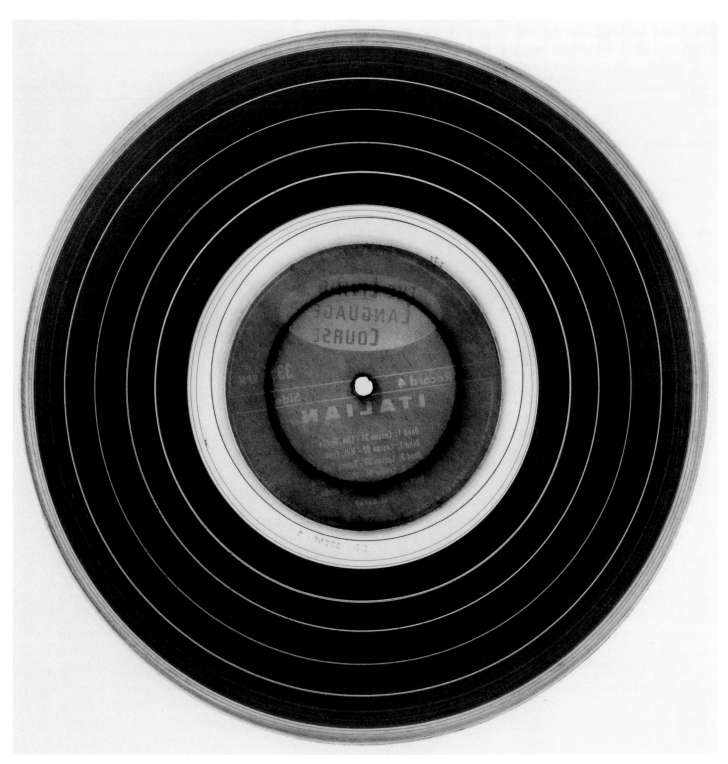

**LIVING LANGUAGE
(ITALIAN)**

1999

Drypoint, from 1 vinyl
gramophone record

Image
Diameter 24.7 cm
9.7 inches

Paper 34.5 x 32 cm
13.6 x 12.6 inches

ATLAS PROCESSION (2000)

Processions and marches and demonstrations have been a feature of the body of the artist's work for a quarter of a century. Combined with his work using shadow puppets for the projected backdrops of theatre productions, this interest culminated with the presentation of *Shadow Procession* (1999) at the Istanbul Biennial. It was subsequently projected onto Times Square, New York, in 2001. In the film, his grotesque Ubu tyrant drives the weak and overburdened shadow puppets laterally across the face of the screen or wall or hoarding, until their oppressed shuffling is transformed into an elated and determined marching step. In the following year, *Overvloed* (2000) showed a procession of animated shadow characters on the move with their wares on their backs. In the same year, in *Stair Procession* (2000) oversize black silhouettes, made out of torn paper, occupied the walls of a stairwell in New York's P.S.1 to make visible the mountain of invisible suffering on which every globalised metropolis depends.

When combined with his interest in the way that projections add scale to images, and render them as contemporary equivalents to frescoes as visions of the world, this idea takes on a harder political edge. In 1999, Kentridge projected such figures of torn paper onto the ceiling of the city hall in Amsterdam, where they moved around the barrel vault in endless procession. In the *Atlas Procession* prints (2000), they move around the globe in endless migratory flows, and with all of the hope and energy, the futility and pain, and all of the determination that such human waves have always possessed.

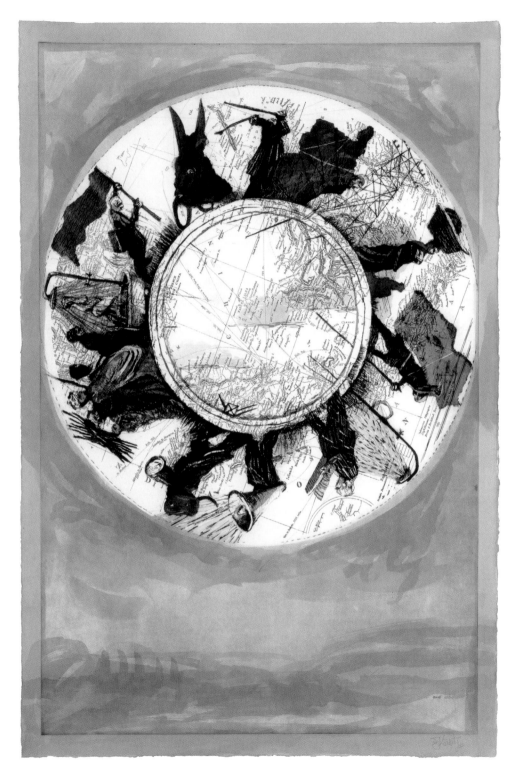

ATLAS PROCESSION II

2000

Etching, aquatint & drypoint, from 1 copper
plate & letterpress from a mylar sheet,
with further hand painting by the artist,
on Vélin d'Arches Blanc 300 gsm paper

Image 158 x 108 cm
 62.2 x 42.5 inches

Paper 158 x 108 cm
 62.2 x 42.5 inches

ZENO WRITING (2002)

Kentridge was inspired by a fascination with Zeno, the hero or anti-hero of Italo Svevo's novel of 1923 *Confessions of Zeno*. Zeno suffers the paradox of being socially and politically and personally paralysed yet unable, because of his weakness, to decide not to act or to speak. His commitments and determinations are valeities: he engages in serial resolutions to stop smoking, he remains married but engaged in affairs, and he agonises about this condition but, as with all else, is unable to act on it to change his behaviour. The perspectival absurdity of these concerns is compounded by the context – a Europe trudging towards war.

In 2002, Kentridge assembled drawings, film footage of cigarette smoke, and documentary footage of World War I to produce a short animated film *Zeno Writing* that confronted this gulf between heroic and overarching political context and the insulations of private existence, and the failure of this gulf to achieve the relief to consciousness that would be provided by effective insulation. The worlds of hearth and city commingle unavoidably. These nine photogravures are from that project.

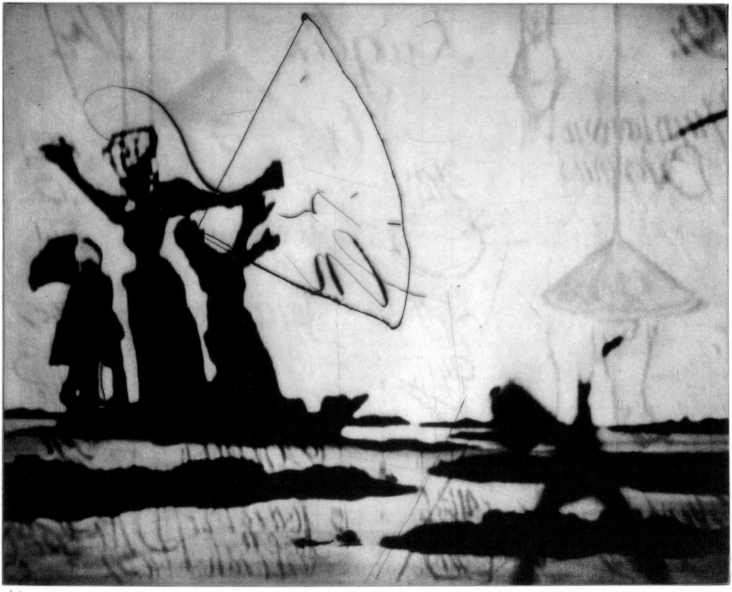

ZENO WRITING
(CHORUS)
2002

Photogravure,
drypoint &
burnishing on paper

Image 21 x 27.5 cm
 8.3 x 10.8 inches

Paper 39.5 x 53.3 cm
 15.6 x 21 inches

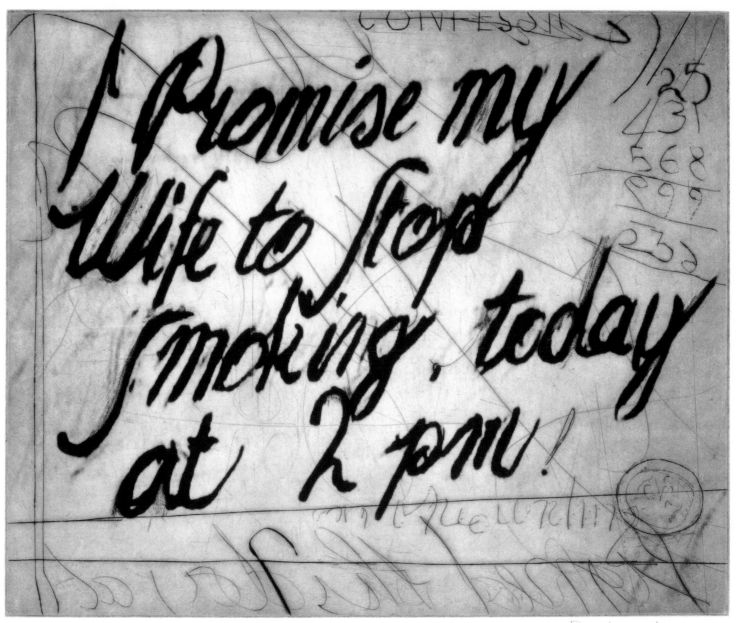

A/D

**ZENO WRITING
(I PROMISE MY WIFE
TO STOP SMOKING)**

2002

Photogravure,
drypoint &
burnishing on paper

Image 21 x 27.5 cm
 8.3 x 10.8 inches

Paper 39.5 x 53.3 cm
 15.6 x 21 inches

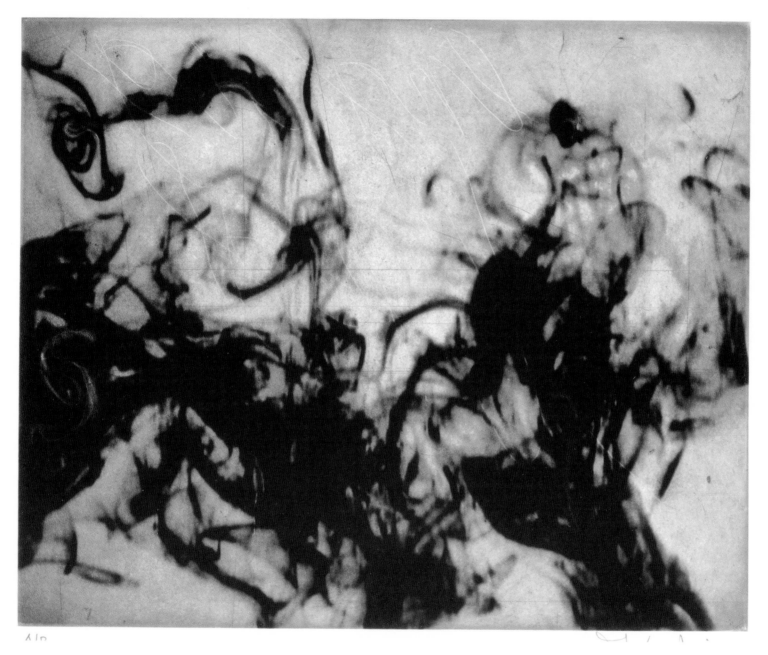

**ZENO WRITING
(SMOKE)**

2002

Photogravure,
drypoint &
burnishing on paper

Image 21 x 27.5 cm
 8.3 x 10.8 inches

Paper 39.5 x 53.3 cm
 15.6 x 21 inches

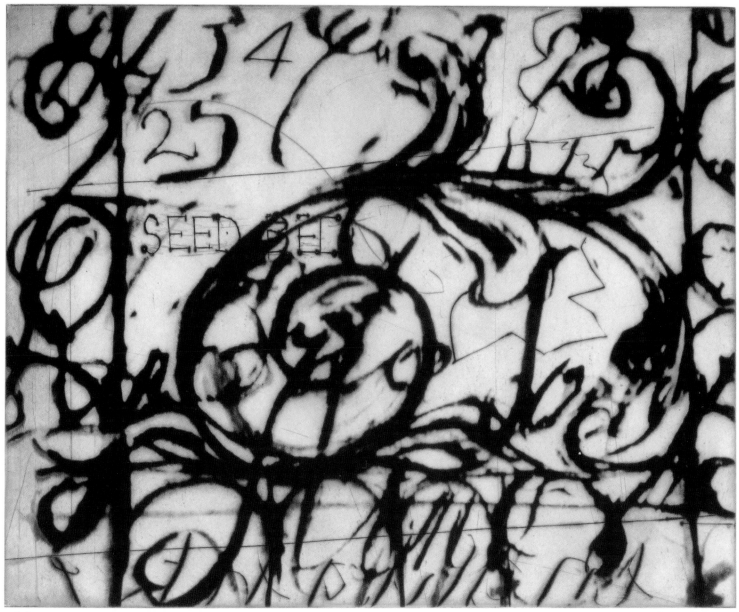

**ZENO WRITING
(ACANTHUS RAILING)**

2002

Photogravure,
drypoint &
burnishing on paper

Image 21 x 27.5 cm
 8.3 x 10.8 inches

Paper 39.5 x 53.3 cm
 15.6 x 21 inches

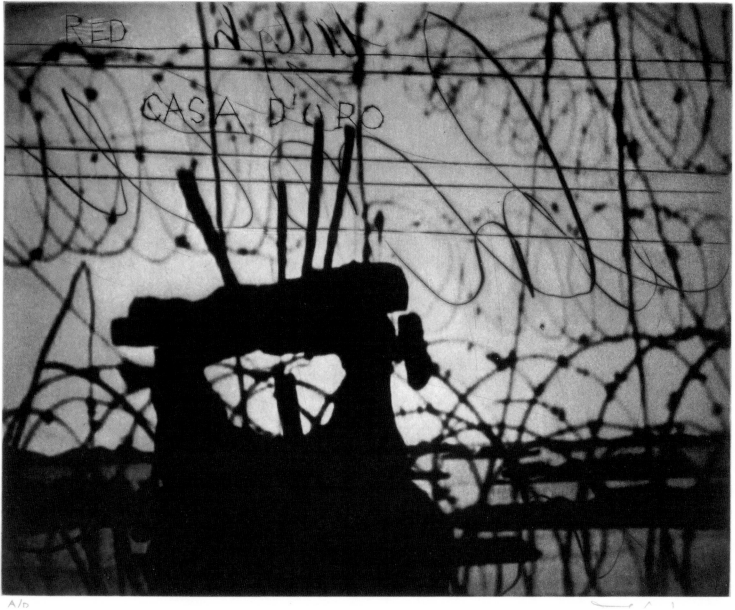

**ZENO WRITING
(TYPEWRITER)**

2002

Photogravure,
drypoint &
burnishing on paper

Image 21 x 27.5 cm
 8.3 x 10.8 inches

Paper 39.5 x 53.3 cm
 15.6 x 21 inches

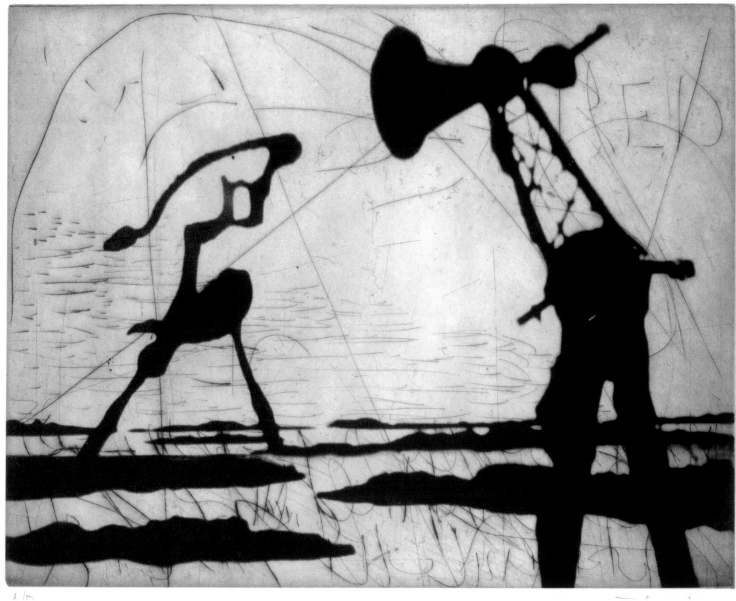

**ZENO WRITING
(SMOKE AND BUILDING)**

2002

Photogravure,
drypoint &
burnishing on paper

Image 21 x 27.5 cm
 8.3 x 10.8 inches

Paper 39.5 x 53.3 cm
 15.6 x 21 inches

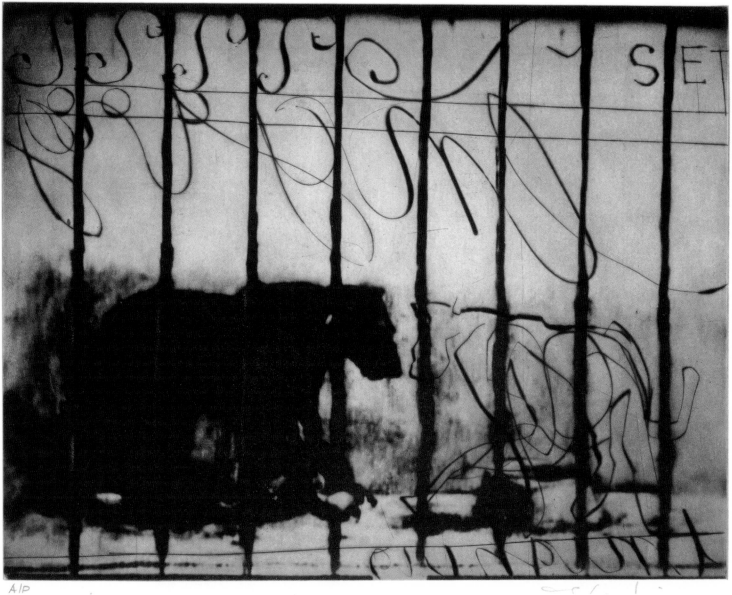

AIP

ZENO WRITING (PANTHER)

2002

Photogravure,
drypoint &
burnishing on paper

Image 21 x 27.5 cm
 8.3 x 10.8 inches

Paper 39.5 x 53.3 cm
 15.6 x 21 inches

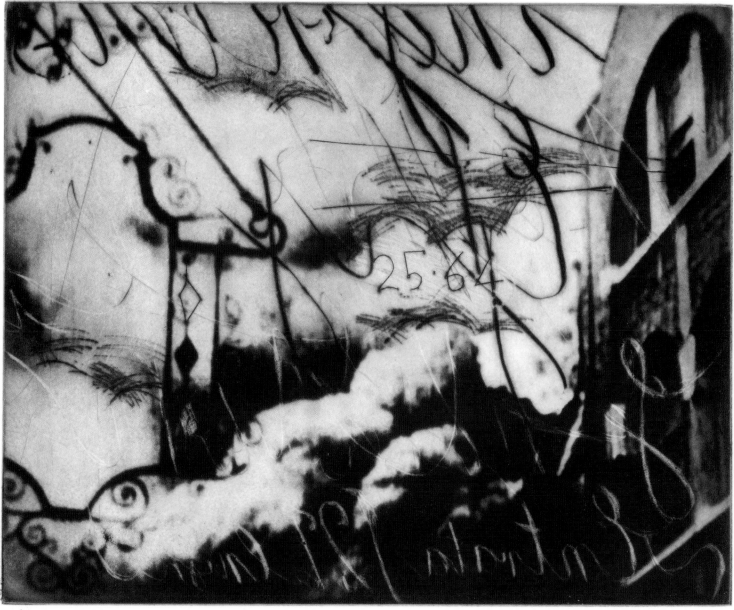

**ZENO WRITING
(SMOKE AND BUILDING)**

2002

Photogravure,
drypoint &
burnishing on paper

Image 21 x 27.5 cm
 8.3 x 10.8 inches

Paper 39.5 x 53.3 cm
 15.6 x 21 inches

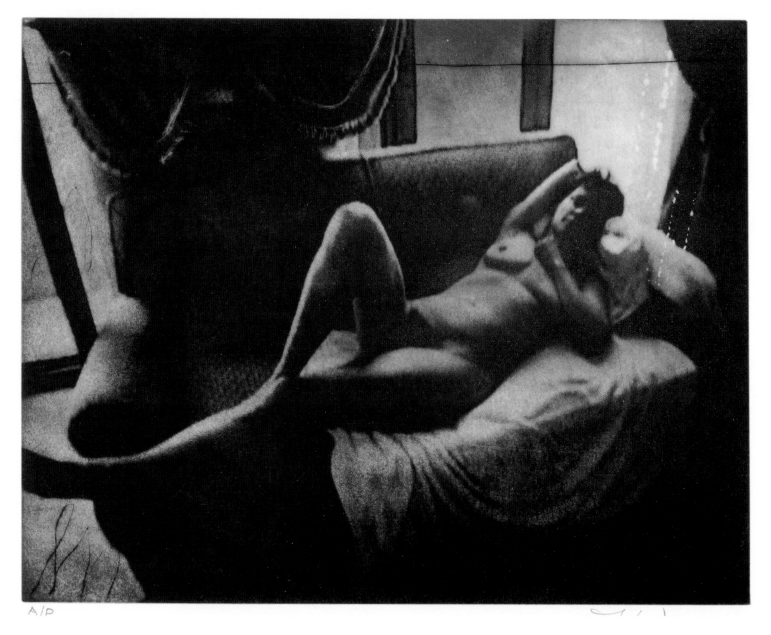

A/P

**ZENO WRITING
(WOMAN ON A SOFA)**

2002

Photogravure,
drypoint &
burnishing on paper

Image 21 x 27.5 cm
 8.3 x 10.8 inches

Paper 39.5 x 53.3 cm
 15.6 x 21 inches

COPPER NOTES (2005)

In 2005, Kentridge opened the first showing of his miniature theatre installation *Black Box / Chambre Noire* at the Deutsche Guggenheim in Berlin. It has subsequently been shown in Johannesburg, and in Malmö, Sweden. This remarkable piece, composed of sculptures, drawings, projections and a musical score by Philip Miller, tells the story of the mass killing and attempted extermination of the Herero and Nama peoples of South West Africa (Namibia) by the Kaiser's troops under General Lotha von Trotha. In so doing, it raises the issue of the relationship between colonialism and the knowledge and values on which invasion and colonisation were built – reason, science and a version of liberal humanism.

The prints in the *Copper Notes* series address some of the central issues in the preparation of *Black Box*. All of the prints were produced from the same plate, worked on over subsequent days to produce a different copper plate at the end of each working from which the day's prints could be lifted. The first prints in the series depict the machines of visual and oral communication, the devises that enable connection across spaces of estrangement, and thereby may facilitate either communication or misunderstanding and misrecognition. Then Megaphone Man, announcing a future and memorialising the past so as better to reinvent it, followed by the coffee pot and skull – the last to be crushed to dust beneath a boot. States 6 and 7 secure the connection to German colonialism (the flag and the eagle). From states 8 to 11, the image of the artist is progressively obscured as the ramifications and implications of what is unfolding become clear, and the ideas of unintentional complicity and the inheritance of responsibility, if not culpability, become unendurable.

**COPPER NOTES
(STATE 0)**

2005

Drypoint

Image 16.5 x 20.7 cm
 6.5 x 8.1 inches

Paper 28.5 x 33 cm
 11.2 x 13 inches

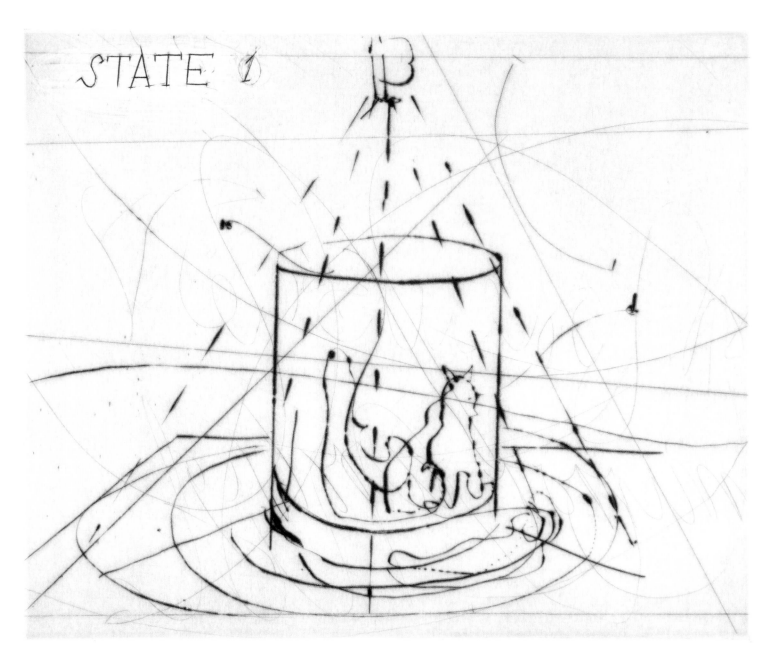

**COPPER NOTES
(STATE 1)**

2005

Drypoint

Image 16.5 x 20.7 cm
 6.5 x 8.1 inches

Paper 28.5 x 33 cm
 11.2 x 13 inches

**COPPER NOTES
(STATE 2)**

2005

Drypoint

Image 16.5 x 20.7 cm
 6.5 x 8.1 inches

Paper 28.5 x 33 cm
 11.2 x 13 inches

**COPPER NOTES
(STATE 3)**

2005

Drypoint

Image 16.5 x 20.7 cm
 6.5 x 8.1 inches

Paper 28.5 x 33 cm
 11.2 x 13 inches

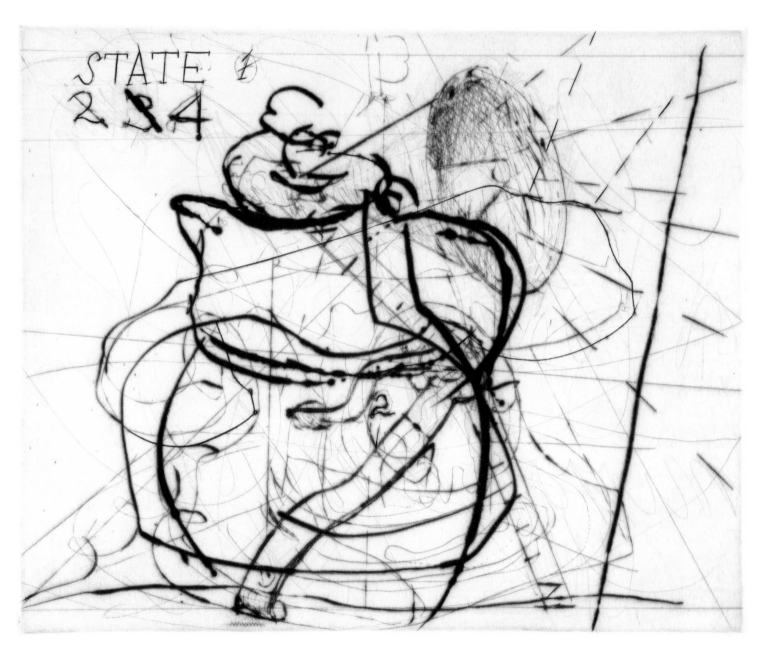

COPPER NOTES
(STATE 4)

2005

Drypoint

Image 16.5 x 20.7 cm
 6.5 x 8.1 inches

Paper 28.5 x 33 cm
 11.2 x 13 inches

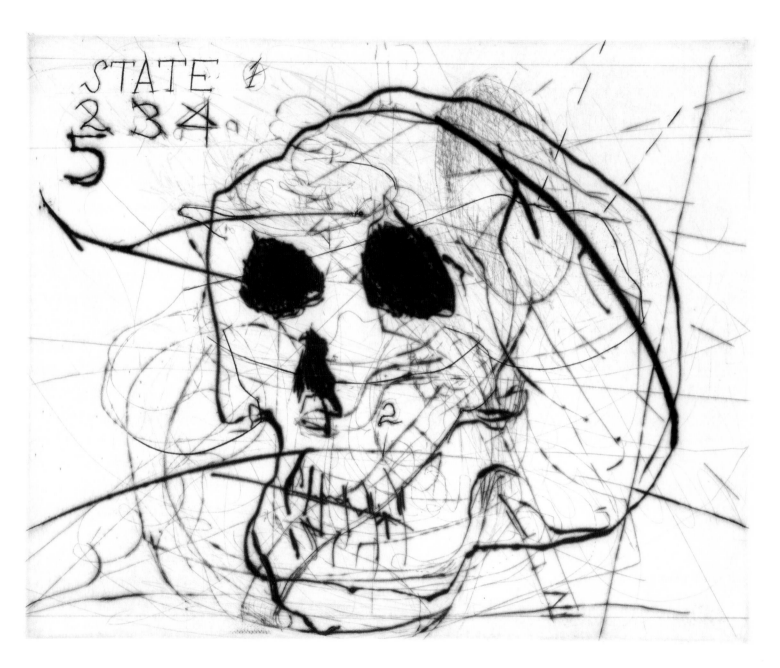

**COPPER NOTES
(STATE 5)**

2005

Drypoint

Image 16.5 x 20.7 cm
 6.5 x 8.1 inches

Paper 28.5 x 33 cm
 11.2 x 13 inches

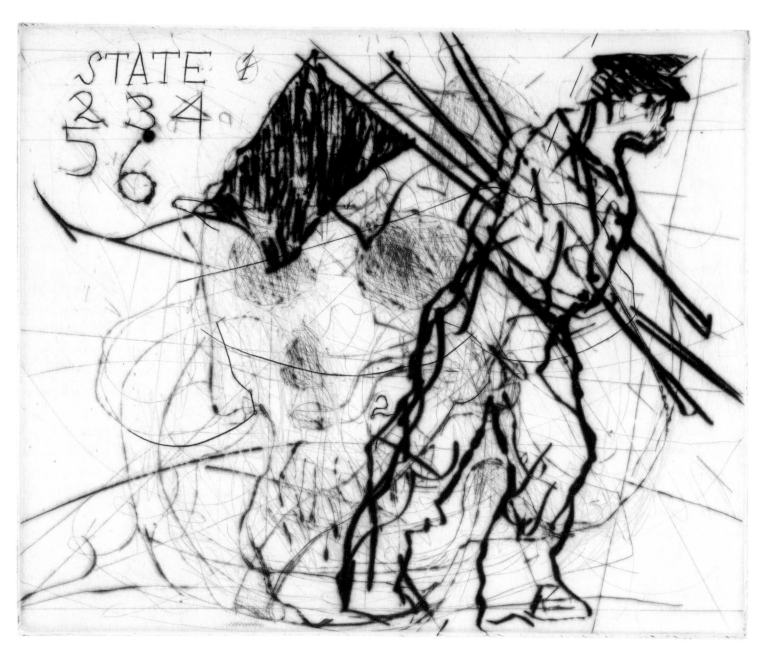

COPPER NOTES
(STATE 6)

2005

Drypoint

Image 16.5 x 20.7 cm
 6.5 x 8.1 inches

Paper 28.5 x 33 cm
 11.2 x 13 inches

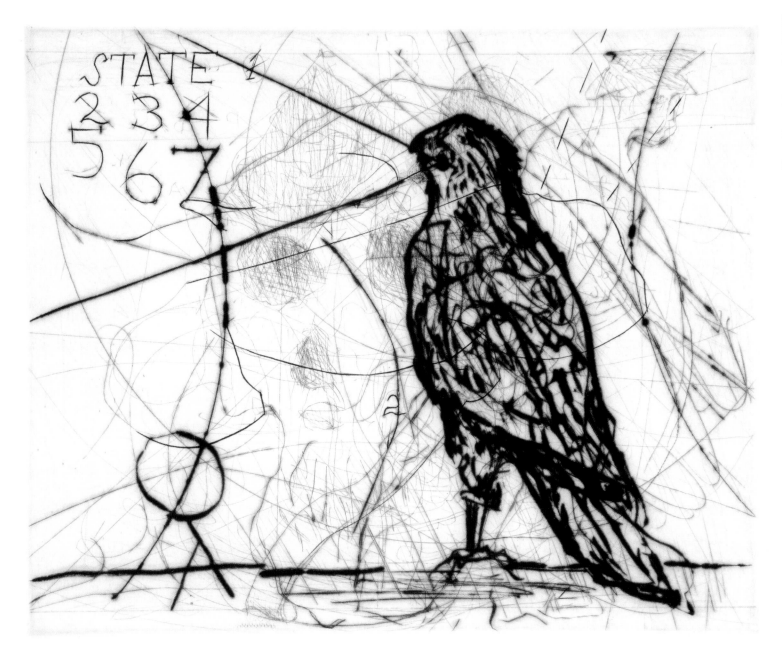

**COPPER NOTES
(STATE 7)**

2005

Drypoint

Image 16.5 x 20.7 cm
 6.5 x 8.1 inches

Paper 28.5 x 33 cm
 11.2 x 13 inches

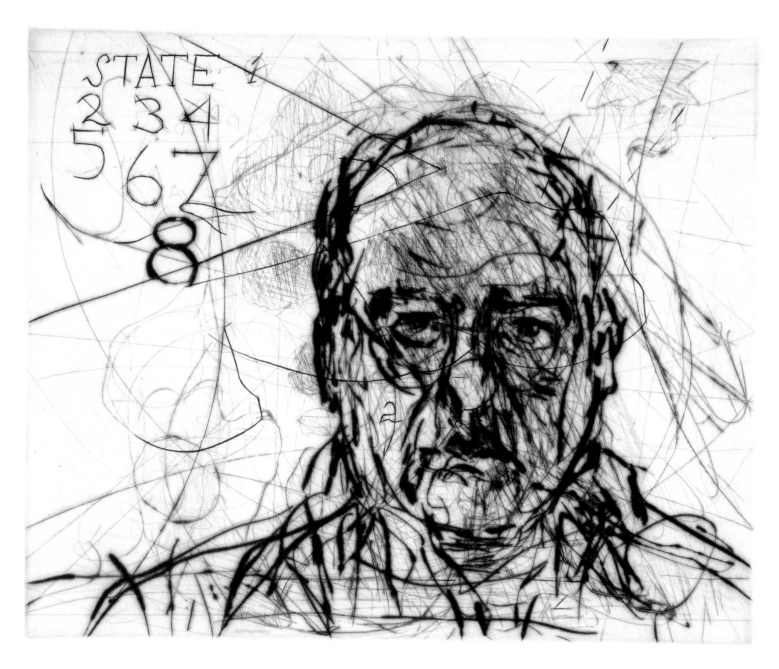

COPPER NOTES (STATE 8)

2005

Drypoint

Image 16.5 x 20.7 cm
 6.5 x 8.1 inches

Paper 28.5 x 33 cm
 11.2 x 13 inches

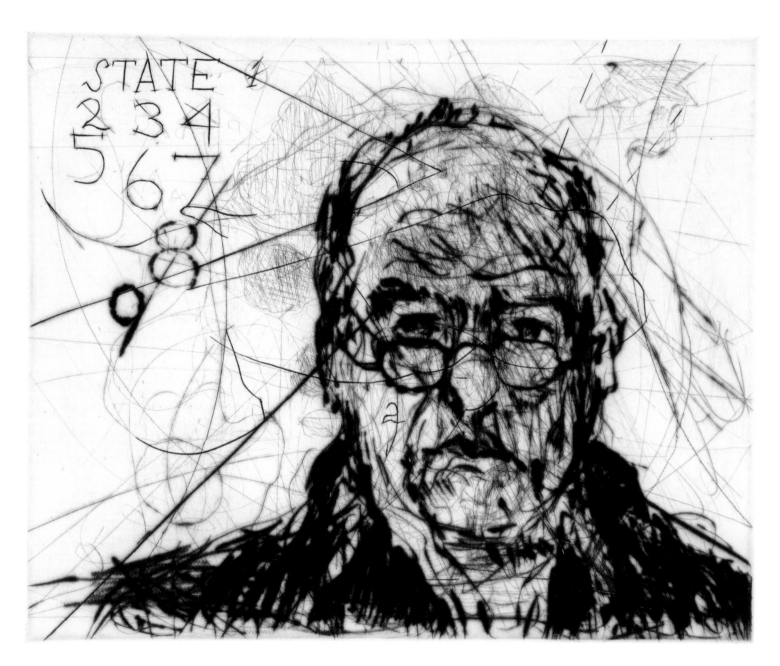

**COPPER NOTES
(STATE 9)**

2005

Drypoint

Image 16.5 x 20.7 cm
 6.5 x 8.1 inches

Paper 28.5 x 33 cm
 11.2 x 13 inches

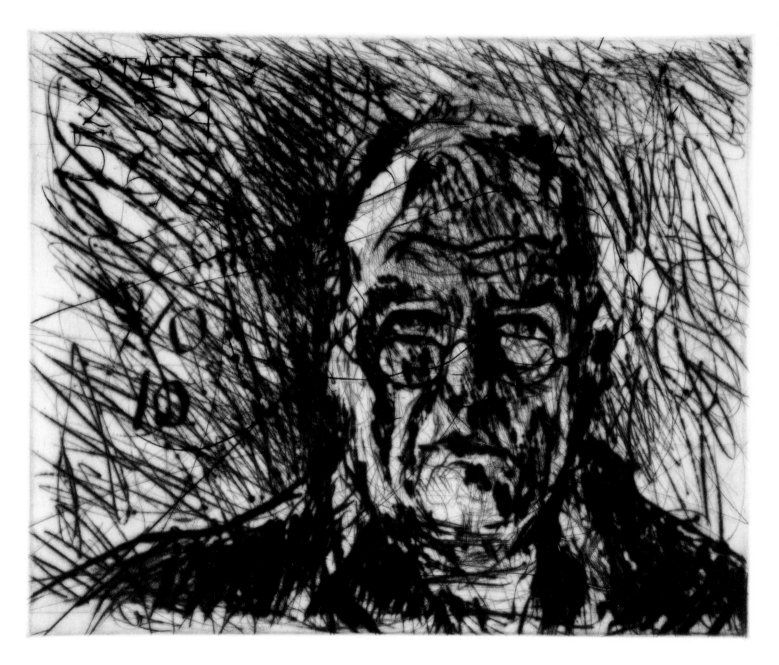

**COPPER NOTES
(STATE 10)**

2005

Drypoint

Image 16.5 x 20.7 cm
 6.5 x 8.1 inches

Paper 28.5 x 33 cm
 11.2 x 13 inches

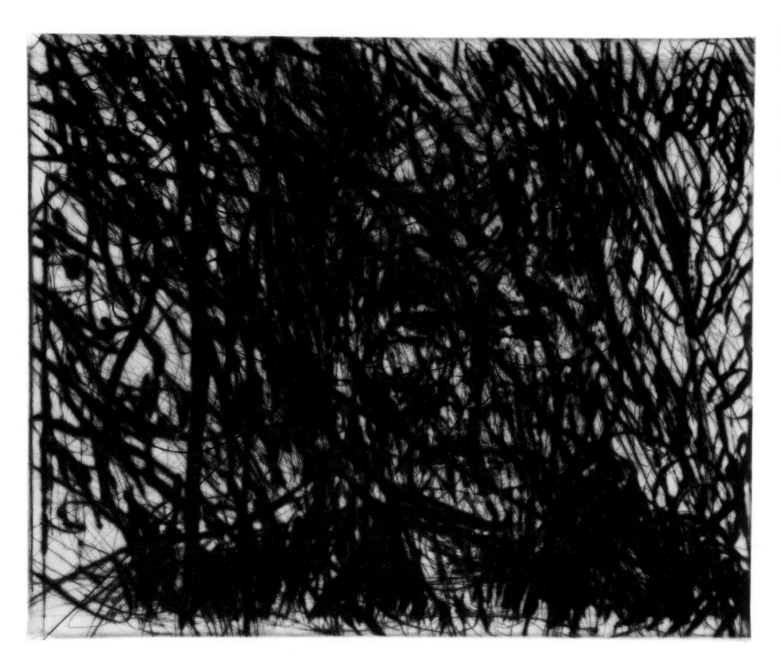

COPPER NOTES (STATE 11)

2005

Drypoint

Image 16.5 x 20.7 cm
 6.5 x 8.1 inches

Paper 28.5 x 33 cm
 11.2 x 13 inches

BIRD CATCHING (2007)

Kentridge's production of Mozart's *The Magic Flute* was premiered at La Monnaie in Brussels in 2005. It then toured in 2006 and 2007 to Lille, to Caen, to Naples, to Tel Aviv, to New York, to Cape Town, and then to Johannesburg. This was a double renewal of the opera. In contrast to many modern interpretations, this production placed centre stage the original central spine of the opera: the struggle of reason and enlightened thinking against vanity, tradition, superstition and self-interest. Many modern interpretations have marginalised this narrative thrust of the opera in favour of a playful delight in the music, and in a plot that is risible if not treated as a serious metaphor. This, despite the fact that both Mozart and his librettist, Shikeneder, were both masons. This was a moment in European history when Freemasonry played a distinctly progressive role. Kentridge, by contrast, insists on Reason as the main character of the drama. This Reason and its associated Enlightenment values, is, however, not a capacity and an attribute that is an uncomplicated good. It is a capacity that is simultaneously necessary (the best, because the only, hope for humanity), and one that is also potentially laden with doom. Here then is a dialectical treatment of the Enlightenment and of the Scientific Revolution.

If Reason contains a promise, it equally harbours a threat. Historically, that threat was redeemed in the c.19th by European colonialism, which brought 'light to the Dark Continent' through the barrels of rifles and cannon, which invaded and suppressed and murdered and exploited in the name of progress. With both his staging and his use of projected imagery for the set of the opera, this is Kentridge's insistent central message. It is supplemented by the forceful reminders throughout that our interpretations of dramas, whether performed on stage or in the world, are always received as images and accounts that have been refracted by our optical or conceptual instruments.

The *Birdcatcher* prints refer to the character in the opera of that profession, Papageno. In the prints, however, it is the artist himself in that role. Here in the prints, in an echo of the way in which the projection of a cage of light onto the stage captures humans as well as birds, it becomes unclear who is chasing what. Is the artist catching the birds, or is he under assault by them; is his line on the surface there as it is drawn because it too is caged by the edge of the plate or by the frame; or is he merely acting out a designated role caged by an historical process which he experiences as identity and memory? It is a celebration of play, certainly, but with a darker side, as the playful artist is transformed, in the final print, into a *murderously* playful black cat.

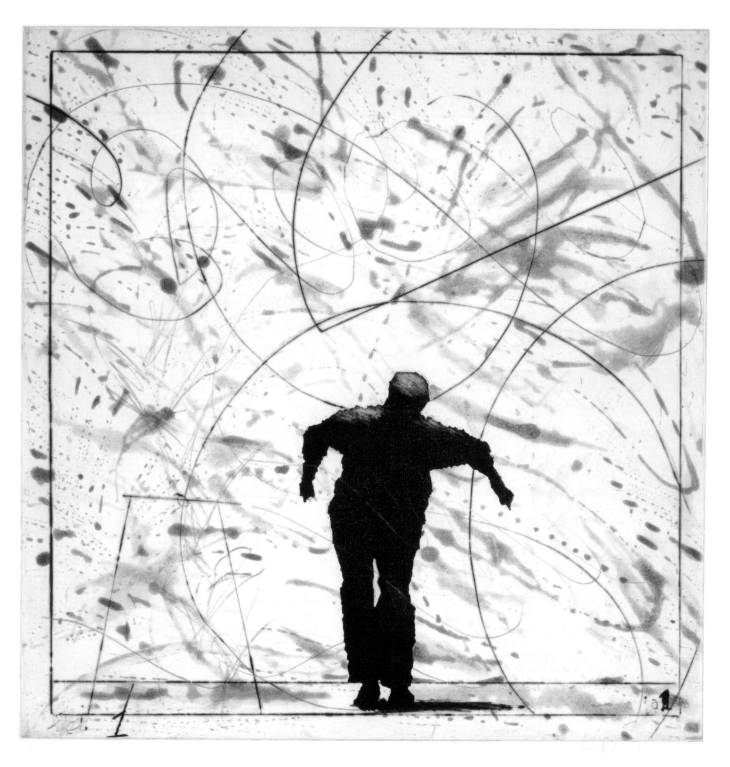

BIRD CATCHING 1

2007

Aquatint &
drypoint on paper

Image 39.5 x 39.5 cm
 15.5 x 15.5 inches

Paper 47 x 47 cm
 18.5 x 18.5inches

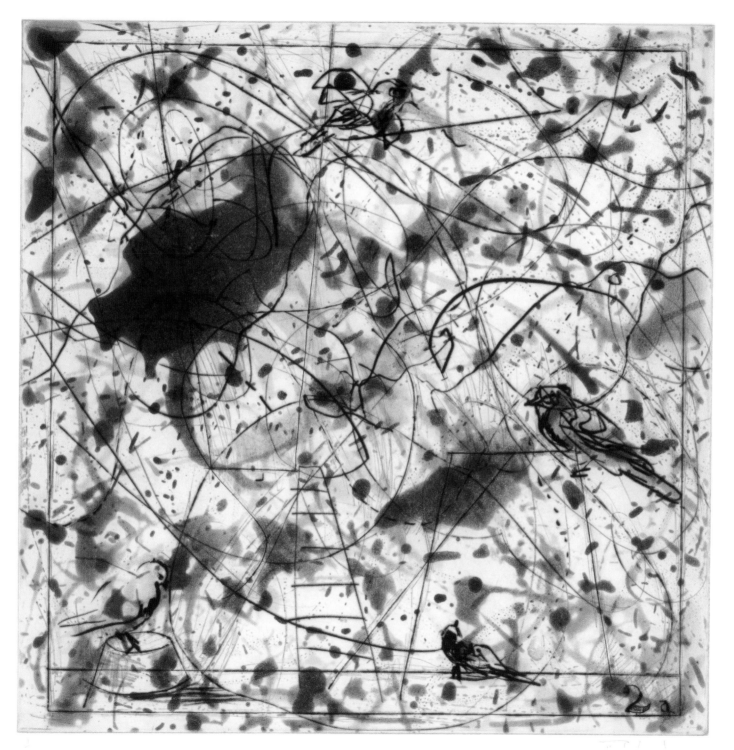

BIRD CATCHING 2

2007

Aquatint &
drypoint on paper

Image 39.5 x 39.5 cm
 15.5 x 15.5 inches

Paper 47 x 47 cm
 18.5 x 18.5inches

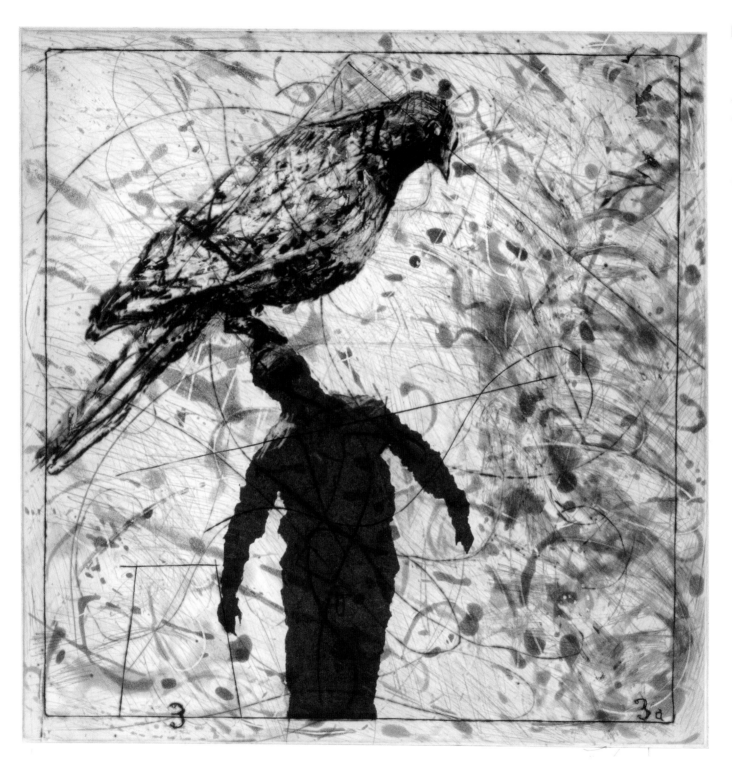

BIRD CATCHING 3
2007

Aquatint &
drypoint on paper

Image 39.5 x 39.5 cm
 15.5 x 15.5 inches

Paper 47 x 47 cm
 18.5 x 18.5inches

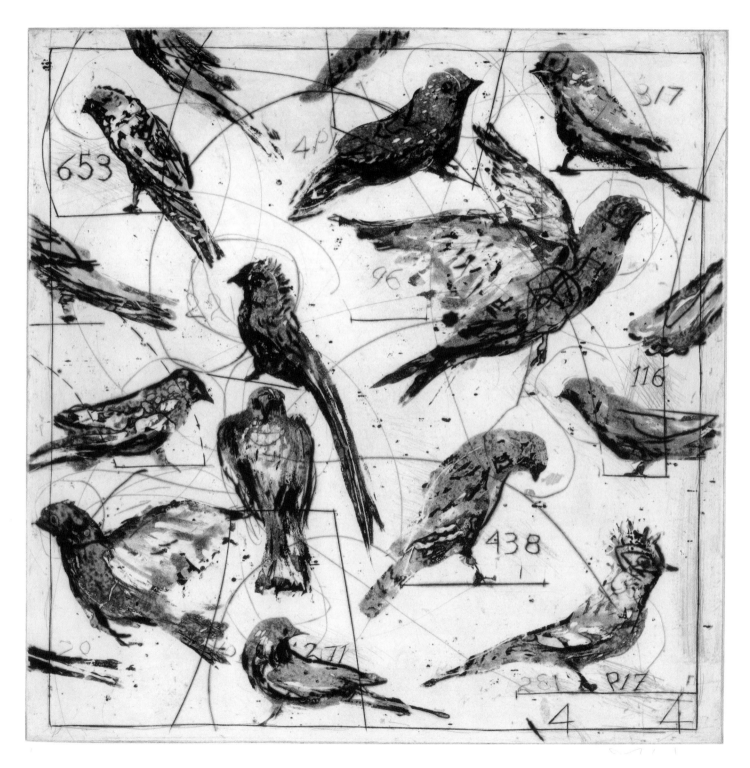

BIRD CATCHING 4

2007

Aquatint &
drypoint on paper

Image 39.5 x 39.5 cm
 15.5 x 15.5 inches

Paper 47 x 47 cm
 18.5 x 18.5inches

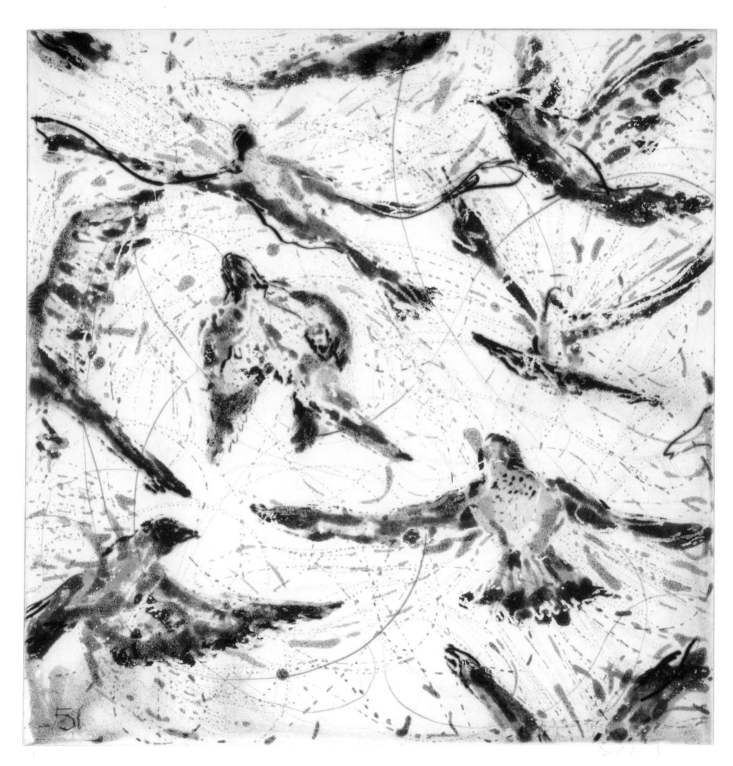

BIRD CATCHING 5

2007

Aquatint &
drypoint on paper

Image 39.5 x 39.5 cm
15.5 x 15.5 inches

Paper 47 x 47 cm
18.5 x 18.5inches

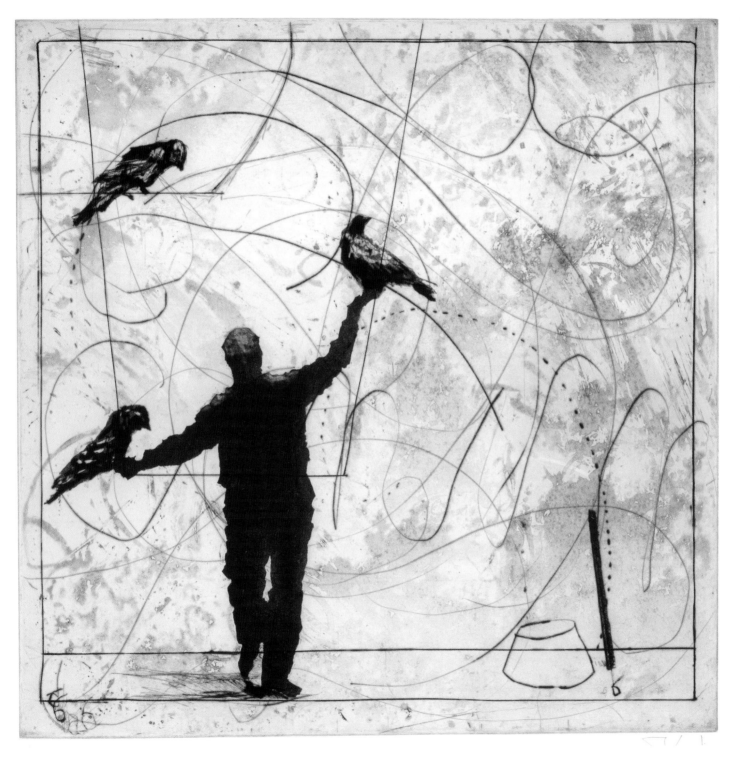

BIRD CATCHING 6

2007

Aquatint &
drypoint on paper

Image 39.5 x 39.5 cm
 15.5 x 15.5 inches

Paper 47 x 47 cm
 18.5 x 18.5inches

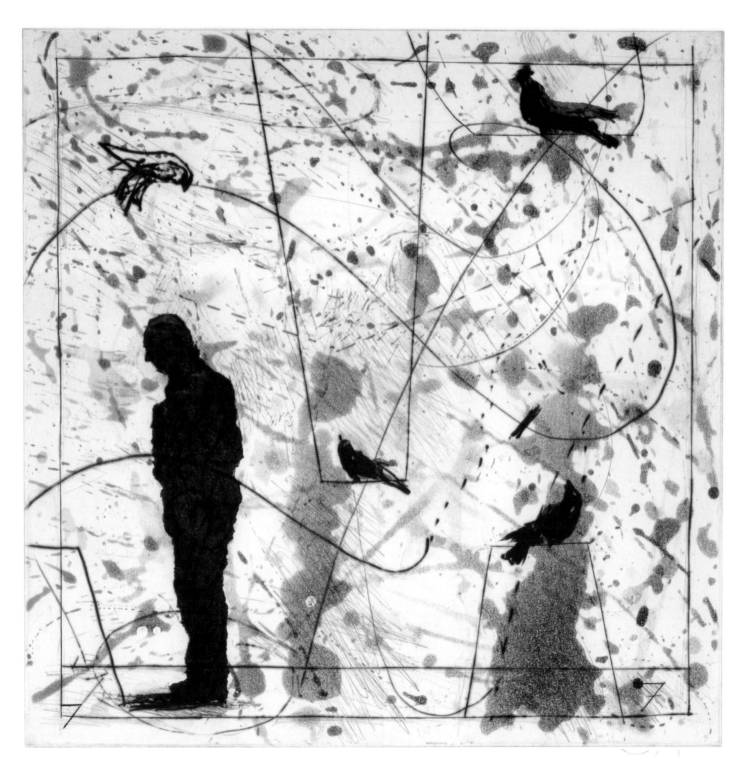

BIRD CATCHING 7

2007

Aquatint &
drypoint on paper

Image 39.5 x 39.5 cm
 15.5 x 15.5 inches

Paper 47 x 47 cm
 18.5 x 18.5inches

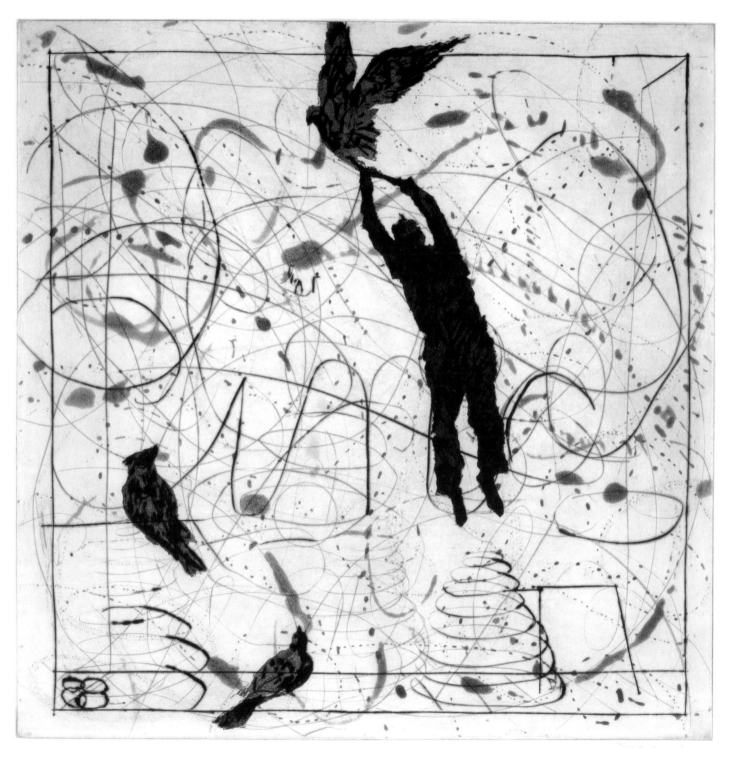

BIRD CATCHING 8

2007

Aquatint &
drypoint on paper

Image 39.5 x 39.5 cm
 15.5 x 15.5 inches

Paper 47 x 47 cm
 18.5 x 18.5inches

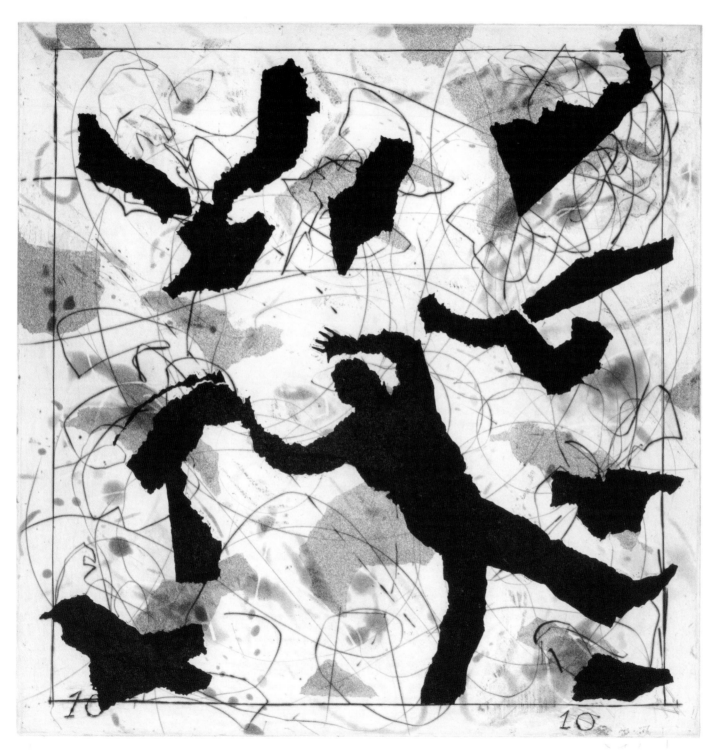

BIRD CATCHING 10

2007

Aquatint &
drypoint on paper

Image 39.5 x 39.5 cm
15.5 x 15.5 inches

Paper 47 x 47 cm
18.5 x 18.5inches

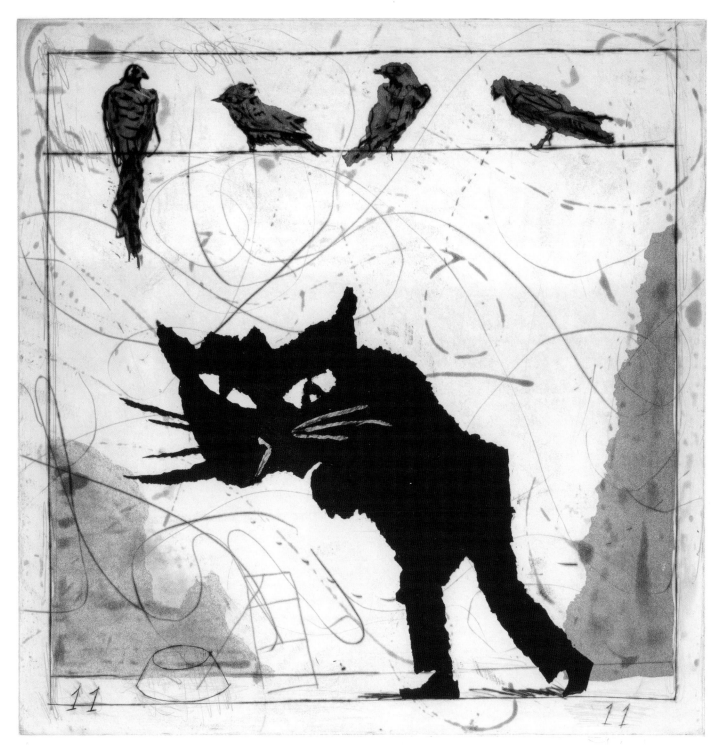

BIRD CATCHING 11

2007

Aquatint &
drypoint on paper

Image 39.5 x 39.5 cm
 15.5 x 15.5 inches

Paper 47 x 47 cm
 18.5 x 18.5inches

COLLAGE FROM *FLUTE* TO *NOSE* (2007)

WITTGENSTEIN'S RHINOSCEROS

The story has it that when Wittgenstein sought out Bertrand Russell to find out if he was any good at philosophy, Russell reported an evening's frustration at not being able to persuade Wittgenstein that there was something to which we could refer beyond language. He spent much time lifting up soft furnishings and furniture to try to persuade Wittgenstein that he should accept, on the evidence, the truth of the statement that there was not a rhinoceros in the room. The young philosopher would have none of it. This too is part of the thrust of Kentridge's work. Not that linguistic philosophy is true in its claims but that the certainties of the kind of positivist approach adopted by Russell will simply not do. Evidence is only evidence when viewed through a particular optic. One does not have to descend into an incoherent relativism in order to recognise that there are no such ready certainties.

In Kentridge's *Flute*, the sharp point about colonialism as the dark side of Reason is heavily made with the documentary images of the killing of a rhino on found footage from 1911-12, projected onto the back of the stage. Earlier we have been introduced to a projected cartoon image of the rhinoceros as a performing circus animal (to the nervous laughter of audiences, warmed and amused but wary), only now to realise that its captivating antics were those of a captive soon to be despatched.

ARITHMETIQUE
and
NEWS FROM NOWHERE

In these pieces, we see some of the preparatory work for Kentridge's next opera commission: Shostakovich's *The Nose,* for the New York Metropolitan Opera. Taken from a Gogol short story, this is a satire of pomposity and bureaucracy, and of the petty civilities of officialdom. In the collage of images we see Constructivist emblems, from El Lissitsky and Malevich and others, and caricatures of Lenin and Stalin and the Nose.

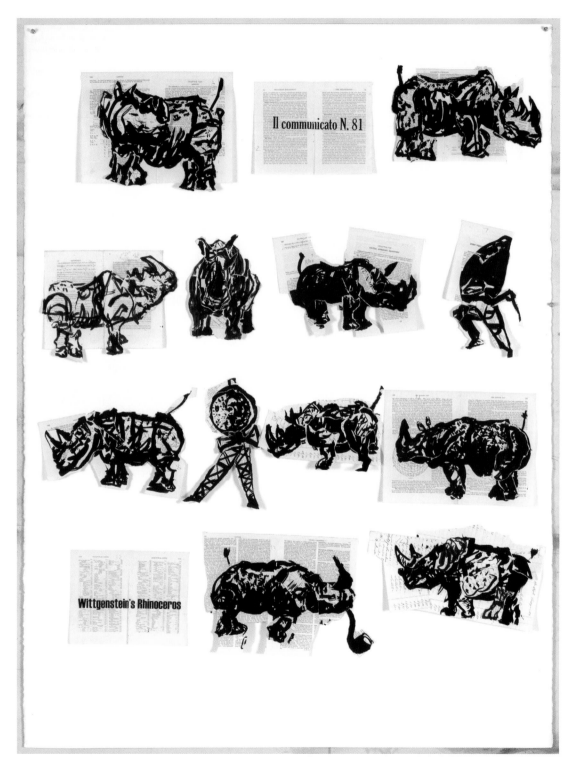

WITTGENSTEIN'S RHINOCEROS

2007

Photo lithography, tearing, hand-colouring
& glueing using Munken & BFK Rives white
250 gsm papers

Image 160 x 122 cm
 63 x 48 inches

Paper 160 x 122 cm
 63 x 48 inches

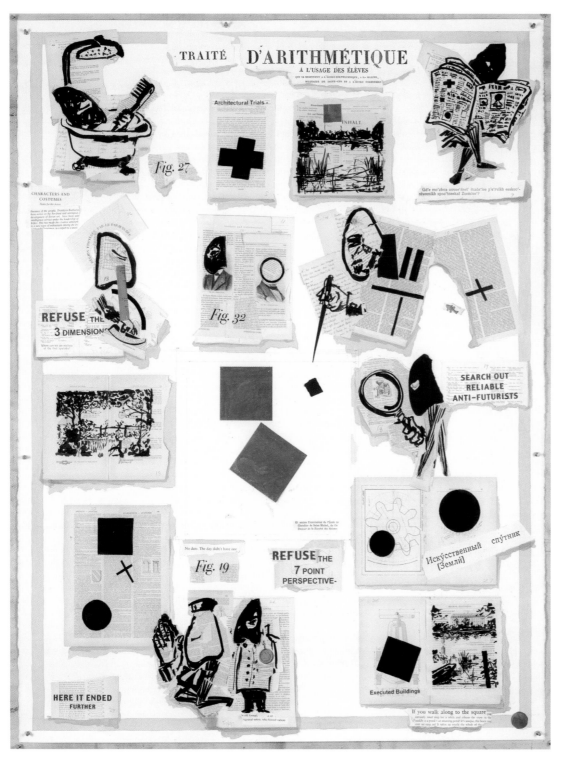

ARITHMÉTIQUE

2007

Photo lithography, tearing, hand-colouring
& glueing using Munken & BFK Rives white
250 gsm papers

Image 160 x 122 cm
 63 x 48 inches

Paper 160 x 122 cm
 63 x 48 inches

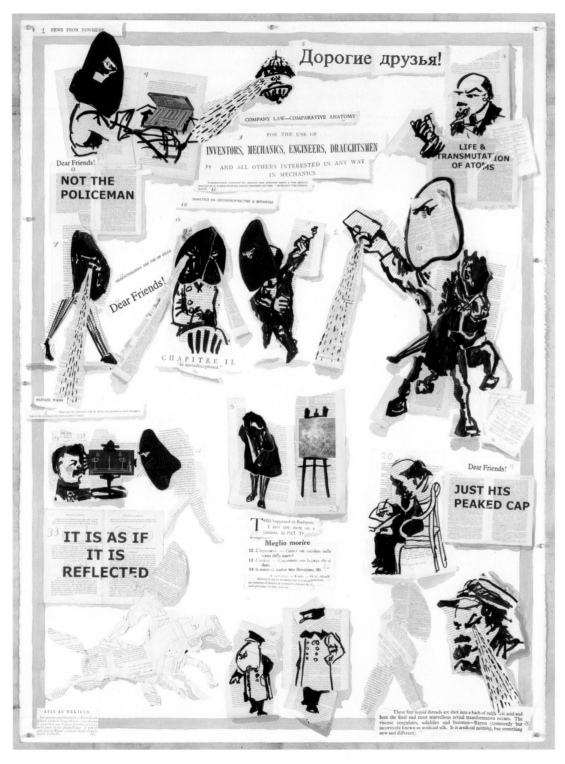

NEWS FROM NOWHERE

2007

Photo lithography, tearing, hand-colouring
& glueing using Munken & BFK Rives white
250 gsm papers

Image 160 x 122 cm
 63 x 48 inches

Paper 160 x 122 cm
 63 x 48 inches

DRAWINGS FOR *IL SOLE 24 ORE*

These five arresting images (exhibited on the first floor of The Regency Town House), are presented both as the original sugarlift and drypoint prints, *and* as the printed versions published in the newspaper, *Il Sole 24 Ore,* the national business daily. The paper published them, blown up and superimposed on whole pages, on four separate days:

Domenica, 25th March 2007
Massacre of the Innocents, 1st April 2007
The World Walking, 8th April 2007
Gasmask, 15th April 2007

A direct, immediate and unmistakable, challenge to the global effects of commercial rivalry and its political consequences in terms of national conflicts, repression, pain and struggle, migration and ecological disaster, the references and debts stretch from Goya to Picasso to H. G. Wells.

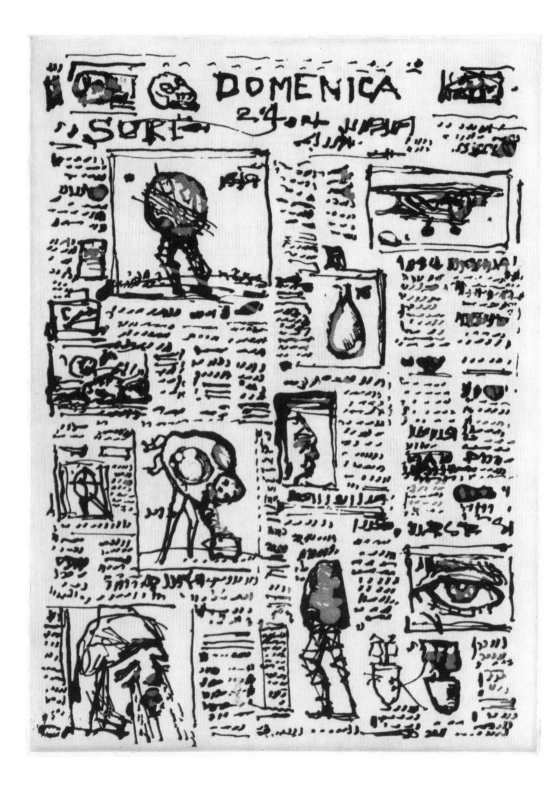

**L'INESORABILE AVANZATA 2
(NEWSPAPER)**

2007

Sugarlift & drypoint on paper

Image 20 x 15 cm
7.8 x 5.9 inches

Paper 40 x 35 cm
15.7 x 13.8 inches

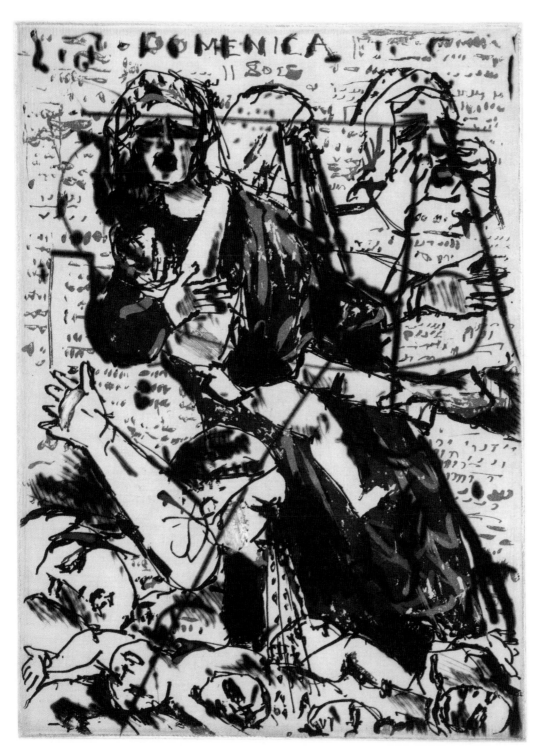

L'INESORABILE AVANZATA 3 (MASSACRE OF THE INNOCENT)

2007

Sugarlift & drypoint on paper

Image 20 x 15 cm
 7.8 x 5.9 inches

Paper 40 x 35 cm
 15.7 x 13.8 inches

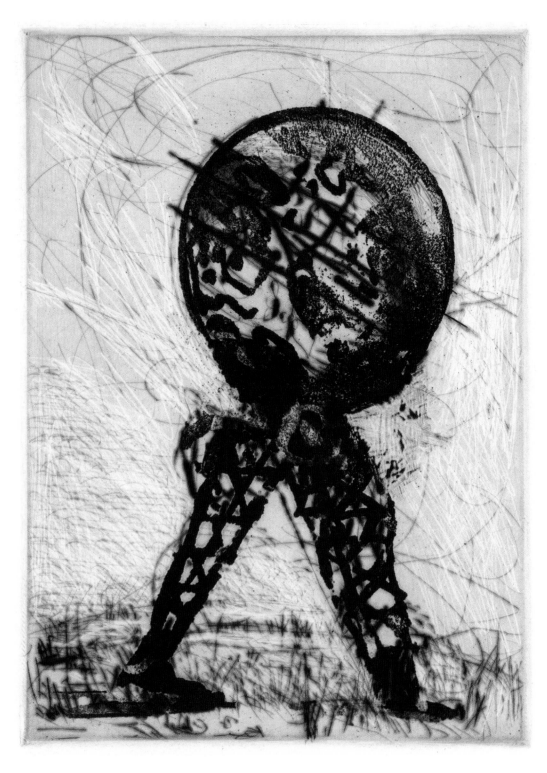

**L'INESORABILE AVANZATA 1
(WORLD WALKING)**

2007

Sugarlift & drypoint on paper

Image 20 x 15 cm
 7.8 x 5.9 inches

Paper 40 x 35 cm
 15.7 x 13.8 inches

**L'INESORABILE AVANZATA 4
(READ NEWSPAPER)**

2007

Sugarlift & drypoint on paper

Image 20 x 15 cm
 7.8 x 5.9 inches

Paper 40 x 35 cm
 15.7 x 13.8 inches

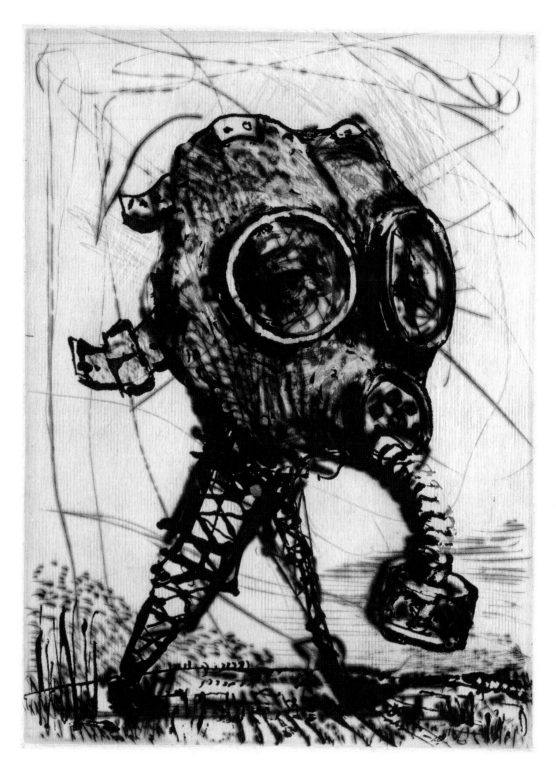

**L'INESORABILE AVANZATA 5
(GAS MASK)**

2007

Sugarlift & drypoint on paper

Image 20 x 15 cm
 7.8 x 5.9 inches

Paper 40 x 35 cm
 15.7 x 13.8 inches

STEREOSCOPIC
PHOTOGRAVURES (2007)

In this installation piece, Kentridge again experiments with perceptual shifts. As with his other work, whether using projection onto walls or furniture or the stage, or using reflected images, this work with light and on perception combines draftsmanship with optical technology in order to make what is, in essence, and epistemological point. As the dual images are brought into focus, and we perceive a depth of field that is not present on the flat surface of the twin prints, we experience a perceptual shock, and have the opportunity to become aware of the partially constructed nature of our perceptual field.

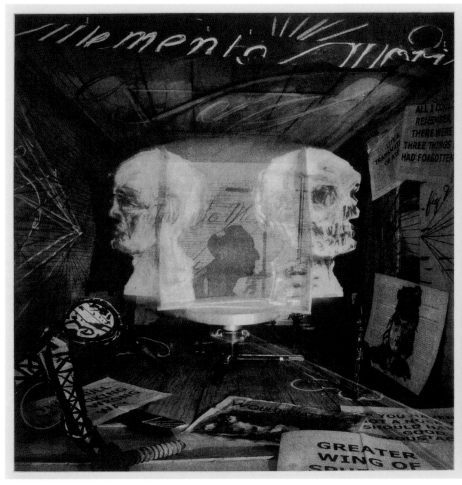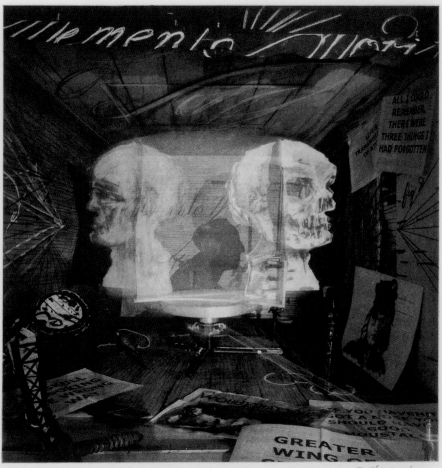

MEMENTO MORI

2007

Photogravure

Each
Image 22.5 x 22.5 cm
 8.9 x 8.9 inches

Paper 34.4 x 57 cm
 13.5 x 22.4 inches

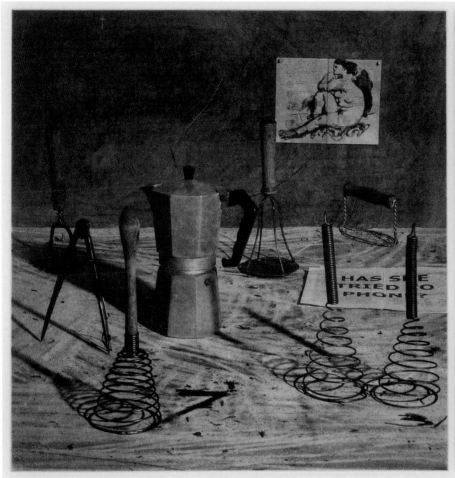
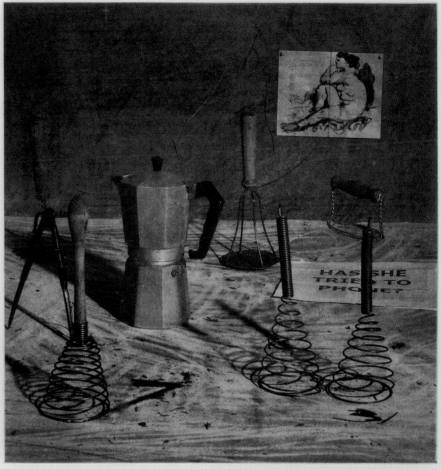

STILL LIFE

2007

Photogravure

Each
Image 22.5 x 22.5 cm
 8.9 x 8.9 inches

Paper 34.4 x 57 cm
 13.5 x 22.4 inches

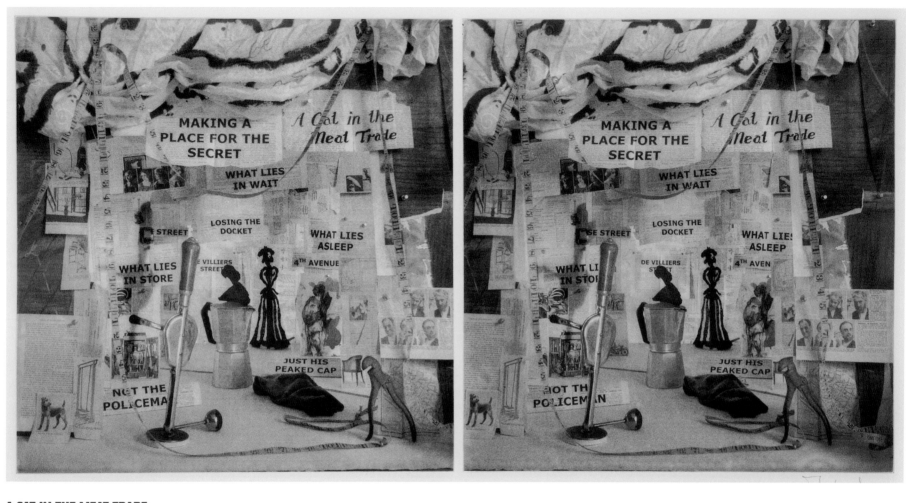

A CAT IN THE MEAT TRADE

2007

Photogravure

Each
Image 22.5 x 22.5 cm
 8.9 x 8.9 inches

Paper 34.4 x 57 cm
 13.5 x 22.4 inches

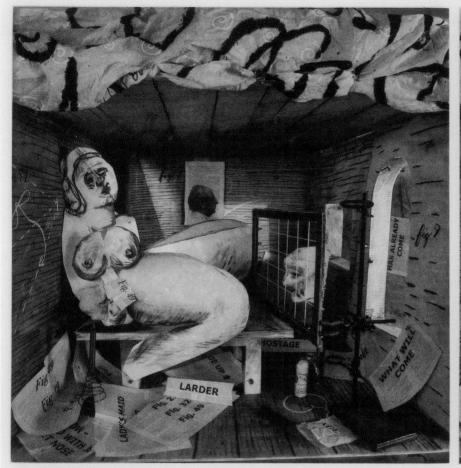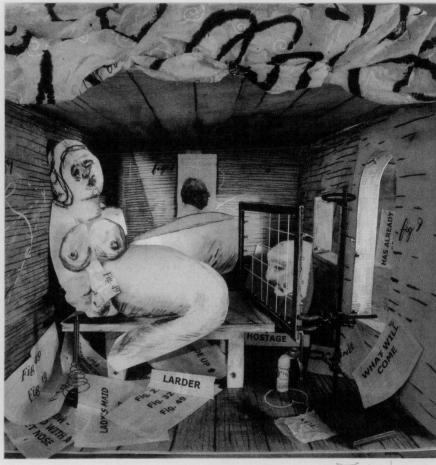

ÉTANT DONNÉE

2007

Photogravure

Each
Image 22.5 x 22.5 cm
 8.9 x 8.9 inches

Paper 34.4 x 57 cm
 13.5 x 22.4 inches

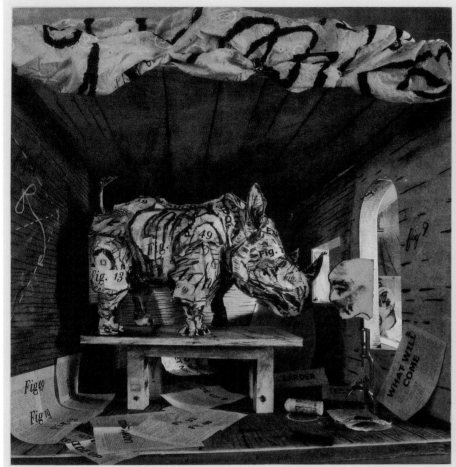 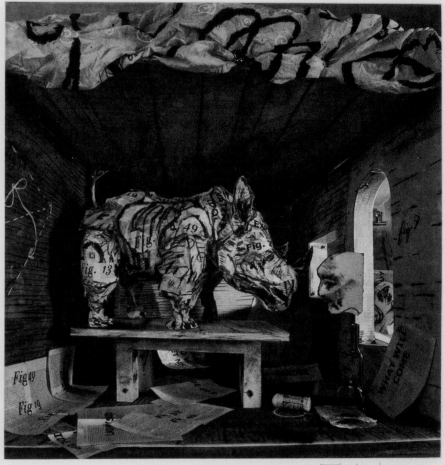

LARDER

2007

Photogravure

Each
Image 22.5 x 22.5 cm
 8.9 x 8.9 inches

Paper 34.4 x 57 cm
 13.5 x 22.4 inches

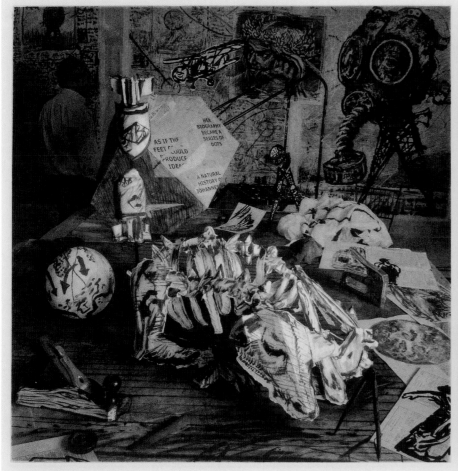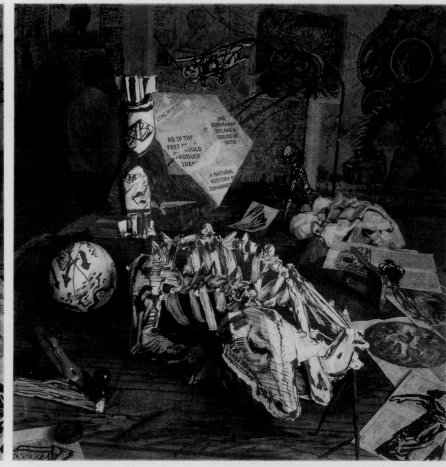

MELANCHOLIA

2007

Photogravure

Each
Image 22.5 x 22.5 cm
 8.9 x 8.9 inches

Paper 34.4 x 57 cm
 13.5 x 22.4 inches

DRAWINGS FOR PROJECTION
THE SOHO ECKSTEIN FILMS

These are the works that first brought William Kentridge the reputation that he now enjoys internationally, as draftsman, animateur, and as an artist who is both politically engaged with the world and possessed of a refined philosophical and aesthetic sensibility.
It is not simply the subject matter of these animated films that render them innovatory engagements with the context in which he works - Apartheid and post-Apartheid South Africa. Kentridge has developed a technique ("stone age film-making" in his words) that resonates powerfully with that subject matter, and which he has continued to use on his other projects.

The substance of the films are the trials and tribulations of Soho Eckstein, property developer and mining magnate, his bored and neglected wife, and her lover Felix Titlebaum. The nine films, in tracing Eckstein's trajectory through the changing social and political landscape of South Africa from 1989 to 2003, tap against some of the most sensitive exposed nerves of white South Africa, and some of most pointed and poignant issues that this society is being forced to confront. Normal daily events for the privileged are here presented against the harsh graphic representations of a blistered and unforgiving and desperately scarred geographical and political landscape.

Here we see the attempt to come to terms with a 'memory' that is not directly recalled and a history that, before the revelations of the Truth and Reconciliation Commission, was a non-existent terrain for part of the white population. The claimed innocence of any knowledge of this history by many might be a form of disingenuity (in the sense of self-deception), or it might be a culpable ignorance, but in either case it will be felt as an innocence. If so felt then any expectation of an admission of guilt will generate no more than resentment. Even if this can be avoided, the adoption of guilt is likely then to generate withdrawal and quietude. We see Soho struggling to identify what he 'should' be, and what he should be doing, during the years of Apartheid – making a buck, and trying to be civic-minded and paternalistic – and we see him through the collapse of his empire, left disconnected from the world, removed after Apartheid from any capacity to influence events. Meanwhile Felix Titlebaum, despite his different aura and circumstances, finds himself similarly distanced from a capacity to act in the world; he finds himself, indeed, unable even properly to experience the world except through the eyes and the sensibilities of the oppressed – an alienation from both action and perception.

The method of producing these works of animation is novel and laborious. Kentridge makes the initial drawing in charcoal, then walks to the camera and shoots it with one or two film frames. He returns to the drawing and erases, and marks again to produce marginal changes which are then shot again. In the end, rather than thousands of original images, as in normal animation practice, he is left with only one drawing per scene. Moreover, these have their history partially erased but partly apparent on their surfaces – just as we find the traces of our past stamped on our present condition (see the article in this catalogue by Pete Seddon). The erasures are a jangling reminder of the attempts to erase political memory or to rewrite personal histories or to force convenient amnesias – practices that afflict liberators and the oppressed as much as they do those who were complicit in oppression.

JOHANNESBURG, SECOND GREATEST CITY AFTER PARIS (1989)

We meet Soho Eckstein for the first time – a mining mogul, archetypical, entrepreneur/capitalist transforming the world to the tune of his fortune. We see the building of a mining town and the emergence of a city, and then the effects of the development on the landscape of Witwatersrand, on the cityscape and on the city's inhabitants.

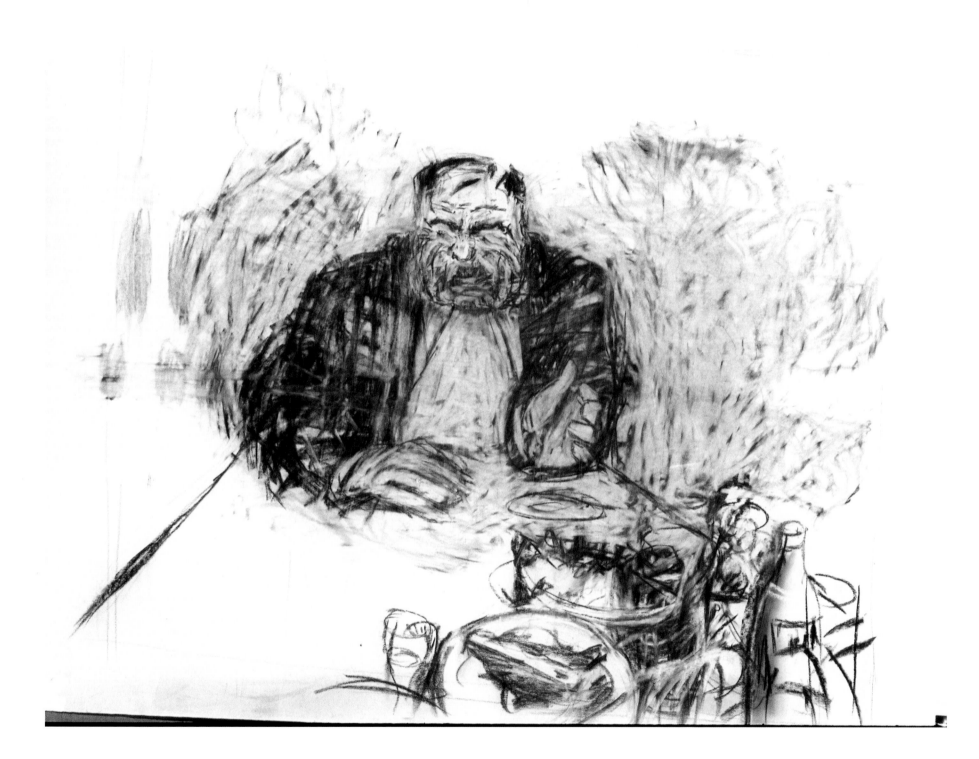

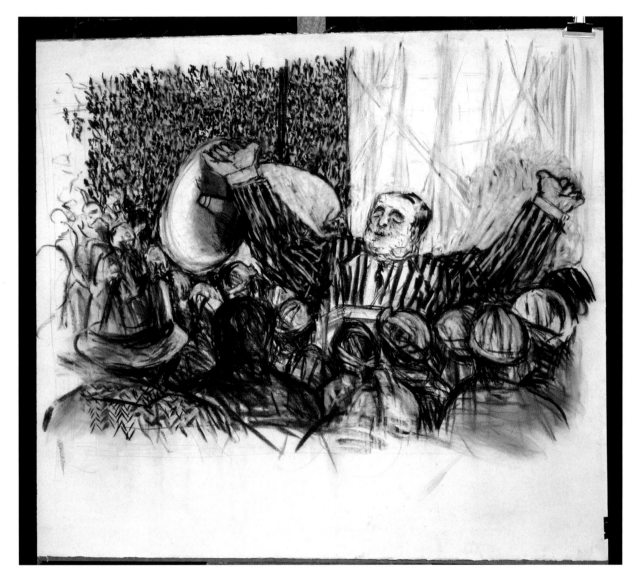

MONUMENT (1990)

Soho, half oblivious of his true position and partly enchanted by his own propaganda,
presents a monument to labour but the monument cracks into movement and life.
The actual instantiations of labour refuse to be monumentalised, to have their pain and
struggle celebrated as 'dignity', and thereby to have their suffering domesticated. In this,
their struggle is complicated by the power of the media, however, in its shaping and
distorting of consciousness.

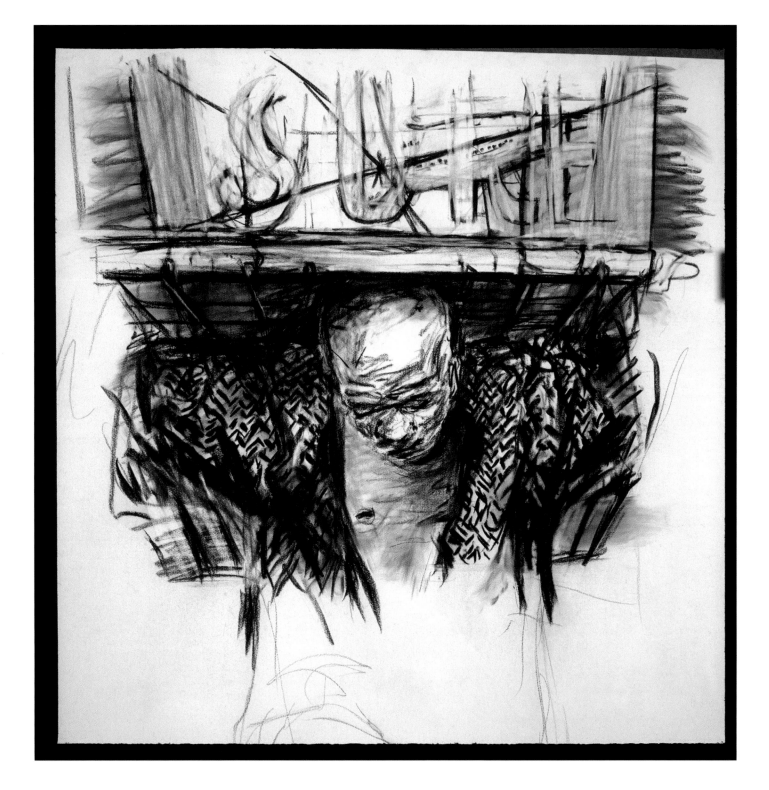

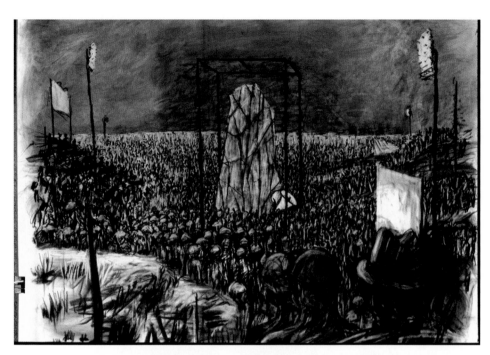

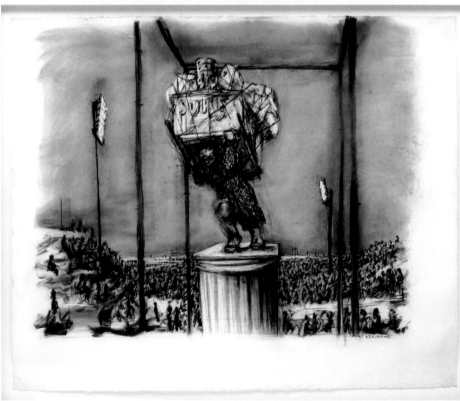

MINE (1991)

Two striations of life coexist but beyond each other's sight. Above ground, the pleasures and dalliances and sonorous certainties of the privileged persist, and are held to more firmly; below ground, the sweat and blood and tears of those whose product sustains all above continue incessantly and unobserved.

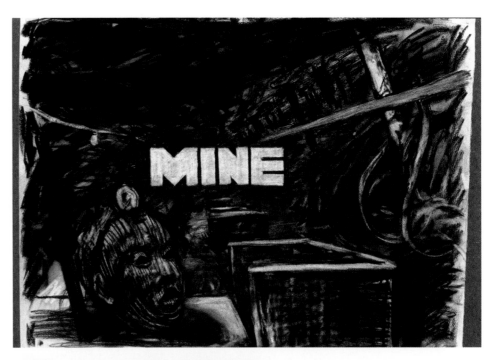

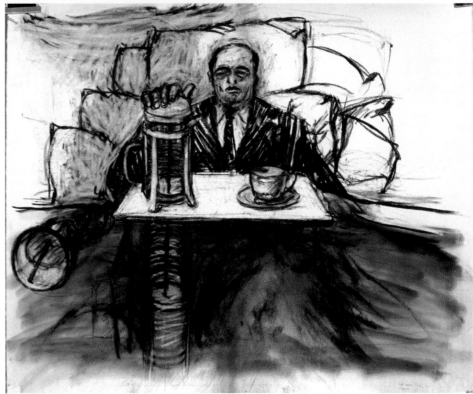

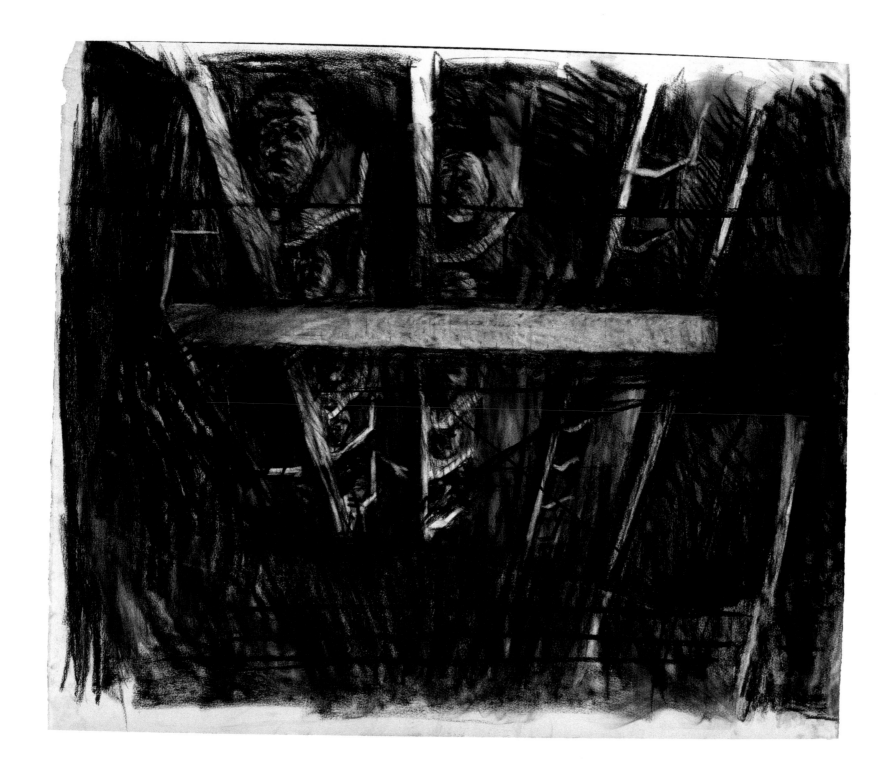

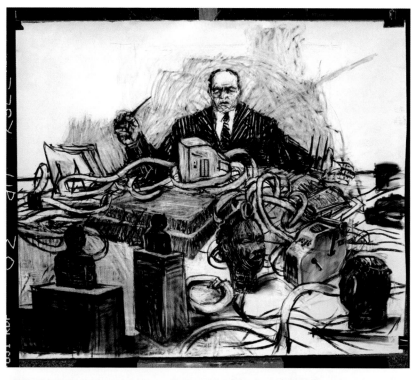

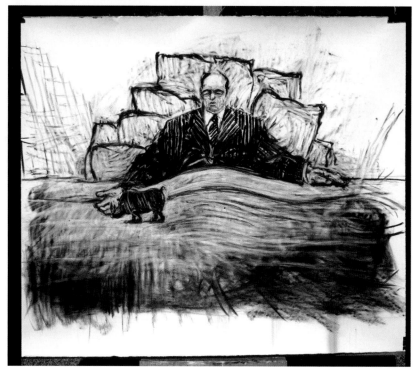

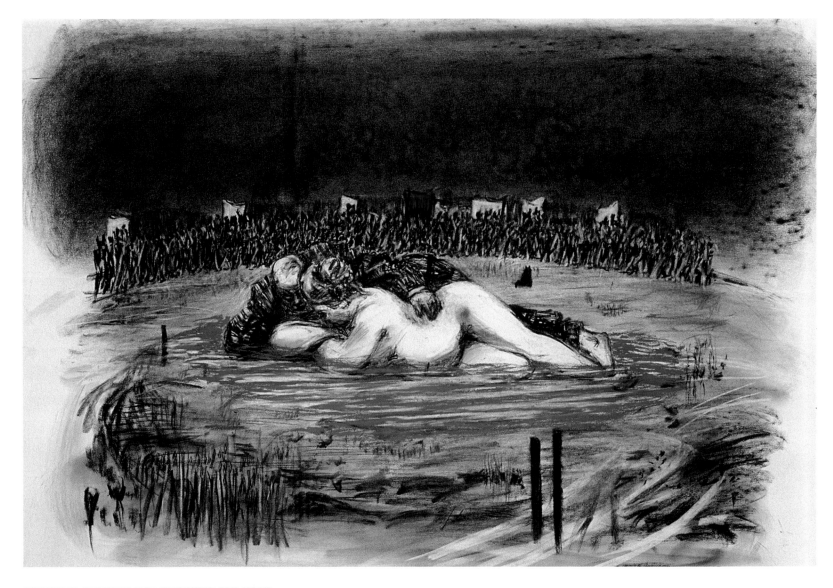

SOBRIETY, OBESITY AND GROWING OLD (1991)

As Soho's private life collapses with the departure of his wife, abandoning her husband's instrumental and pecuniary rationality for the liquid, sensual embrace of Felix, and the passions of his existence, his empire starts to crumble in sympathy. These individual (commercial and private) crises for the hero are played out against the backdrop of an emerging collective struggle of the oppressed, as their capacity for collective agency is discovered.

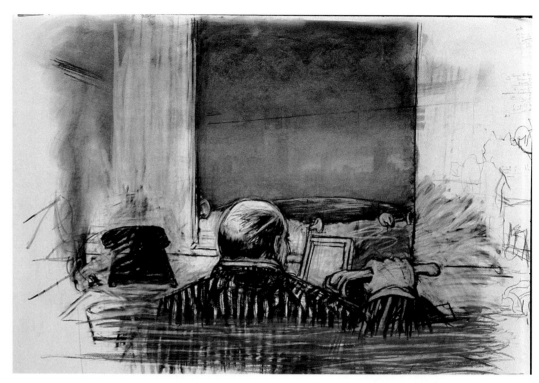

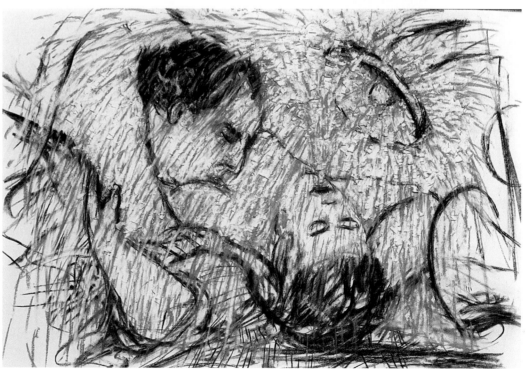

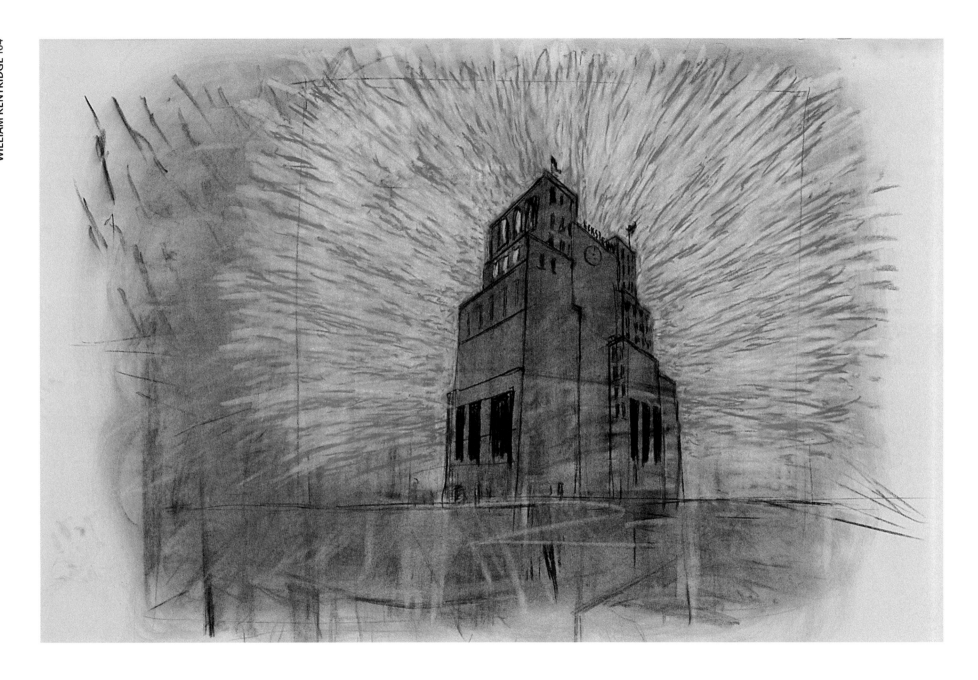

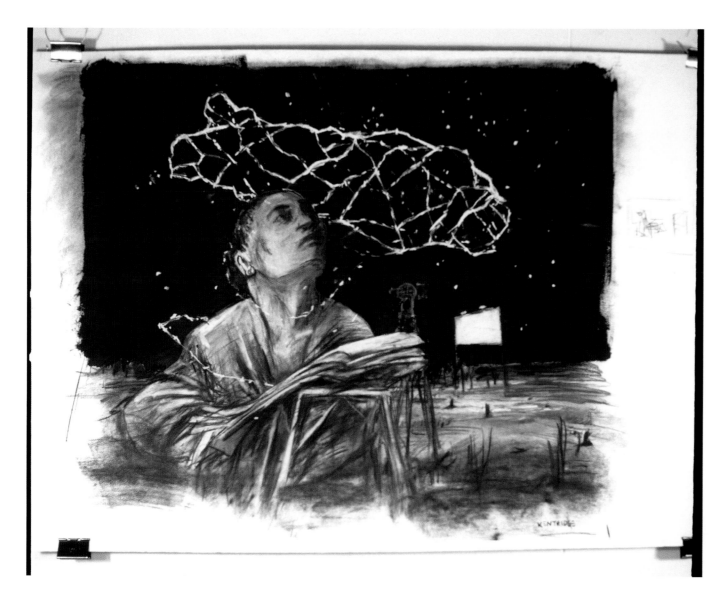

FELIX IN EXILE (1994)

As the political plates of the earth move beneath him, Felix discovers that he can only properly see the torture that is South Africa and its history through the lens of the oppressed; only through the eyes of a black African woman can this be understood. Bodies crown the landscape; and the landscape washes them away. Nature does to detritus and scars what time does to memory. As his mirror image is replaced by that of her face, and they peer at each other through opposite ends of a telescope, both Felix and the black woman realise that they can only inspect their divided worlds at an ineradicable distance.

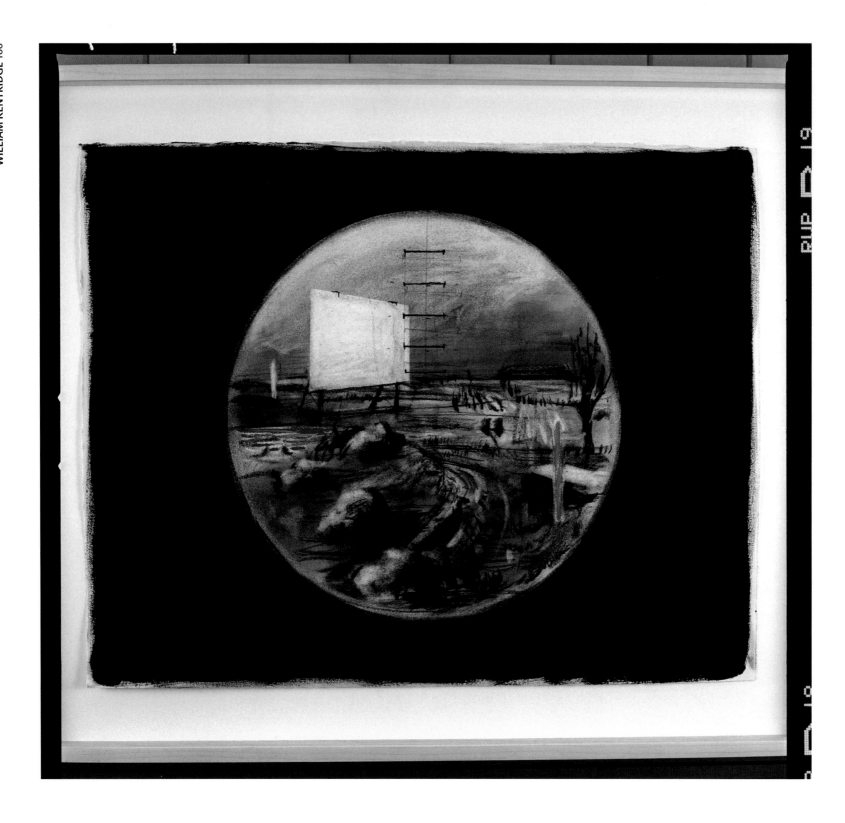

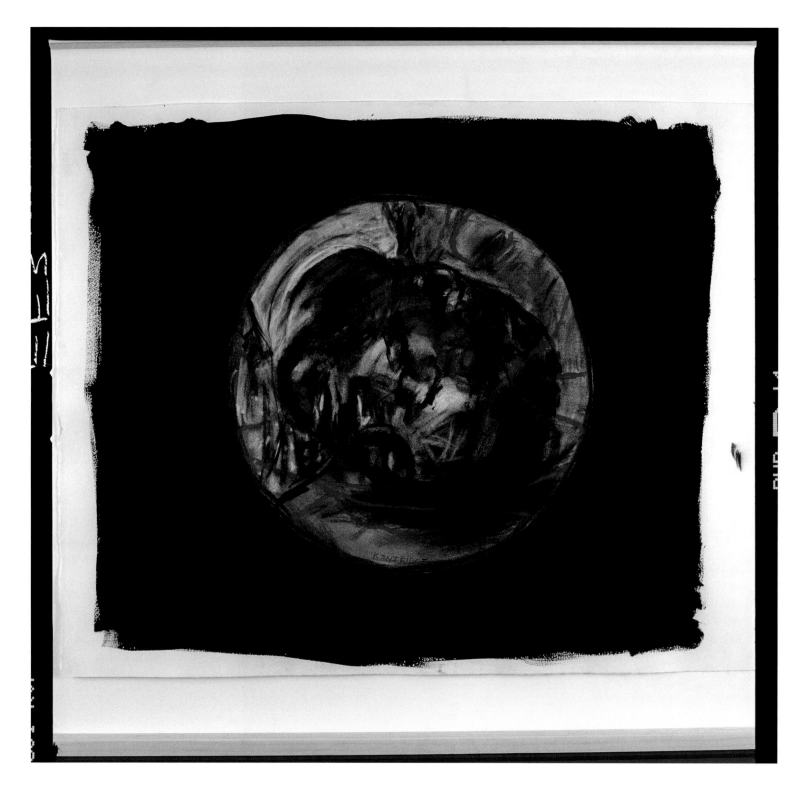

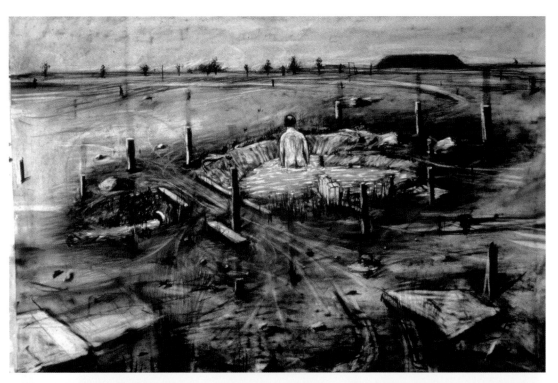

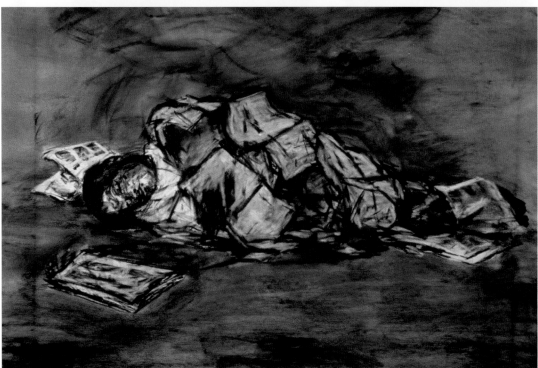

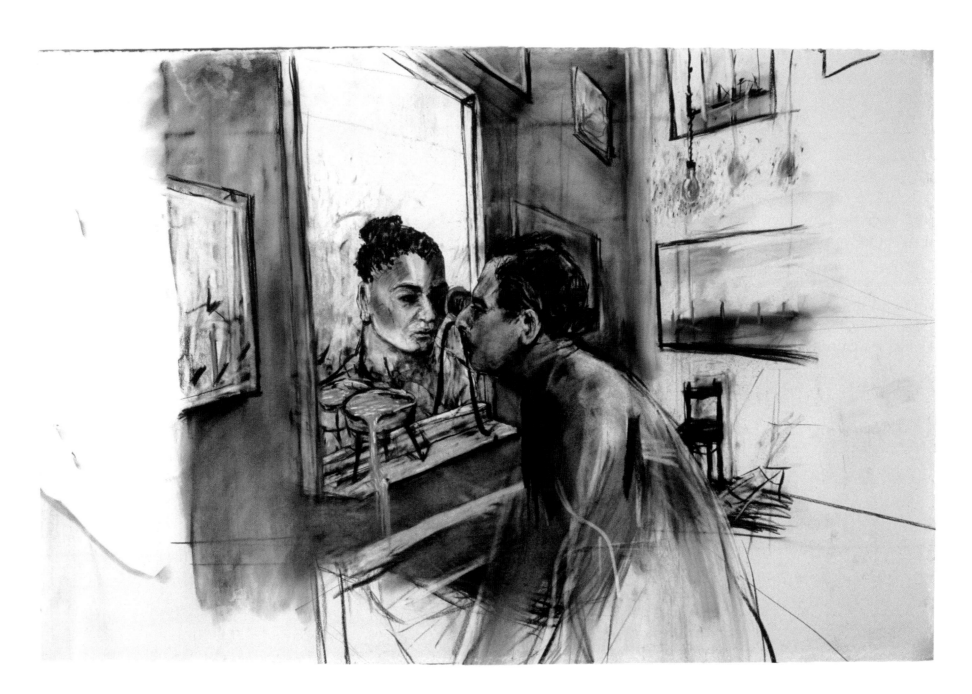

HISTORY OF THE MAIN COMPLAINT (1996)

Consigned to a hospital bed, Soho starts
to come to terms with his own complicity in
the system of oppression. He dreams of an
accident, of a black woman sprawled in the
road, and he awakens. He is surrounded by
medical versions of himself, that partially
inure him to the prick of insight about the
world but he remains tortured by the claims
of memory and identity and responsibility (see
the article in this catalogue by Jess Dubow
and Ruth Rosengarten). Though a sense of
responsibility may be growing, he has no
thought of what might be done, and returns
to his office, to the telephone and the
machinery of his commercial life.

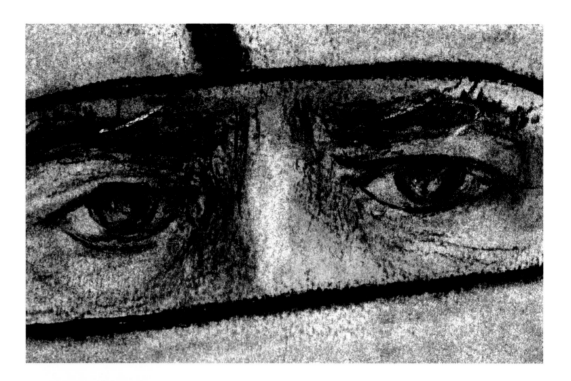

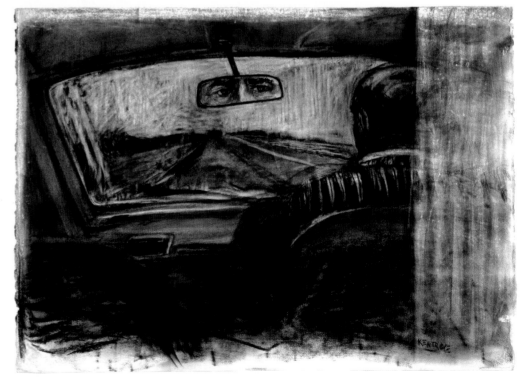

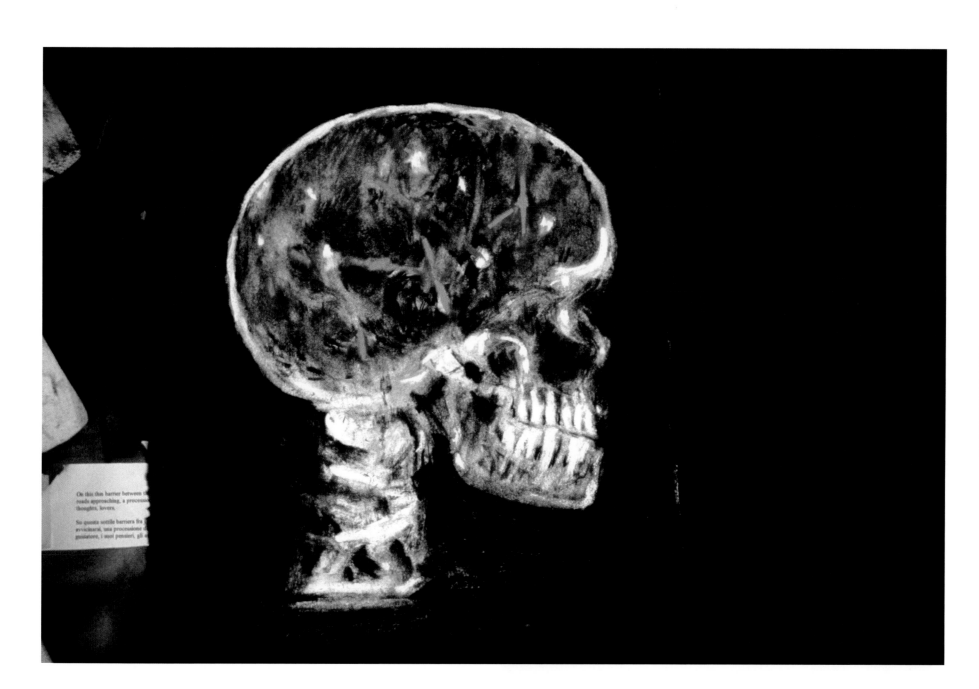

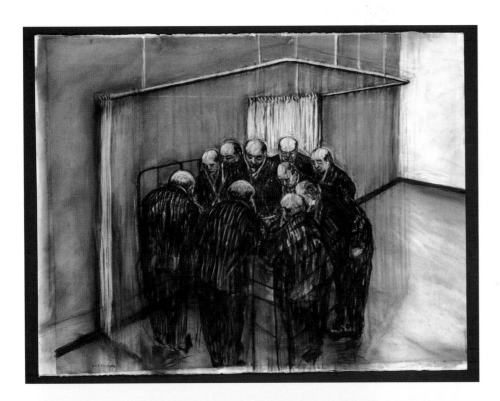

WEIGHING ... AND WANTING (1998)

"You have been weighed in the balance and found wanting ..." Soho is incapable of responding to his dual challenge: the crisis of the public space, and the collapse of his private, protected universe. In an existential moment, the inert rock that he picks up provokes the claims of memory and history.

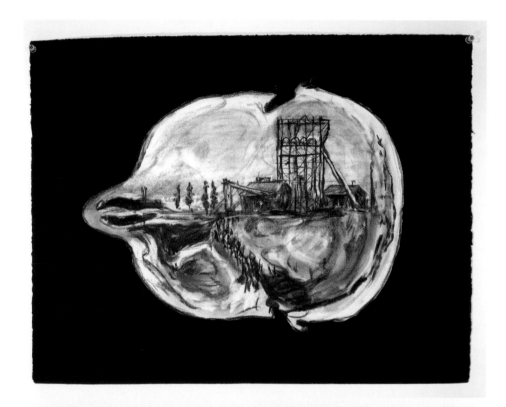

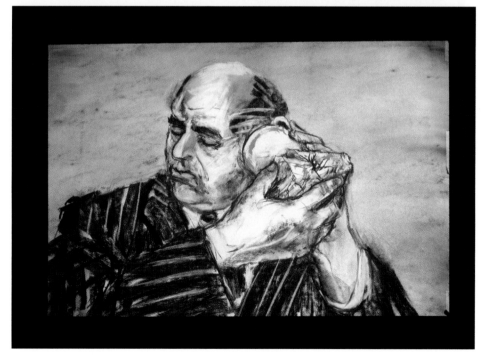

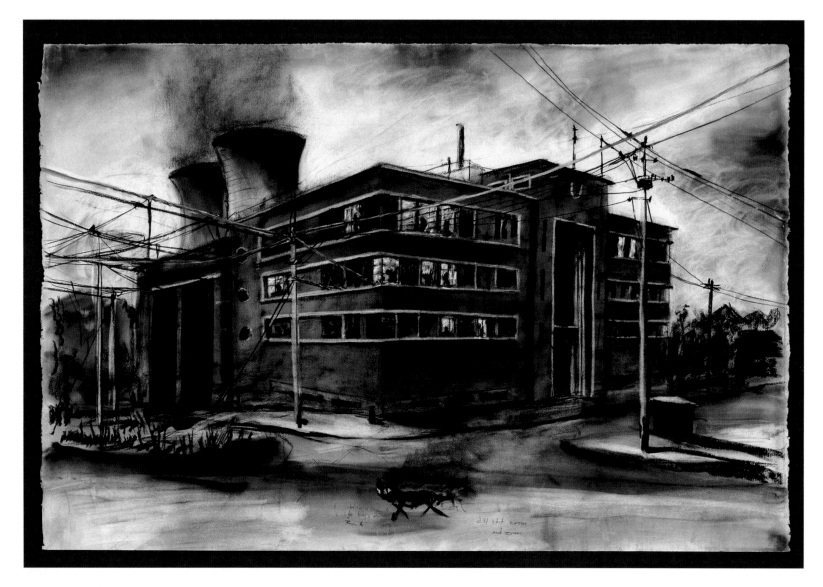

STEREOSCOPE (1999)

Soho attempts to make sense of a confused
and horrific world which presses incessantly
and intolerably on him. Beyond his office walls
are violence and protest and rebellion. He is
imprisoned in his privileged space.

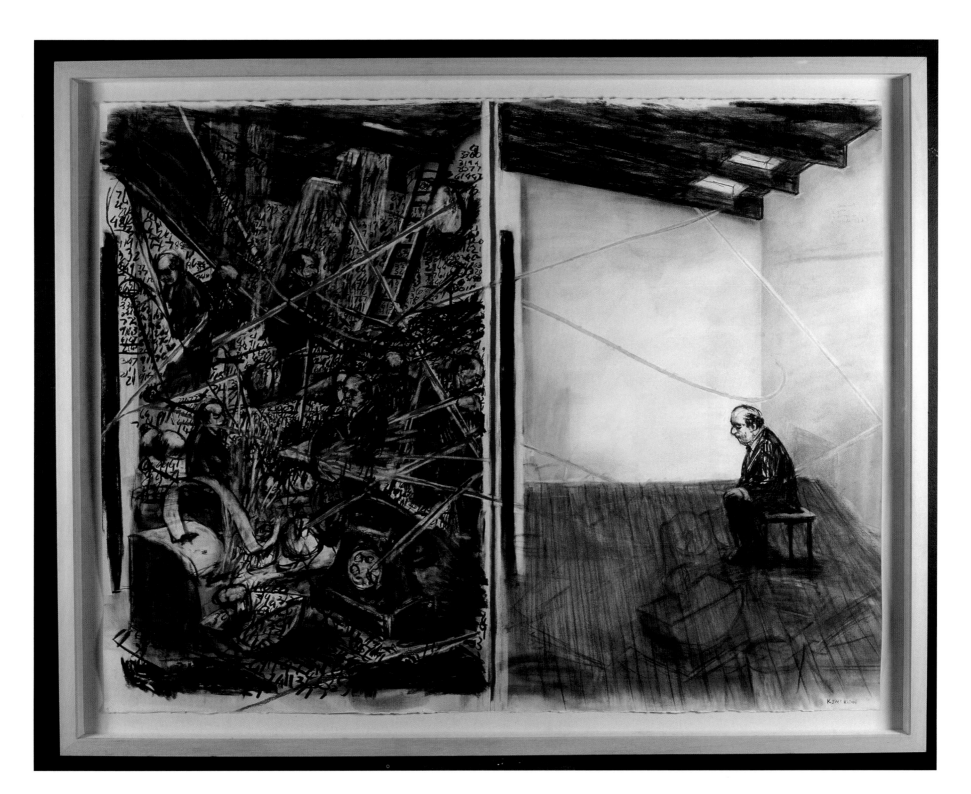

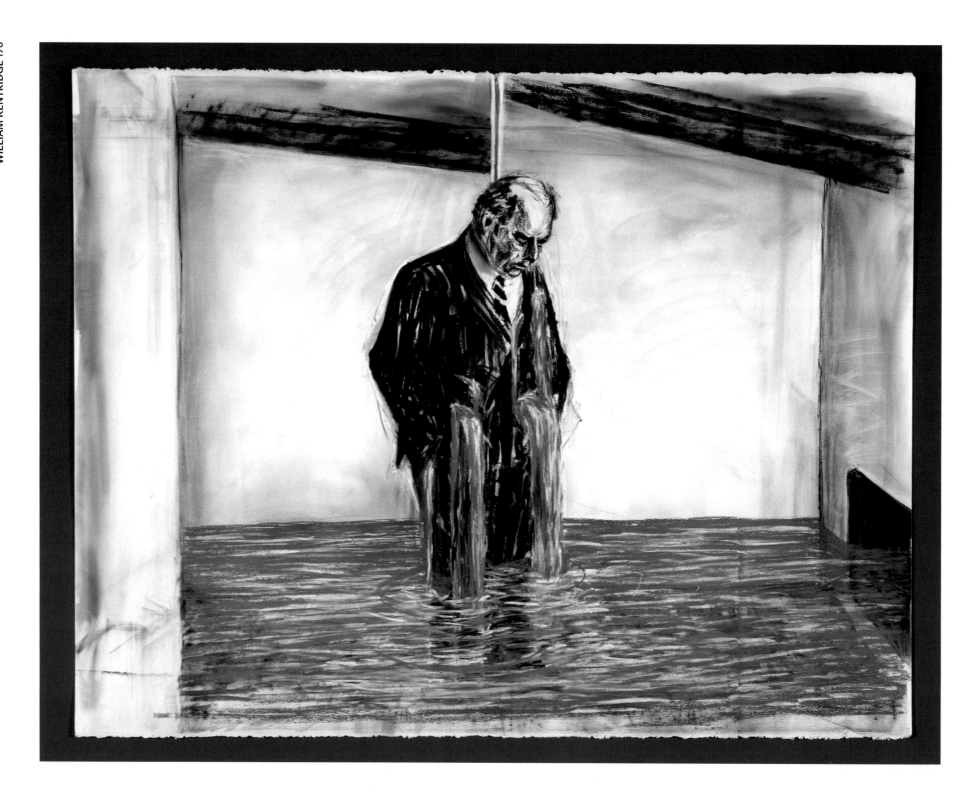

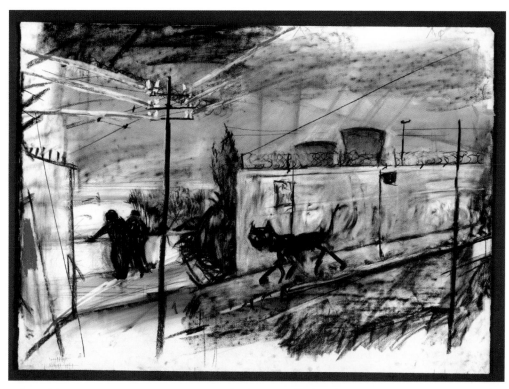

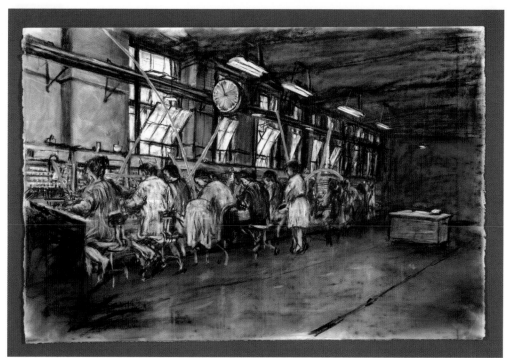

TIDE TABLE (2003)

Soho is a solitary figure, passively observing the world from afar, and allowing the seaside days to wash over him. Even in the newspaper he is just registering the passage of cyclical time. His ambition is exhausted; his engagement with the world is severed. He is a passive observer as life withers and dies of disease around him. Like many white South Africans, he has gone into effective hiding while still walking around. A man holds a sick or dead body, and the sea washes it away. Generals inspect the world from a balcony and through the binoculars of their authority but are equally passive. They too are disjoint from the world. As time unfolds the sea washes flotsam ashore. A temporary resident, Soho has no role, and this sojurn is now expressive of his existence – he awaits something that will never come, and if it did come he would not recognise its arrival. Even the recovery of history through recollection or reconstruction promises to be enervating as personal pasts are so tainted with threatening collective memories that they need to be pushed away. After Truth and Reconciliation, the past needs simultaneously to be forgotten and remembered.

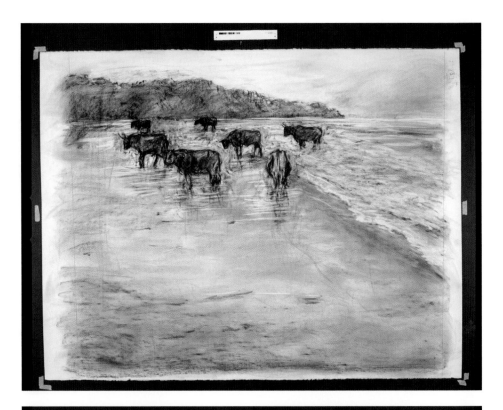

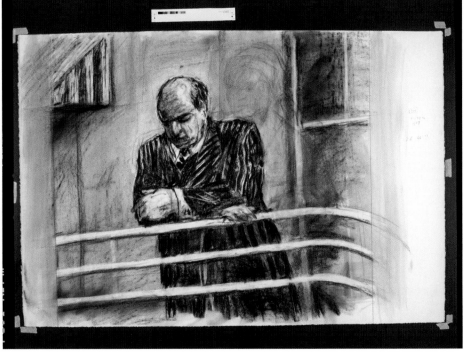

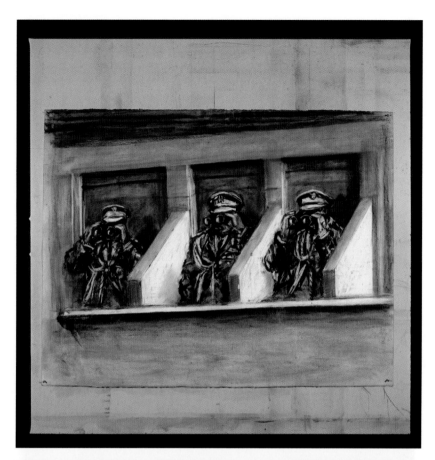

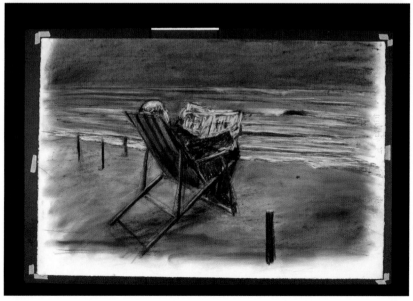

FRAGMENTS FOR GEORGES MÉLIÈS (2003)

HOMAGE TO GEORGES MÉLIÈS

In these seven films, Kentridge responds to the inspiration and provocation of Méliès' experiments. Moving around his studio, moving backwards and then reversing the film, operating on the objects that surround him, reversing his tearing of the paper so as to restore in film its perfect continuous texture, he explores the nature of making.

DAY FOR NIGHT

Here an army of ants learn to write and to draw. With the aid of sugar trails, he coaxes and corals them as the actors of the drama. Negative reversal of the exposures then completes the process.

JOURNEY TO THE MOON

Here the mundane objects of existence become the heroic objects of space flight. Cigar and coffee pot and cup become the rocket on the moonscape, the space capsule and the telescope.

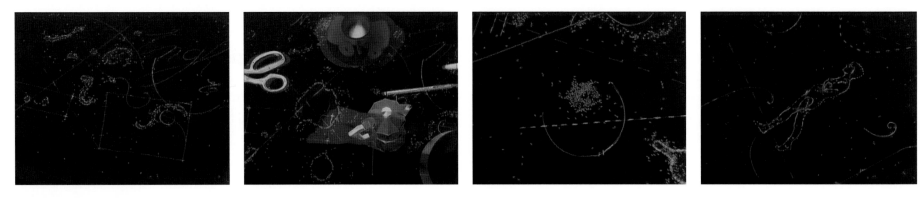

DAY FOR NIGHT (2003)

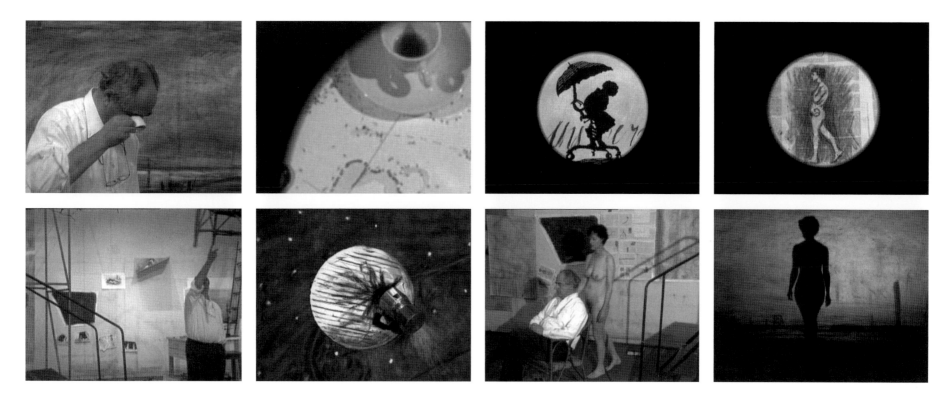

JOURNEY TO THE MOON

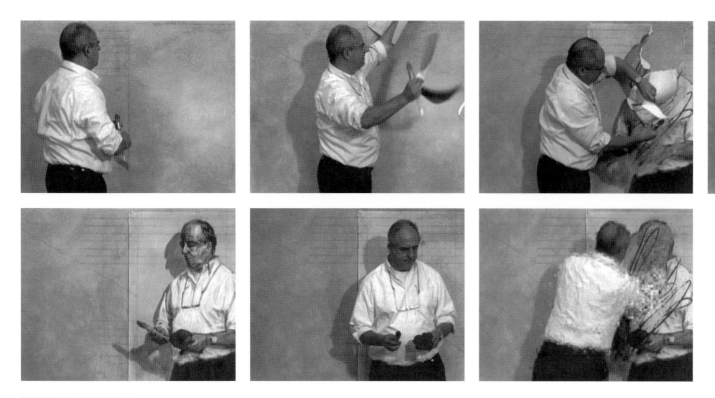

INVISIBLE MENDING

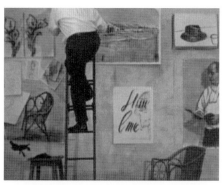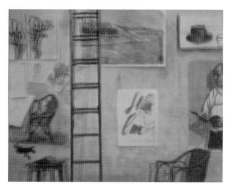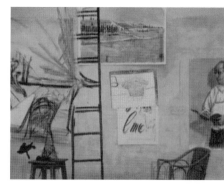

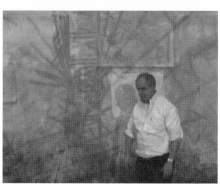

BALANCING ACT

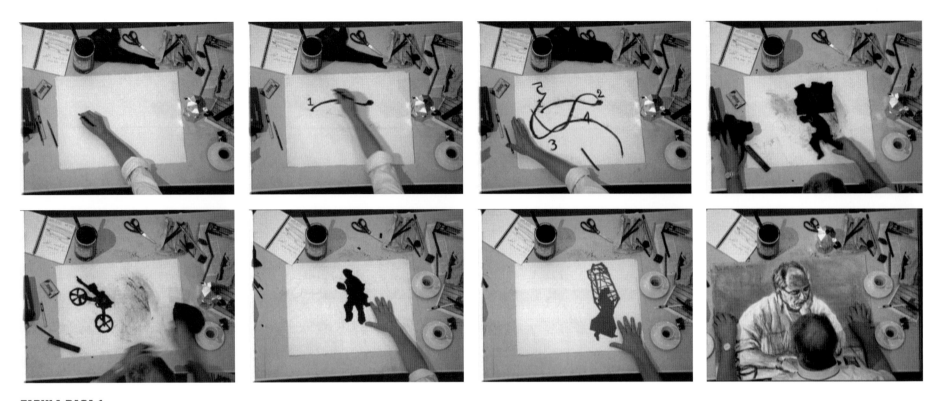

TABULA RASA 1

TABULA RASA 2

MOVEABLE ASSETS

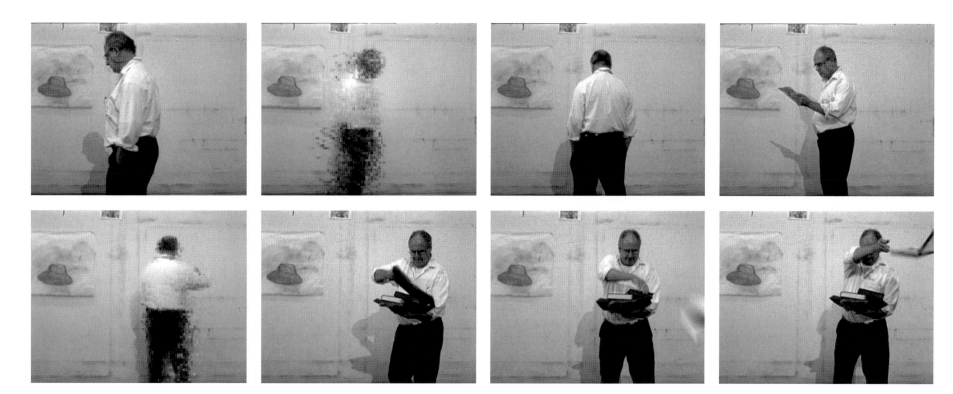

AUTO DIDACT

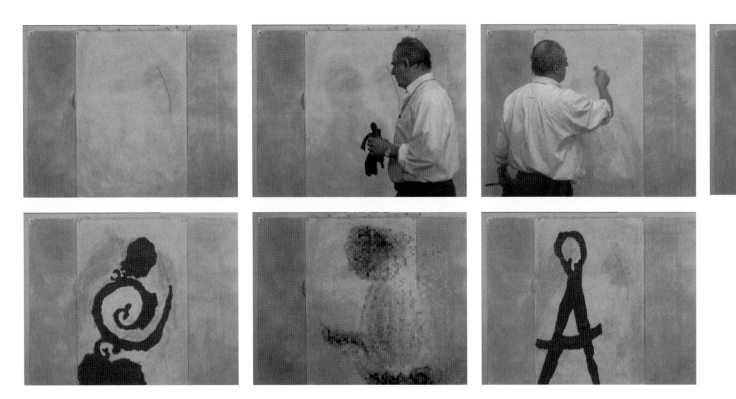

FEARS OF PRESTIDIGITATION